b0655434n

D0788912

REYNOLDS

Ellis Waterhouse

REYNOLDS

PHAIDON

PHAIDON PRESS LIMITED, 5 Cromwell Place, London SW7

Published in the United States of America by Phaidon Publishers, Inc.
and distributed by Praeger Publishers, Inc.
111 Fourth Avenue, New York, N.Y. 10003

First published 1973 © 1973 by Phaidon Press Limited
All rights reserved

ISBN 0 7148 1519 5
Library of Congress Catalog Card Number : 78–158100

Printed in Great Britain by W. S. Cowell Ltd, Ipswich

Contents

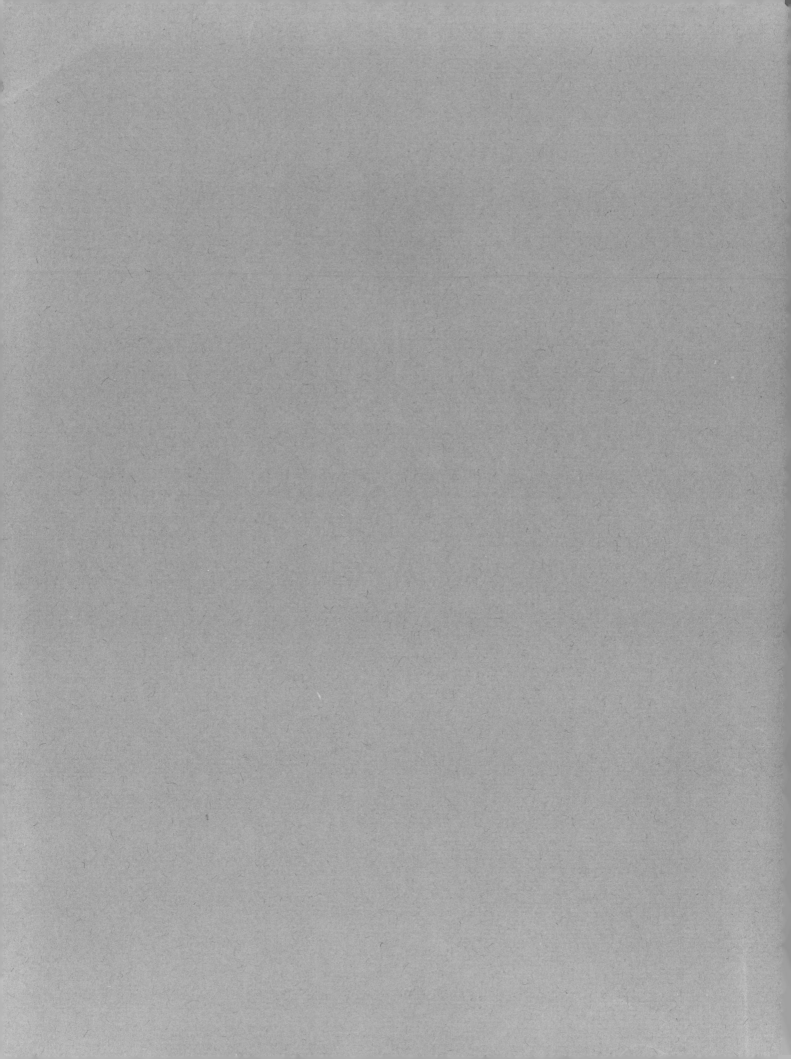

Foreword

THE STUDY of British painting, perhaps especially of British portraiture in the eighteenth century, has had an odd history. The handsomer portraits began to fetch very high prices before any serious study had been made of the artists who painted them. This happened towards the close of the last century and the situation was made more curious by the fact that what is now known by the rather Germanic term 'art-history', as far as any period later than the Middle Ages was concerned, had no place anywhere in the educational establishments of the British Isles. The art trade needed some bibliographical buttress for its profitable activities, and what were to become for thirty years the 'classic' books of reference for Reynolds, Romney and Hoppner were all promoted by the art trade. The most singular was Graves and Cronin's *Reynolds*, the four volumes of which appeared by subscription, in a limited edition of 125 copies, between 1899 and 1901, and it is reported that, although a 'copyright' copy was presented to the British Museum, an arrangement was made restricting access to it for a number of years! As late as the 1930s I can recall Lord Duveen expressing horror that one could venture to disbelieve a statement which was enshrined in Graves and Cronin. In the early 1930s, when I was first forced to take an interest in British painting (as the first junior assistant ever appointed by the National Gallery), there were in existence these 'classic' works of the beginning of the century: no serious work had been done for years, or was being done, on eighteenth-century portraits, many of the once famous works had not been seen in public for years, and photographs of surprisingly few of them were available without great difficulty. It has thus been one of the conscious but unadvertised preoccupations of my life for the last forty years, by encouraging photographic campaigns, and borrowing for exhibition pictures which have not been photographed and other such activities, to bring about a change in this situation, so that serious research into British painting – and not least into the portraiture of the eighteenth century – could be undertaken with some hope of benefit. For this reason I would like to dedicate the present book to the Paul Mellon Centre for Studies in British Art, set up in London by Yale University very largely to promote this end.

My own specific research on Reynolds was completed before the last war and detailed acknowledgements for help appeared in my *Reynolds*, which finally came out in 1941. What of Reynolds I have seen since – and it has been a good deal – is what has come my way to some extent by accident and I have

experienced a different set of obligations. To list them all would be impossible. One's greatest debt is naturally to those who have allowed the illustration of pictures they own or care for, and even of these an increasing number, for sound prudential reasons, prefer to lurk under the generic title of 'private collection'. The public institutions for which I have been especially indebted for help in the matter of Reynolds have been the Libraries of the National Portrait Gallery and the Royal Academy and the Witt Library: and an especial debt is owed to the City of Birmingham Museum and Art Gallery for allowing me to use much of the excellent photographic material made at the time of their Reynolds Exhibition in 1961.

In choosing the illustrations for the present book I have conceived myself as in the role of curator of a *musée imaginaire* – which has the advantage of being unconcerned with accessions or 'deaccessioning'. He has an equal duty to the artist, to show 'how various he is', and to the public, to choose those works, whether familiar or unfamiliar, which will together give the fullest insight into the artist's contribution to the great achievements of the human spirit.

<div align="right">E.K.W.</div>

Oxford, May 1973

Introduction

IT MAY PERHAPS seem absurd to anyone chiefly familiar with the artistic scene of today to suggest that it is possible for a professional portrait painter to be a great artist. A 'professional portrait painter' is someone who is at the mercy of moderately well-to-do private individuals or, more particularly, of committees who have control of funds, who wish for a reasonably accurate record of the appearance of a sitter whose features are, as often as not, very far from zographogenic, and whom the painter has very probably never seen in his life before. Yet, if we are to do him justice, it is precisely as a professional portrait painter that Reynolds must be judged. He had great aspirations—as did Hogarth, Gainsborough and Romney (but not Allan Ramsay)—to be something much grander; portrait painting ranked very low in the hierarchy of genres in the eighteenth century, as it still does in the very different fashionable pecking order of today. He wanted to be judged as a 'history painter', the highest category at that time, and, such was his reputation as a portrait painter, that he managed to sell a number of indifferent history pictures at much higher prices than he could charge for his portraits. For at least two generations after his death the history pictures still commanded fairly high prices. But the history of taste has not very much in common with the history of art. It would be merely wilful today to try and claim that any of Reynolds's 'histories' could be reasonably called a 'masterpiece', but some of his portraits may well seem to us today to be the works of a great master. They reveal universal human values beneath an individual human likeness, which has been observed with the detachment proper to the professional portrait painter.

Successful portrait painters in later years, such as John Singer Sargent, have been able to refuse to paint sitters they thought uninteresting or ugly. Not so Reynolds—or any painter in the eighteenth century. Only by putting up his prices was he able to stem the tide of sitters; there is no evidence that he ever declined to paint someone who applied to him, even though his superior eminence was acknowledged as early as 1763, when an American client could write home 'my portrait without frame will come to 25 guineas, an extravagant price, but you desired it should be done by the best hand.'[1] No doubt there is a considerable number of portraits (especially of 'heads') in which the painter's interest does not seem to have been very keenly aroused, but the general level of response to individual character is so wonderfully fresh that one cannot doubt that he was fascinated by contact with each new person. His superiority

over most other portrait painters seems to lie in the immense width of reference of his visual system of classification. Reynolds's aspirations to history painting led him to study the old masters in a way not normal to the professional portrait painter. He was interested above all in the aptness of movement or gesture to convey the character of the protagonists in a history picture. His drawings—or rather 'notes'—from old masters are mainly of the pose and gestures of single figures. He clearly had a most remarkable visual memory for what he had seen and studied in this way, and I can only suppose that, when first encountering a new sitter, he searched in his memory for some visual hint which fitted with the observed character of the sitter. This would be an instinctive process of the same order as that by which similes present themselves to a poet.

It is in this richly associative power that he differs from all his contemporary portrait painters in Britain (and in France) and moves into the imaginative world—though at a much lower level—of Rembrandt and Rubens. It is this quality which Gainsborough understood when he made his famous remark, 'Damn him! How various he is!' This is honourable envy. It is perfectly reasonable to speak of the thirty years from 1755 to 1785 as the 'Age of Reynolds', for he gives us a rounded picture of the period. To imagine a meaning for the 'Age of Gainsborough' is merely to summon up a vision of a group of fashionable or Bohemian persons. It does not seem to me to be doubtful that, to the historian, Reynolds must seem a great artist, although we may still ask how accurate a record of the features and characters of his contemporaries are Reynolds's portraits.

A good many of his most speaking likenesses are of sitters whom he never encountered except in his painting room, and the portraits of his closest friends—Goldsmith, Burke, Boswell and Sheridan—seem much more inscrutable and tell us surprisingly little about them. Dr Johnson is an exception to this, but it would require a genius of reticence to tone down the communicativeness of his features. Yet what seems to us blankness did not appear to be so to contemporaries. It may be that *the* original of the portrait of Sheridan has not yet appeared, but we at least have the engraving of 1790. It tells us very little that we should like to know about the sitter, but to Walpole this portrait was 'animated nature; all the unaffected manner and character of the admired original'. It can hardly be that the fading of his flesh tints—which

became a cliché to critics of his own time and succeeding generations—has produced this loss of character.

There is at least evidence that Lavinia, Countess Spencer, of whom he painted one of his most enchanting portraits (Plate 94) and to whose family he was a friend of long standing, felt that, as a record of a beloved person, a Reynolds was immensely superior to a Gainsborough. In a letter to her husband[2] she wrote 'I can't bear the idea of anybody having a picture by Sir Joshua of you beside myself' and she thought a Gainsborough could do as well as anything else for Lord Spencer's college. With many artists the portraits painted of a wife or mother or other near relation can usually be detected by their look of sympathy and affectionateness which is lacking in commissioned portraits. With Reynolds this look is to be found in a surprising number of portraits, and those who have lived with a knowledge of them for a long time tend to regard the sitters as living personalities whom they know. It seems to us an age in which dissimulation, among people of good education, was less at a premium than it has ever been before or since. Perhaps a secret of the good manners which survive among those increasingly few ancient families which have retained their ancestral portraits is that to live daily with their forbears as Reynolds saw them is an education in itself! It is only the more pretentious Reynolds portraits—which, it must be admitted, were sometimes those he most prized himself, such as *Three Ladies adorning a Term of Hymen* (Plates 72 and 74)—which are really at home in a public art gallery. The Reynolds drawing room at Althorp is the most entirely satisfactory setting in which to see the best of Reynolds's work in conditions for which it was painted.

Reynolds seems to have known his own limitations. He knew that he had never learned to draw properly, and he was conservative enough to accept the prevailing aesthetic, derived from Vasari, that Florentine draughtsmanship was superior to Venetian colour. In the *Discourses*, as Vasari would have approved, Michelangelo is praised as the creator of 'the language of the Gods', and Titian is played down. Yet Reynolds's mastery lies essentially in the Venetian tradition, in colour, in chiaroscuro, in the arrangement of masses in which the outlines are never hard. His feeling for the placing of a figure within the confines of a frame is never at fault, and his control of the pattern of light and shade over the whole area is equally masterly. The texture of the paint is sometimes attractive in itself, but there is often uncertainty whether

the passages which we admire are from Sir Joshua's own hand. There is, for instance, in the portrait of Archbishop Robinson (Plate 95), a fragment of almost impressionistic landscape with a distant church spire, which is of admirable quality. It is not easy to believe that it is from Reynolds's own hand, but it is even more difficult to believe that Northcote, who states that he painted the drapery in this picture, had anything to do with it. The final tone effect of the drapery is also so characteristic of Reynolds at his best that one is inclined to believe that Northcote only laid in the larger forms of it. We are—and I am inclined to think that we must remain—in the dark about these detailed problems of connoisseurship. But what is clear is that the studio, as such, was most admirably organized. This studio participation was not, at any rate among the better informed of Reynolds's patrons, in any way a secret. Horace Walpole, writing to William Mason on 10 February 1783,[3] makes an interesting comment on the portrait of the Ladies Waldegrave (Plate 96). He begins by speaking of Reynolds's portrait of Lord Richard Cavendish, of which he says 'little is distinguished but the head and hand; yet the latter, though nearest to the spectator, is abominably bad; so are those of my three nieces, and though the effect of the whole is charming, the details are slovenly, the faces only red and white; and his journeyman, as if to distinguish himself, has finished the lock and key of the table like a Dutch flower-painter.'

The one superiority that Gainsborough's portraits have over those of Reynolds is that Gainsborough, with inconsiderable exceptions, executed the whole of each picture with his own hand. Although Reynolds does not quite admit this as a superiority (in his Fourteenth Discourse, which is largely concerned with Gainsborough), he comes near to doing so. But this was a superiority on the technical side only: on the mental side Reynolds's notions of the world and of the place of the individual in it were so much larger and wider than those of any contemporary portrait painter that no comparison makes sense. There are moments in history when the demands on a contemporary portrait painter are not sufficiently profound or humane to require more than technical competence: the later eighteenth century in England was not one of them. Posterity will perhaps learn more about our present generation from the caricaturists than from the portrait painters. As a young man in Italy Reynolds was tempted in this way, but he abandoned caricature for the more mature study of his fellow beings which they were intelligent enough

and mature enough to require. He was fortunate in the age in which he lived, which did not mistrust a generalizing habit of mind; and he is one of the most satisfactory examples of what may or may not be a true maxim—that every age gets the portrait painter that it deserves.

JOSHUA REYNOLDS was the seventh child of a family of eleven, of whom all but five died young or in infancy. His family might be considered to have retained a place on the fringe of the lesser gentry: all the men entered the Church, and his sister Fanny—who kept house for him in London for a quarter of a century—was very distressed by the idea of her relations being involved in 'trade' (as they sometimes were). His father was a classic example of the good-natured and absent-minded schoolmaster, whose enquiring mind was easily distracted towards new interests, but who was lacking in steady application to any one pursuit. The household was bookish, pious and always short of money. The young Joshua benefited from the books, and discovered his bent for the arts and an elevated idea of the possible status of a painter, from the presence in the house of editions of Andrea Pozzo's book on perspective, Jacob Cats's *Book of Emblems* and, above all, Jonathan Richardson's *Essay on the Theory of Painting*; but he seems early to have reacted against too much piety and impecunious habits. He probably never entered a church, except for a funeral, during the last forty years of his life, and his sister Fanny as well as Dr Johnson often reproved him for practising his art on Sundays. He was always very close on money matters, especially where his family was concerned, and his sister and, later, his niece found it very difficult to extract from him the necessary housekeeping money. Professional assistants were treated in a manner one is almost inclined to call ungenerous.

Reynolds's education was desultory, but he was always aware of the value and prestige of learning, and his father (who had been a Fellow of Balliol) taught him a certain amount of Latin. All his life he was concerned to improve his knowledge by reading and by the conversation of learned and clever friends; he admitted himself that his mind was formed above all by the society of Dr Johnson. He discovered early how useful the type of book which would now be called a 'digest' can be for a man who wishes to pass as well informed; and, by hard work and constant association with the best writers of the day, he taught himself to write with lucidity and distinction. Towards the end of his

life he valued his reputation as writer at least as highly as he did that as a painter. Both were acquired as the result of prodigously hard work.

It was bad luck, but probably inevitable, that it should have been Thomas Hudson to whom Reynolds was apprenticed in 1740. Devonshire solidarity was strong and Hudson was a Devonshire man; he was also the son-in-law of Jonathan Richardson, whose *Essay* had inspired Reynolds to become a painter and who retired from practice at about that date. Although we know from George Vertue's notes that Hudson was in good practice in the earlier 1740s, there are surprisingly few portraits from those years which can now be identified. Unlike his father-in-law, his method did not require preliminary drawings, and hardly a single drawing is known today which is with any probability ascribed to Hudson. But, like Richardson, he was a great collector of old-master drawings and of engravings. Reynolds no doubt failed to learn from him that facility in drawing from the model, the lack of which he regretted all his life; but he did learn the enormous value to an artist—and especially to a portrait painter—of having a collection of drawings, prints and paintings by the old masters to which he could constantly refer. The evidence is elusive and has never been collected, but there is some reason for thinking that Reynolds was one of the principal *marchands amateurs* of his age.[4] He certainly frequented the picture sales from the first, and it was while bidding for his master, Hudson, at the Earl of Oxford's sale in March 1742 that he had the chance to see and shake the hand of Alexander Pope. He remembered this encounter all his life, and it is the earliest evidence of his predilection for men of literature. There is no indication that he ever seriously admired or sought the intimate friendship of a contemporary painter.

One other point about his years with Hudson is worth stressing. A very substantial amount of the surface of Hudson's portraits of these years was executed not by his apprentices, but by the professional drapery painter, Joseph van Aken (died 1749). It was alleged that the final break between Reynolds and Hudson in 1743 was precipitated by the reluctance of Reynolds to take a portrait to van Aken's studio one wet evening. At any rate Reynolds not only became habituated at this early stage to the use of the drapery painter (as Gainsborough, for instance, never was), but he frequented the studio of van Aken, who performed the same chore for Ramsay, Highmore, Knapton and half a dozen other portrait painters. In this way a young man

apprenticed to Hudson had a chance of seeing the latest works of most of Hudson's rivals at the same time. No doubt Reynolds continued to frequent van Aken's studio when he was again in London on his own in the later 1740s. This would explain how he may have come to have known Ramsay's *Chief of Macleod* of 1748, where the ingenious use of the Apollo Belvedere pose in reverse is first found. Five years later he was to adapt it to the portrait of Augustus Keppel (Plate 10), with which he established his reputation in London in 1753/4.

The number of pictures which can be ascribed to Reynolds with any confidence from the years before he sailed for Italy in 1749 is not large,[5] but one or two of them, which seem pretty certain, show that he must have looked with attention at any old masters he could get a sight of, and had already determined, before his Italian experience, the lines on which he hoped to remake the British tradition of face painting. His portrait of the Hon. John Hamilton (Plate 3), traditionally dated 1746, is clearly modelled on Titian, and the enchanting *Boy reading* (Plate 4), which is signed and dated 1747, is inconceivable without a sympathetic study of a Rembrandt such as the *Titus* in Rotterdam.

There can be no doubt, to our hindsight, that the best portrait painter working in London at the time of Reynolds's apprenticeship was Hogarth. It is true that he painted rather few portraits during the 1740s, and these were mostly of his own family or close friends. But the great *Captain Coram* of 1740 was available for any young painter to inspect in the offices of the Foundling Hospital, and it does not seem to me to be possible to doubt that Reynolds looked at any available portrait by Hogarth with close attention—and that he modelled his own ideas of the interpretation of character on what he could read from Hogarth. His portrait of the Reverend William Beele (Plates 6 and 7), chaplain to the naval dockyard at Plymouth, which may well have been the last portrait painted before sailing for Italy in 1749, is in the tradition of Hogarth's *Reverend John Hoadley* of 1741 (Northampton, Massachusetts, Smith College), and might at first sight be mistaken for a Hogarth. It shows that, in power of incisive interpretation of character, Reynolds's mind was already fully formed before his Italian experience. This was in fact the natural bent of his genius. Also before the Italian journey we see him adapting, with a natural wit, an old-master motif, the Venetian parapet behind which a

sitter poses, into the sea-wall behind which the *Boy in a leather Jacket* (Figure 2), perhaps the son of a Plymouth naval officer, is characteristically posed. When he went to Italy he was already on the look-out for such devices, which he could adapt to enrich his own repertory.

Unlike an earlier generation of British painters, who had gone to Italy with no very clear idea of what they were looking for, Reynolds, when he was suddenly given the chance in 1749 of a trip to Italy, knew just what he wanted. Brushing aside the recommendation of his patron, Lord Edgcumbe, that he should put himself to school with Batoni, Reynolds set himself to try and understand the tradition of the accepted great masters of the past, who had worked not merely (if at all) in the narrow field of portraiture, but in the nobler sphere of what the age called historical painting. The bent of his mind was towards generalizing ideas, and he seems to have grasped, at a remarkably early age, that the art of portraiture—which English patrons at the time considered only slightly above the level of dressmaking—could be treated as a branch of historical painting and ennobled by the same resources of art. Those who disliked Reynolds could talk about 'plagiarism', and those who dislike him today can call his methods of adaptation and transformation of the ideas of others a 'gimmick';[6] but one may appropriately quote the words of an artist in the literary field[7] who exploited the tradition of the past in the same sort of way—'for the artist borrowing is a means of achieving originality . . . The sounds that carry furthest and last longest are echoes.'

During his two years in Rome, from 1750 to 1752, Reynolds devoted his time to trying to understand the reasons for the hold over the imaginations of men attained by the accepted great masters—the sculptors of antiquity, Michelangelo, Raphael and the Bolognese classicists. On his way home, in the three weeks he spent at Venice, he made fuller notes than he had made elsewhere about the technical mastery of the Venetians in the control of light and shade. He seems to have at once realized that the Venetians had clearer messages for him personally than any other school. He had studied hard in Italy and had genuinely achieved the knowledge he had been looking for—which served him all his life. It is significant that he seems never to have contemplated returning to Italy to see again those works of art he recommended, year after year, as models for the study of the students at the Academy. He felt he had mastered their secret, and he kept his knowledge of them fresh by

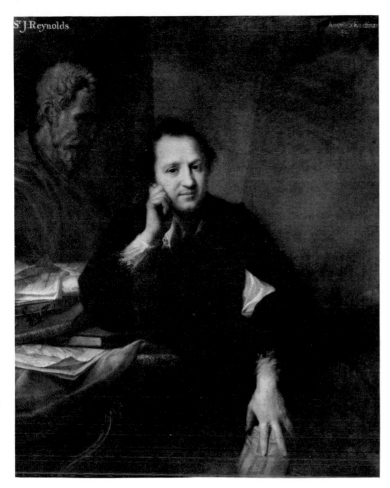

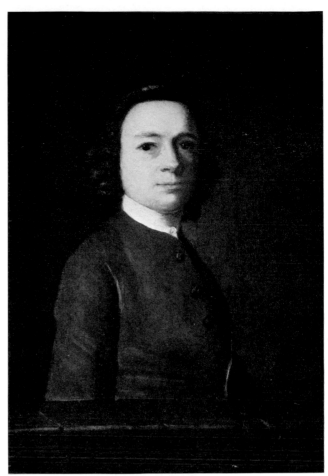

1. ANGELICA KAUFFMANN: *Reynolds.* 1767.
127 × 102 cm. Saltram, The National Trust

2. REYNOLDS: *Boy in a leather Jacket.* About 1746.
36 × 25 cm. Birmingham University, The
Barber Institute of Fine Arts

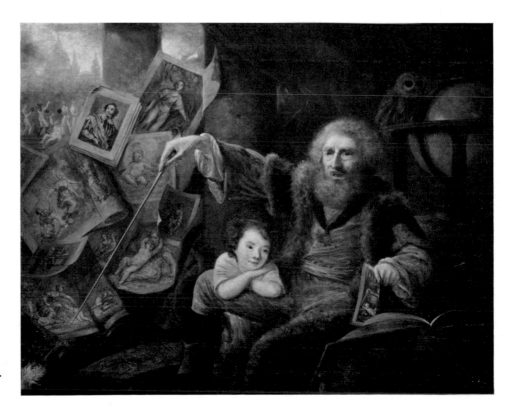

3. NATHANIEL HONE: *Sketch for
'The Conjurer'.* 1775. 57 × 82 cm.
London, Tate Gallery

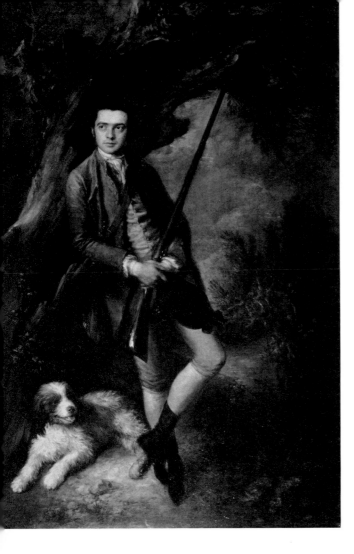

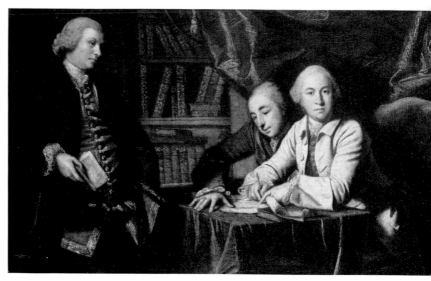

4. GAINSBOROUGH: *William Poyntz of Midgham and his Dog, 'Amber'*. 1762. 231 × 152 cm. Althorp, Earl Spencer

5. REYNOLDS: *Edgcumbe, Williams and Selwyn*. 1759. 53 × 82 cm. Bristol, Museum and Art Gallery

6. *Lady Charlotte Fitzwilliam*. 1754. Mezzotint by James McArdell after Reynolds

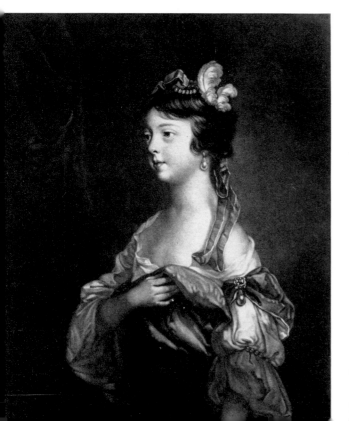

7. REYNOLDS: *Lord Rockingham and Burke*. About 1766. Unfinished. 146 × 159 cm. Cambridge, Fitzwilliam Museum

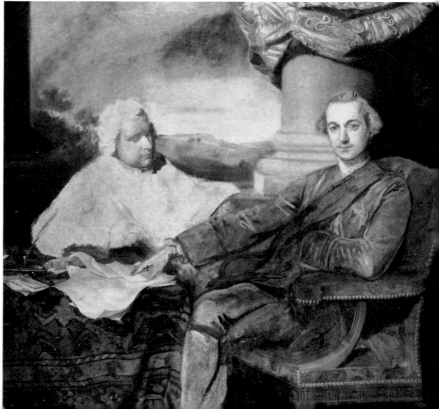

bringing together a truly remarkable collection of old masters, as well as numerous drawings and engravings.

During the two years (1750–2) that Reynolds was in Rome, Pompeo Batoni was at the beginning of a period of some thirty years as the most successful face painter for the Englishman on the grand tour. In fact he was painting the portraits of a number of those very Englishmen (and Irishmen) with whom we know Reynolds was in contact from the curious *Caricatura of 'The School of Athens'* (Figure 12), which Reynolds painted in 1751.[8] This picture seems intended to convey the notion that these travelling English milords 'who were perhaps already beginning to reflect on the buildings they would set up when they returned home, were not profiting at all by the experience of Rome, but were still thinking in terms of Gothic and Chinese whimsies'.[9] Reynolds certainly looked attentively at Batoni's portraits of them, and his own *Lady Anne Dawson* of 1753–4[10] and the two Cathcart portraits (Figure 10 and Plate 13) are exercises in the style of Batoni, from whom they take over a degree of easiness and informality never to be found in Hudson. But when he set up in London on his own in 1753 he was hoping to have a chance to display his powers on a grander scale.

From the last quarter of the sixteenth century the British landowning classes had shown a predilection for the life-size, full-length portrait. It had been carried to a very high pitch of elegance by van Dyck, and, in 1740, in his *Captain Coram* (which he presented to the Foundling Hospital), Hogarth had shown how this tradition might be updated. Hogarth's spiky personality was no doubt the reason why he was never commissioned to do anything similar; but Hudson and Allan Ramsay in 1746 both presented ambitious full-length portraits to the Foundling Hospital in a bid to advertise themselves as painters of full-lengths.[11] When Reynolds set up on his own in London in 1753, he must have realized that Ramsay was his only serious rival.

The precise relationship between Ramsay and Reynolds has to be surmised. There is no doubt that, during the 1750s, each watched the other's work closely and was to some extent influenced by it. A 'Mr Ramsay' sat to Reynolds in 1755 but need not have been the painter. They were never close friends but, in 1778, each at least dined once with the other, and they shared a number of mutual friends among the men and women of letters of the day. Northcote reports Reynolds as calling Ramsay 'the most sensible among all

those painting in his time'.[12] No other painter ever enjoyed Reynolds's hospitality, except when he entertained the committee of the Academy *en masse* and on one occasion in 1782, when Fanny Burney met Benjamin West at his table. Ramsay, like Reynolds, in later life fancied himself as a writer. Secure of his position in the good graces of the new King, George III (although he had to wait for Shackleton's death to be appointed Principal Painter), Ramsay never exhibited with the Society of Artists when public exhibitions started in 1760. In spite of formidable efforts in the 1760s,[13] Reynolds never won the favour of the King, and although in 1768 he appeared as the inevitable person to be made the first President of the new Royal Academy, and was duly knighted, this could not have happened if Ramsay had not virtually ceased to paint about 1766 and had not deliberately withdrawn from active competition. Each had probably a considerable respect and a healthy mistrust for the other. Ramsay alone of painters, with the clannish support he received from the Scottish nobility, had established for himself a social position of considerable distinction when Reynolds came to London. This position, and the accompanying aloofness from the more Bohemian world of artists, was the model for Reynolds's future conduct. Throughout his life Reynolds did not meet with much serious competition, but where he scented the possibility of competition (as with Romney) he behaved rather ungenerously.

Not many people will commission a full-length portrait from an unknown young man, and it is likely that the portrait of Keppel (Plate 10), painted in 1753/4, with which Reynolds made his name, was not so much a commission as a thank-offering for Keppel's having conveyed him to Italy. No doubt it eventually passed into the sitter's possession, but I doubt that it was paid for and it presumably remained for a considerable time in the studio so that sitters who came with more moderate intentions could see what possibilities of immortality were available. As if to balance it, Reynolds also painted in 1756 a heroic military portrait of a soldier of no particular consequence, Captain Orme (Plate 14)—who certainly never paid for it—which remained an admired ornament of the studio until 1777.[14] Anyone who visited the studio must have realized at once that a new artistic personality had arisen, fit and anxious to record a new age. To our hindsight it appears that the first age of British imperial aspirations had summoned forth, by a sort of Pirandellian necessity, its fit recorder. It only remained for Reynolds to demonstrate his

powers in portraying the peerage. Thanks to Lord Edgcumbe (who ordered a copy), he painted in 1753/4 the aged Lord Chamberlain, the Duke of Grafton, in his robes of office; in 1755 he painted Lord Ludlow (Plate 11) at full length in a Hungarian uniform of the sort that Batoni was beginning to use in Rome for travelling milords; and in 1757 he painted and presented to the Foundling Hospital—where it would be seen as a deliberate rival to the full-lengths of Hogarth, Hudson and Ramsay—the curiously dull portrait of their Vice-President, the Earl of Dartmouth, in his robes. In 1756 he painted Samuel Johnson, in 1757 Horace Walpole; and in 1759 we have the appraisal of Horace Walpole, which establishes Reynolds's position just before the opening of the new reign.

Walpole, writing to Scotland to Sir David Dalrymple on 25 February 1759, says: '[Mr Ramsay] and Mr Reynolds are our favourite painters . . . Mr Reynolds and Mr Ramsay can scarce be rivals; their manners are so different. The former is bold and has a kind of tempestuous colouring, yet with dignity and grace; the latter is all delicacy. Mr Reynolds seldom succeeds in women; Mr Ramsay is formed to paint them.' This view is borne out by the only three full-length portraits of ladies known from Reynolds's first years in London—one of which was of Walpole's favourite, the Duchess of Grafton (better known in her later role as Lady Ossory). They are all rather trite variants of a standard formula, a pose taken from an ancient statue (either in peeress's robes or in pseudo-classical drapery), with a backdrop of a park terrace in twilight and one edge diversified by the shadowed profile of an enormous half-seen urn. Where Walpole is wrong is in saying that the two men could scarce be rivals. When it became clear, soon after the accession of George III in 1760, that Ramsay was to be the King's painter—with the backing of his Scottish patron, Lord Bute—Reynolds, as he had done before with his portrait of Keppel, at once produced a more elaborately orchestrated variation on the pose of Ramsay's *Lord Bute*, choosing for his purpose another Scottish peer, the Earl of Lauderdale (Plate 27). That he was doing this quite consciously appears from the story[15] that, when painting Lord Rockingham (about 1767), he told his sitter that he wished 'to show a leg with Ramsay's *Lord Bute*'. During the early sixties he also made prodigious efforts[16] to wean the King from a taste for Ramsay, and took a lesson from his rival in the 'delicacy' Ramsay employed in devising patterns for portraits of women.

During the 1750s Reynolds had lost no opportunity to bring his art to public notice. The English upper classes have always been more willing to let an untried painter do a portrait of their children than of themselves, and there are at least half a dozen unpretentious and wholly charming portraits of children from these years. It was one of the earliest of these, the *Lady Charlotte Fitzwilliam* (which is signed and dated 1754), that Reynolds chose to have engraved at his own expense by the young Irish mezzotinter, James McArdell (Figure 6), who had already scraped portraits after Hogarth and Ramsay. McArdell scraped at least eighteen mezzotints after Reynolds during the 1750s and must have contributed a good deal to Reynolds's rising reputation. He died young, in 1765, and it was presumably in the 1770s that Northcote heard Reynolds say, on turning over a number of McArdell's prints, 'By this man, I shall be immortalized.' It takes nothing from the compliment to add that that had always been Reynolds's intention!

The first of his sitter books to survive (quite possibly it was the first to be kept in the way he continued to keep them until 1789) is that for 1755.[17] For a young man who had been settled only two years in London, it is remarkable and explains why, in about 1758, and again in 1759, he had to raise his prices in order to reduce the number of his sitters, although there is some reason to suppose that more portraits were commissioned in the period 1755 to 1760 from all painters of any merit at all than at any other time in the eighteenth century. In these years Reynolds also settled on his choice of friends.

It would be interesting to know if Reynolds was aware of the fact that Titian had had as his crony Pietro Aretino, the founder of modern journalism, and had profited much from this relation. Certainly Reynolds deliberately picked for his friends (or cronies) a group of men of remarkable literary parts who could and did make his name resound all over London. He seems to have first met Dr Johnson, Burke and David Garrick about 1756; Goldsmith in 1762; and James Boswell in 1769. There is no doubt that he was sincerely attached to Johnson and Goldsmith, and his attachment to Burke was strong enough to make him put up with all Burke's intolerable Irish relations. Northcote suggests that his closeness to Burke and Boswell (and Malone) right up to the end of his life was because he hoped one of them would be his biographer—and there may be a grain of truth in this. But it is simpler to believe what Reynolds himself says in a revealing letter to Boswell, written in October 1782:[18]

'Everybody has their taste. I love the correspondence of *viva voce* over a bottle with a great deal of noise and a great deal of nonsense.' He worked very hard all day from about nine in the morning until his dinner hour of four p.m., most of the time on his feet. He was too keen on his painting and too deaf to have a chatty 'bedside manner' with most of his sitters, and he needed convivial company at the end of the day. Angelica Kauffmann may have thought she had caught him at the time she painted her portrait of him in 1767 (Figure 1), but one can almost tell from the portrait that he had decided not to accept her! He enjoyed feminine society and it may well be significant that the pictures which he almost seems to have painted with love are those of the great courtesans of the day: Kitty Fisher, Nelly O'Brien and Nancy Parsons (Plates 24, 25, 29 and 48). In his sister Fanny he had a perpetual warning of the possible defects of the feminine character. She fussed and she could never make up her mind. For all his famous bland good nature, which he showed to the outside world, Reynolds was basically a rather selfish man and the worst in him came out in his dealings with his nearest relations.[19] By 1760, when he bought the lease of a rather grand house in Leicester Fields (later to be known as Leicester Square), where he was to live for the rest of his life, he had settled down to a regular routine. He spent more than £3,000 on the lease and on improvements to make a painting room at the back—a formidable sum for a mere painter—and during the next ten years he concentrated on building up his fortune and advertising himself by any means in his power. He bought a very spectacular coach in which he caused his naturally very unspectacular sister to go out driving as often as possible; and the first public exhibitions in the rooms of the newly founded Society of Artists gave him a perfect opportunity for self-advertisement.

I suspect an alliance with Garrick in the early 1760s. Garrick was perhaps the greatest master of advertising of his age; so successful was he that posterity is still familiar with his name, though most actors are forgotten soon after they have left the stage. He was the first actor to realize that paintings of stage scenes and of actors in character parts, exhibited to the public and multiplied by superlative engravings, were the best advertisement in the world. He discovered the genius of Zoffany, and, at nearly every public exhibition in the 1760s, a picture or statue of Garrick in some role or other was to be found. The most memorable was by Reynolds, shown at the Society of Artists in

1762: the picture of *Garrick between Tragedy and Comedy* (Plates 31 and 46). This ingenious picture, which is a transformation into modern terms of the ancient subject of 'The choice of Hercules'—a theme much more familiar to educated persons then than it is today—is not only an advertisement to Garrick's incomparable versatility, but an advertisement also to Reynolds's own comparable powers. Tragedy is an exercise in the manner of Guido Reni and Comedy is a reminiscence of a figure in Correggio's *Virtue triumphant over Vice* in the Louvre. It was the first picture which was not a straight portrait that Reynolds exhibited, and it displayed in a compendious way the rich resonance of his imagination. From his first acquaintance with Dr Johnson, he deliberately went to school to that powerful mind, and he owned that it was Johnson who 'had qualified his mind to think justly'. The Garrick picture is one of the most profoundly characteristic of English eighteenth-century masterpieces, an invention in the very centre of the European classical tradition. It exhibits the same mind that was later to write the *Discourses*, whose practical eclecticism places them in the same relation to the European aesthetic tradition.

Reynolds did not always choose for public exhibition those pictures which seem to us today to be his greatest masterpieces. The one full-length which he showed in the first public exhibition ever to be held in London, at the Society of Arts in 1760, was the *Duchess of Hamilton*[20] (Port Sunlight, Lady Lever Art Gallery). Admittedly she was the reigning beauty of the moment, but the picture is in the conventional classical manner of his earlier female full-lengths and is as nearly dead as a Reynolds of a very handsome sitter can be. If we compare it with the tender informality of the *Countess Spencer and her Daughter* (Plate 21), which Reynolds was painting at the same time, it is hard to believe that the two pictures were invented by the same man. The Althorp picture was painted to hang over a mantlepiece and to be seen at a certain height; this may explain why it was not exhibited, as the conditions of public exhibition were appalling throughout the century and made no concession to any picture that required careful hanging to bring out its qualities. But one is forced to suppose that neither Reynolds himself, nor contemporary patrons, realized that he had here painted a picture which, in both human and decorative terms, is one of the most splendid images of a mother with her daughter. Horace Walpole (whom Reynolds painted in 1757) rather characteristically

caused him to paint, in 1759, a small conversation piece (Figure 5) of three of his closest friends, Edgcumbe, Williams and Selwyn, a genre alien in spirit to everything that Reynolds was aiming at. Here too he produced a highly original work, which has hardly any parallel in the century—except perhaps for the two groups of the Dilettanti Society (Plates 81 and 82).

It took a good many years for art journalism to get under way after the first exhibition of 1760, but a foretaste of what was to happen in the future was discovered by William Whitley in the *Imperial Magazine*,[21] which alone gave a review of the exhibition. This short-lived periodical (it lasted only from 1760 to 1762) had a notice of the exhibition from an unnamed correspondent. It contained an astonishing puff of Reynolds, 'whose merit is much beyond anything that can be said in his commendation'. It is clear that it must have been written in connivance with the painter since the names of Reynolds's sitters (which are not given in exhibition catalogues until 1798) were known to the writer. As Francis Hayman's portrait of Garrick as Richard III is also praised extravagantly, it may even be possible that Garrick was somehow involved in the puff.

It was in the 1760s that Reynolds's genius came to full flower in the diversity and geniality he was able to give to his full-length portraits. He was no longer solely dependent on models taken from classical statuary, although the *Duke of Beaufort in academic Dress* (S.A. 1761) and the *Earl of Carlisle* of 1769 (Plate 52) are only variations on the Apollo Belvedere, and the splendid *Lord Bute and his Secretary* (Plate 35) seems derived from a Pasitelean model. Two unexhibited pictures of 1763, the *Philip Gell* (Plate 34) and *Mrs Riddell* (Plate 41), are the first to show the English country gentleman and his wife at ease in their own countryside. It seems highly probable that the *Philip Gell* was a deliberate answer to Gainsborough's *William Poyntz* (Figure 4), which had been shown at the Society of Artists in 1762. Reynolds was exceedingly sensitive to competition and was determined to beat every competitor at his own game— first Ramsay, then Gainsborough. By the end of the 1760s, since Ramsay was out of the running, Reynolds was the inevitable painter candidate for the presidency of the new Royal Academy.

It is probable that Reynolds quite genuinely (as well as ostensibly) had rather little to do with the intrigues—for they were little better—that led to the foundation of the Royal Academy in 1768. The King disliked him and

probably already thought his associates too Whiggish, so that any outright support to the scheme by Reynolds would have been a hindrance. The master mind was William Chambers—he was later allowed to use in England a Swedish knighthood he was given in 1771—who had taught drawing to the young George III and was much in royal favour. He was every bit as ambitious as Reynolds, whom he had first met in Paris in 1752, when Reynolds had painted the lovely portrait of his wife (Plate 9). Chambers would have dearly liked to be President of the Academy himself, but it was clear that most of the members would be painters and, to get their support, he had to submit to the President being a painter. He needed their support also to ensure that no other architects—not even the brothers Adam, who were also employed by the Crown—should have a say in the establishment. He persuaded the King that the only possible candidate was Reynolds, but he effectively spiked Reynolds's guns by getting himself appointed accounting officer to the new Academy and ensuring that the treasurer was responsible directly to the King. At the persuasion of the Prime Minister, the Duke of Grafton, the King knighted the new President, an honour which had not been conferred on a painter since Sir Godfrey Kneller was knighted in 1692. Reynolds insulated himself from his fellow artists by getting Dr Johnson and Goldsmith appointed to the honorary positions of 'Professors' of Ancient History and Literature to the Academy, revealing the kind of concern he had for the intellectual status of the new institution.

This was also apparent from his contributions to the first exhibition, which took place in 1769. There were only 136 items (a smaller number than in any later exhibition), which had been selected with considerable care and may have included less rubbish than any later exhibition. Reynolds sent four pictures, each no doubt very carefully chosen to indicate the breadth and variety of his art and the kind of picture he hoped the public would want. One was inevitably in his classical vein ('*A lady in the character of Juno, receiving the Cestus from Venus*'); and one was an exercise in the manner of Correggio, but only slightly idealized from the living model, with the title of *Hope nursing Love*.[22] The other two were novel inventions in the 'historical-portrait' style, to which he had been inspired by his visit to Paris in the autumn of 1768. He had there seen in the Louvre Albano's picture of *Cupids disarmed by Nymphs*, from which he had extracted the motif for the '*Lady and her Son . . . in the*

character of Diana disarming Love' (private collection); and the two figures musing on mortality at the right of Poussin's *Et in Arcadia ego* inspired the fourth of his contributions to the Academy, the double portrait of Mrs Bouverie and Mrs Crewe (Plate 45), which is a psychological experiment of an entirely novel kind. In an English park, such as forms the normal background for Reynolds's portraits, the two close friends pause before a memorial of friendship that bears the inscription *In Arcadia ego*. It was probably Walpole's malice alone which commented that they were 'moralizing at the tomb of Lady Coventry' (who had died some nine years previously, partly from an abuse of cosmetics); but it is instructive that Walpole, whose taste was in advance of that of Reynolds, should have commented on the two classicizing portraits as 'attitude bad', and 'very bad'. Reynolds never again exhibited in public quite such heavy borrowings from the antique; and his position as the leading portrait painter in London received some competition during the 1770s.

At the time of the foundation of the Royal Academy his one serious rival was Francis Cotes, who had won, about 1767, the favour of the Queen and the Princesses, now that Ramsay had given up painting original portraits. Cotes and Reynolds shared the services of a drapery painter, Peter Toms, who—rather discreditably—was made a foundation R.A. over the heads of such portrait painters as R. E. Pine. But Cotes died in 1770 and the fine studio he had built for himself in Cavendish Square remained empty until it was taken over by Romney in 1776, some six months after he had returned from Italy. Before that, however, in 1774, Gainsborough had moved from Bath to London, and, by 1777, he was beginning to be the favourite portrait painter of the royal family. Northcote indicates that Romney's popularity did in fact substantially reduce the number of Reynolds's sitters and gave him more leisure to paint fancy pictures. But there does not seem to be any evidence that Reynolds's dominant position in the minds of the 'taste-makers' of the age was ever seriously threatened. It is true, however, that he had rather fewer sitters during the first few years of the Academy's life than at any other time. It is probable that this represents a general situation that prevailed with all portrait commissions, and was due to economic reasons.

It may also be the reason why Reynolds exhibited an unusual number of pictures during these years, at least a dozen in each year from 1773 to 1777, of which rather few count among his major masterpieces—though the

Colonel Acland and Lord Sydney (Plates 50 and 51) of 1770 is a splendid experiment in the vein of Rubens, painted with a Venetian accent. It was not until 1771 that he showed himself in public in a less pretentious vein, which still seems irresistible to us today. The *Mrs Abington as Miss Prue* (Plate 54) has wonderful character and sparkle, and its companion in the 1771 R.A. of his niece, *Offie Palmer reading 'Clarissa Harlowe'* (Plate 55), which is as much a character study or fancy picture as a portrait, is an entirely new kind of invention. During the 1770s a succession of nieces lived in the house at Leicester Fields: Offie from 1770 to 1773, when her elder sister Mary Palmer joined her; and Elizabeth Johnson also for the years 1774 to 1777. About 1777 Reynolds's sister Fanny departed from the house and Mary Palmer took over the housekeeping—and eventually became Sir Joshua's heir. These attractive girls were the models for a number of his fancy pictures; he also painted a great many such pictures from a motley crew of beggars.

Whenever Reynolds saw promising children he would have them come to the house and use them as models in the intervals of waiting for his grander sitters. According to Northcote he was never idle and 'was for ever painting from beggars, over whom he could have complete command, leaving his mind perfectly at liberty for the purposes of study! Good God! how he used to fill his painting room with such malkins; you would have been afraid to come near them, and yet from those people he produced his celebrated pictures. When any of the great people came, Sir Joshua used to flounce them into another room until he wanted them again.'[23] It was in fact during the years when Northcote was living in his house, in the early 1770s, that Reynolds perfected this new genre. One of the few explicit statements we have about such pictures occurs in a newspaper comment[24] concerning a picture exhibited as *A Girl* in the R.A. of 1782, which described the picture as 'a female head painted for Mr Campbell as companion for his Rembrandt'. It is my impression that all these fancy pictures were designed to be able to be hung as companions, or at least acceptable neighbours, in galleries in which nothing but old masters were normally admitted. *The piping Shepherd Boy* of about 1773 (Plate 62), which was passionately admired by Benjamin Robert Haydon,[25] is a deliberate exercise in the vein of Giorgione, and may even have been inspired by Giorgione's picture of the same subject in the royal collection. *The Student* of about 1777 (Plate 80) is known to have been the only picture in the library at Warwick

Castle and seems to be a deliberate exercise in the vein of Rembrandt, hung as an appropriate companion to two Rembrandts which the second Earl of Warwick was later to buy from Reynolds himself.[26] The famous Murillo design of a child Good Shepherd—which was later to inspire Gainsborough's fancy pieces—was the probable provocation for the picture *Shepherd Boy* in the Earl of Halifax's collection, bought by Lord Irwin in 1772.

Reynolds was rather less happy in real history pictures, of which the earliest to be publicly exhibited was the *Count Ugolino and his Children*, shown at the R.A. of 1773 and least unfavourably seen today in Raimbach's engraving of 1774 (Figure 11). It is significant that the genesis of the picture was accidental. The main head was a character study from a favourite model of the time, and one of Reynolds's literary friends—it is uncertain whether Burke or Goldsmith—detected in it an appropriate head for the subject of Ugolino, with which it is likely that Reynolds was quite unfamiliar. Reynolds enlarged his canvas and read some Dante (probably for the first time). The result was noted by Walpole as 'most admirable'; but the taste of today is more inclined to agree with Mrs Thrale's waspish comment—which was not made on this specific picture—that Reynolds showed 'a rage for sublimity ill-understood'.

At this time Reynolds was certainly trying to combine portraiture and history almost inextricably. Northcote provides the evidence for the picture being painted at the same time of *Three Ladies adorning a Term of Hymen*[27] (Plates 72 and 74), shown in the Academy of 1774. It was commissioned by Luke Gardiner, who was engaged to one of the three sisters involved in the picture, and who wished to have 'their portraits together at full length, representing some emblematical or historical subject'. Reynolds and the three sisters seem to have chosen the subjects between them—'the adorning a Term of Hymen with festoons of flowers' which afforded 'sufficient employment to the figures, and gives an opportunity of introducing a variety of graceful historical attitudes'.

This bias towards the historical, which Reynolds certainly attempted to impose on public taste, was by no means universally admired among his Academy colleagues. The first serious criticism was not an unsubtle one, and revealed a mind which had clearly been watching very closely what Reynolds was doing. Nathaniel Hone, an Irish foundation member of the R.A., who was some five years older than Reynolds and had known him in Italy, submitted

to the Academy in 1775 a picture entitled *The Conjurer*.[28] A figure, taken from the same model (Figure 3) that Reynolds had used for his *Ugolino*, is waving a wand and conjuring up a collection of named prints after the old masters, from each of which Reynolds had cribbed a motif for one of his portraits. Some of the prints are pretty esoteric—notably the two from which the figures in *Three Ladies adorning a Term of Hymen* had been derived—and there is no doubt that it is a remarkably scholarly and ingenious attack. It was rejected, at the request of Angelica Kauffmann, who protested that certain small naked figures in the background (later painted out) included a libel on herself, but it seems likely that this public accusation of plagiarism on the part of the President was the chief reason for the rejection. There is no written criticism of the time which reveals the same attitude, but it can hardly be doubted that it was fairly widespread.

As if to indicate the spirit in which he made these borrowings, in the following year (1776) Reynolds showed his *Master Crewe as Henry VIII* (Plate 60), in which this form of 'wit' (as Walpole called it) is triumphantly justified.

A group of children's portraits from the next few years shows Reynolds in a very sympathetic light, only rivalled in this respect by Gainsborough's few portraits of his own children. This deaf middle-aged man seems to have been one of the first people to understand that children have private and separate minds. One of the most enchanting is the *Miss Frances Crewe* (Plate 61), which is interesting for other reasons, too. Recent cleaning has shown that it can never have been quite finished, and the reason was no doubt that the little girl died before the picture was ready for exhibition. Certain areas of paint, of remarkable beauty of execution, are not altogether intelligible from a purely representational point of view (for example, a lighter strip, partly in shadow, in the folds of the black cape on her right side); no doubt they would have been altered in the final stage and the spontaneous charm of execution would have been lost. This reinforces what Reynolds himself said, that, at some point before the last in their evolution, his pictures were probably at their best.

The very end of the 1770s marked a culminating point in Reynolds's development as the almost obsessive promoter of the style of Bolognese classicism. *The Marlborough Family* (R.A. 1778; Plate 78) was the grandest commission of its kind he was ever likely to receive, and is the masterpiece of this style in the same way that Blenheim Palace, which was to house it, is the

masterpiece of English baroque classicism. It is very much an exercise in a formal style, and it was surely deliberate that Reynolds, at the same time (during the years 1777 to 1779), should have tackled a more original and more difficult task, the two groups of the members of the Society of Dilettanti (Plates 81 and 82). In these pictures fourteen fashionable young men, most of them of fairly decided character, are seen grouped informally at a convivial table, or standing behind it. The thread that justifies each pose or movement and binds the scene together is a diffused interest in the purposes of the Society of Dilettanti, especially the classical antiquities of Italy and a liking for wine. One of Sir William Hamilton's splendid publications on ancient vases rests on the table, and it is generally accepted that the motif of the scene is the drinking of the health of Sir William, who was elected a member in 1777. He is the only figure not drinking and he looks a little more serious than the others, some of whom, behind his back, seem to be making gestures which allude to one of Sir William's less edifying discoveries about the ancient world.[29] All the sitters seem to have taken a little wine, which has made them more genial. There is no other picture known to me which gives such an insight—of the same order as we get from some of Horace Walpole's letters to his closest friends—into the way of life of what the eighteenth century meant by a 'dilettante', a word which has come down in the world since it was first in general use. We are not surprised from the glimpse of them that some of the most splendid archaeological publications should have been sponsored by this Society of Dilettanti, and Reynolds gives the flavour of their civilized enjoyment of the ancient world. It has nothing of the hysteria of neoclassicism.

Sir Joshua's first public incursion into the field of religious painting was at the Academy of 1776, when he exhibited two fancy pictures with the respective titles of *St John* (cf. Plate 71) and *Infant Samuel*, the first an exercise in the manner of Guido, the second perhaps derived from Rembrandt. It is curious, in view of his almost total detachment from religious matters, that Reynolds should have attempted religious painting at all, but he had been prominent among those academicians who, in 1773, had proposed the adornment of St Paul's Cathedral with religious pictures—a scheme which was defeated through the opposition of the Bishop of London. It seems that Reynolds thought that a national school of painting—such as he felt was beginning to form in England—must inevitably graduate into a field which was held by

academic tradition (and by himself) to be the highest to which a painter could aspire. In *A Journey to Flanders and Holland*, which he wrote in the 1780s, he returned to this theme, saying:[30] 'It is a circumstance to be regretted, by painters at least, that the Protestant countries have thought proper to exclude pictures from their churches: how far this circumstance may be the cause that no Protestant country has ever produced a history-painter may be worthy of consideration. . . . Why the house of God should not appear as well ornamented, and as costly as any private house made for man, no good reason I believe can be assigned. This truth is acknowledged, in regard to the external building, in Protestant as well as Roman Catholick countries: churches are always the most magnificent edifices in every city: and why the inside should not correspond with the exterior, in this and every other Protestant country, it would be difficult for Protestants to state any reasonable cause.' It was presumably this view which led Reynolds to accept a commission to design a stained-glass window, to be executed by Jarvis, for the antechapel of New College, Oxford. The original proposal was merely that he should design the cartoons, but he seized the excuse to execute them as finished pictures, which he exhibited at the Academy in 1779, 1780 and 1781. Stained glass was acceptable to the most thorny Protestants.

The central feature of the window (engraving by Richard Earlom: Figure 8) was a *Nativity*, which was a conscious exercise in the style of Correggio. It certainly impressed contemporaries, since it was bought by the Duke of Rutland for £1,200, a sum vastly in excess of anything which had hitherto been paid for a picture by an English painter. It must have seemed to Reynolds that he had attained what had always been his political objective, that British collectors should be prepared to regard and pay for works by native artists at the same level as they would those by old masters. Unfortunately the painting perished in the fire at Belvoir Castle in 1816, and all that we have to judge it from is Jarvis's rather opaque stained-glass transcription of it, a disappointment to contemporaries and to modern taste, an eyesore amid some of the finest medieval glass in England.

It is interesting that Reynolds did not modify—for what he himself must have considered a painting in a 'higher' style—the methods he was in the habit of using for portraits and fancy pictures. Some of the seven figures of the *Virtues* were modelled on his nieces (we know that Elizabeth Johnson posed

for *Fortitude*), and Haydon, who saw them at the sale in 1821,[31] correctly commented: 'What emptiness for breadth, what plastering for surface, what Portrait individuality for general nature!' William Mason, who happened to call on Reynolds while he was at work on the *Nativity*, reports that he saw: 'Three beautiful young female children, with their hair dishevelled . . . placed under a large mirror which hung accurately over their heads, and from the reflections in this, he was painting the charming group of angels which surrounded the Holy Infant.' But subject matter of this kind did not fire Reynolds's imagination, and it is instructive to compare, with the *Virtues* exhibited in 1781, another picture which appeared at the same exhibition under the title of *Thaïs*[32] (Plate 99). The model for this figure of the girl who set Persepolis on fire was the sprightly Emily Coventry, who had set a number of people on fire, and the picture has a splendid vitality which contrasts with the classic tameness of the others.

In the summer of that year (1781) Sir Joshua went on a six weeks' trip to Flanders and Holland (and also to Düsseldorf). It is clear from the account that he later wrote of this journey that his chief motive was the study of Rubens, whose major works—except for the series in the Luxembourg in Paris—he had never seen. It is a fair guess that his work on the Oxford window had made him realize that he would be well advised to study Rubens, whose merits he had somewhat underestimated in the Fifth Discourse,[33] where he says that there is in him a 'want of that nicety of distinction and elegance of mind, which is required in the higher walks of painting'.

The published account of *A Journey to Flanders and Holland* closes with a very good critical study of Rubens, in which he to some extent revises what he had written earlier, saying that Rubens's 'style ought no more to be blamed for not having the sublimity of Michael Angelo, than Ovid should be censured because he is not like Virgil'.[34] Reynolds's notes in Flanders are mainly on Rubens's history pictures, but he did study also a certain number of his portraits (and some of van Dyck's, too) with attention. One of these was the *Chapeau de Paille* (London, National Gallery), and that this lingered in Reynolds's memory we know from the fact that a picture of Anne Bingham (Plate 105), which he was painting in 1785, was specifically given by himself the nickname of 'Sir Joshua's *Chapeau de Paille*'.[35]

In fact the less formal portraits of the next few years—and those Reynolds

exhibited at the Academy include for the first time an absolutely natural bust portrait in the costume of the day, notably the wonderful *Lavinia, Countess Spencer* (Plate 94) of 1782—reflect this attentive study of Rubens. For certain portraits requiring the grand manner (such as *Mrs Siddons*) Reynolds still used his old formulae, but many of his finest later works are simple heads and it is probable that these alone were painted by Sir Joshua's hand unaided. In a letter of 1777[36] to a possible sitter he had written: 'It requires in general three sittings, about an hour and a half each time but if the sitter chooses it the face could be begun and finished in one day. It is divided into separate times for the convenience of the person who sits. When the face is finished the rest is done without troubling the sitter.' He might have added 'and often without troubling the painter either'.

In the last decade of his painting life, the 1780s, Reynolds created the patterns for the portraiture of the next generation, as it was carried out by Hoppner and Beechey. Even the style of Lawrence owes a great deal to the new inventions of Sir Joshua's last years. These inventions indicate a talent that was extremely sensitive to the changes which were taking place in society. After the peace treaty of 1783, which secured American independence, and the final elimination of Lord North's government, Whig society—with which Reynolds had always been most closely associated, to the detriment of his reputation with the King—took control of the future. The Prince of Wales, admittedly a frivolous character, came of age and provided a centre for a more relaxed style of living, which was out of sympathy with the pomposities of the older generation. The Whig leaders, Fox, Burke, Portland, Cavendish and Sheridan, all of them sitters to Reynolds, were dominant in this new climate of opinion, and I think if a careful analysis were made of the political associations of Reynolds's sitters after 1783, it could probably be shown that he had become more the official portrait painter of a Party than, as he had been in the sixties, the impartial recorder of all shades of opinion. It is instructive to compare the *Warren Hastings* (Plate 40) of 1766/8 with the *Joshua Sharpe* (Plate 108) shown at the Academy of 1786, both of which belong to the same general class of three-quarter-lengths seated in a study before a curtain. The later picture is almost a judgement upon the earlier, not only in the more sober clothes of the approaching nineteenth century, but in the abstinence from all baroque ornament and in the way in which the figure has been placed lower down in the canvas.

8. *Nativity*. Engraving by Richard
Earlom after Reynolds's design
for the west window of the chapel
of New College, Oxford, 1754.
London, British Museum

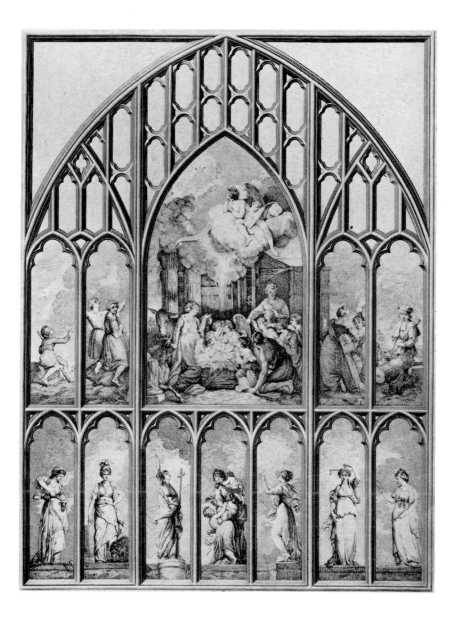

9. (*below*) *The Infant Hercules*. Mezzotint by
James Walker after Reynold's painting of
1786–8, now in Leningrad

10. (*below right*) REYNOLDS: 9*th Lord
Cathcart*. 1753–4. 127 × 120 cm.
Manchester, City Art Gallery (on loan
from Earl Cathcart)

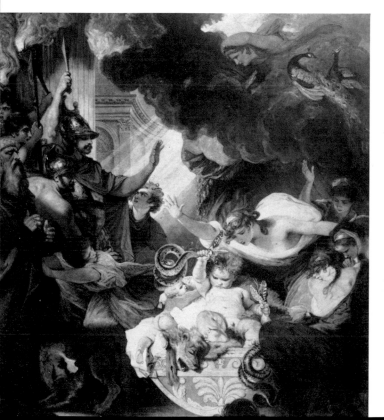

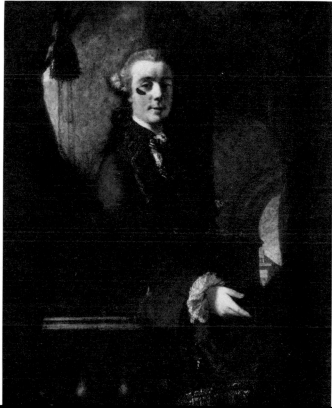

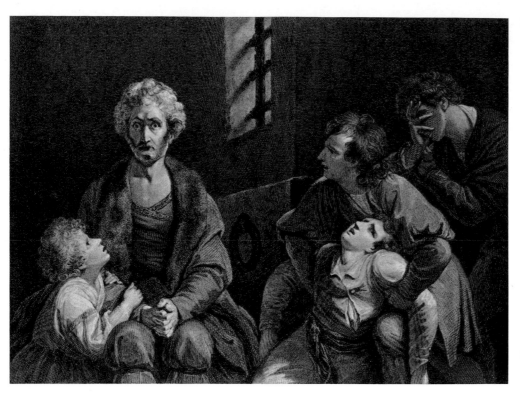

11. *Count Ugolino and his Children.* 1774. Engraving by Abraham Raimbach after Reynolds

12. REYNOLDS: *Caricatura of 'The School of Athens'.* 1751. 90 × 108 cm. Dublin, National Gallery of Ireland

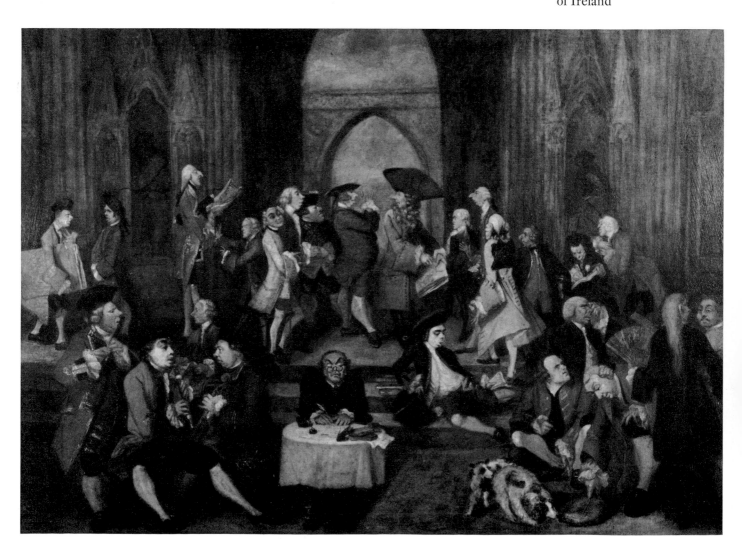

Contemporaries rightly regarded the portrait of Sharpe as 'a simple and accurate representation of the individual person, with a degree of truth that has never been surpassed'; and Northcote relates[37] that when a friend remarked upon this to Sir Joshua, the latter replied 'that it was no merit in him to do it as it was only making an exact copy of the attitude in which the old man sat at the time, and as he remained still and quiet, it became a matter of no more difficulty in the representation than that of copying from a ham or any object of still life'. In fact, perhaps Reynolds's greatest strength in this last phase of his career was that he made no pretensions to being a psychologist. He could in fact write very penetrating word portraits of his closest friends,[38] but in a draft of such a description of Dr Johnson, written for Boswell (who knew him well enough so that only perfect accuracy in the matter was possible), Reynolds said: 'The habits of my profession unluckily extends [sic] to the consideration of so much only of character as lyes on the surface, as is express'd in the lineaments of the countenance.'[39] To this should be added a very close observation of the way people sit or stand or move their hands. Even Reynolds's heroics are perfectly natural and issue from this close, and perhaps deliberately self-limited, observation. There is nothing in the *Lord Heathfield* (Plate 107) or the *Admiral Lord Rodney* (Plate 125) beyond what could have been observed by attentive study of the surface presented by the sitter to the painter. This becomes strikingly clear if we compare the latter picture with Gainsborough's slightly earlier portrait of Lord Rodney,[40] in which that artist had made an unusually serious attempt to achieve a heroic portrait by more artificial means.

This penetrating observation depended on the excellence of his eyesight, and it is significant that the moment this began to fail Reynolds was unable to continue portrait painting. In the sitter book under 13 July 1789 he wrote 'prevented by my eye beginning to be obscured'; this occurred so suddenly that it has generally been supposed that he must have suffered from a detached retina. Although he may have occasionally tinkered about with repairing the work of an old master, he never attempted portraiture again. Within ten weeks the sight of the left eye was entirely gone and he began to have fears for the sight of the other. It is remarkable that the sitter book records no sitters after that day on which he was 'prevented'; one would have expected there to be at least a number of appointments which had been made in advance for the next

few days. This suggests that these appointments were normally made at very short advance notice, a fact which we would not otherwise have known. Who finished Reynolds's uncompleted portraits is something of a mystery. The names of former 'pupils' and professional copyists of Reynolds that are occasionally mentioned in the 1780s are those of John Powell and William Score, but these men are almost totally unknown. The seven portraits shown at the Academy in 1790 show no falling off in quality and the two heads are remarkably good, while the *Lord Rawdon* (Plate 126) is one of the liveliest of his later full-lengths. Hoppner certainly modelled his earlier style on the later style of Reynolds, but there is no evidence that he painted on any of Reynolds's last portraits. Giuseppe Marchi, whom Reynolds had brought with him from Italy in 1752, was still with him at the end and, though Marchi's documented unaided work is only of moderate ability, his is the most likely hand.

In the last decade of his life Reynolds also devoted more time and energy than ever before to history painting. This culminated in the *Infant Hercules* (Figure 9), painted on commission for the Empress of Russia from 1786 to 1788 and for which he received 1,500 guineas. This was followed by a commission from Alderman Boydell for two large 'histories' for his Shakespeare Gallery, which had nearly been completed when Sir Joshua went blind. The two Boydell pictures (*Macbeth and the Witches* and the *Death of Cardinal Beaufort*) can be seen by the curious at Petworth and appear to me to be unmixed disasters. We ought perhaps to take more seriously the *Infant Hercules* in Leningrad (which I have never seen). James Barry,[41] who had in the past been more savagely critical of Reynolds than anyone else had been, makes the following observations in a footnote to his Sixth Lecture, which he delivered soon after Reynolds's death: 'His efforts of the historical kind were all made within the compass of a few years before his death. No student in the academy could have been more eager for improvement than he was for the last twelve years, and the accumulated vigour and value which characterize what he has done within that period, to the very last, could never have been foreseen or expected from what he had done, even at the outset of the academy and for some years after . . . ', and he adds, 'Nothing can exceed the brilliancy of light, the force, and vigorous effect of his picture of the infant Hercules strangling the serpents; it possesses all that we look for, and are accustomed to admire in Rembrandt, united to beautiful forms and an elevation of mind,

to which Rembrandt had no pretensions . . . ' At any rate one of the few contemporary painters who was entitled to an opinion thought well of it, but, in the main, Sir Joshua's genius did not lie in the direction of dramatic compositions, although he was a very constant visitor to the theatre. The story related by Cotton[42] about the third of his pictures for Boydell's Shakespeare Gallery—*Puck* or *Robin Goodfellow* (Plate 109)—explains how it came about that Reynolds achieved at least one happy illustration to Shakespeare. Alderman Boydell and Cotton's grandfather visited the studio while Reynolds was painting the *Death of Cardinal Beaufort*, and there 'Boydell was much taken with the portrait of a naked child and wished it could be brought into the Shakespeare Gallery. Sir Joshua said it was painted from a little child he found sitting on the steps of Leicester Fields. My grandfather then said "Well, Mr Alderman, it can very easily come into Shakespeare if Sir Joshua will kindly place him on a mushroom, give him faun's ears, and make a Puck of him." ' It is amusing that Reynolds, who normally charged only fifty guineas for his fancy pictures, having converted this one into a history piece, charged Boydell a hundred guineas!

Reynolds was able to read the last of his *Discourses*, which closes with the memorable encomium of Michelangelo, at the Academy on 10 December 1790, but the *Discourses*, when spoken, seem never to have been very audible, and their impact on contemporaries was mainly through the printed text.[43]

In an estimate of the significance of Reynolds as a historical figure, the *Discourses* are important, but they tell us very little, and that only by indirection, about his own practice as an artist. Sir Joshua was keenly aware that his own academic training—and that of all his British contemporaries—had been very unsatisfactory; and he had a lively feeling that, if a British school were to develop and survive, it must fall into line with what was accepted European theory. The theory behind the *Discourses* is thus somewhat old-fashioned and what Reynolds felt he ought to have had but did not get. What makes them memorable, and also sometimes inconsistent, is that when he has enunciated some hoary chestnut of an idea from the common stock, he finds himself forced by common sense sometimes to modify its force by an appeal to his own experience. They are also remarkably well written and are a pleasure to read today, except by those who hope to discover a consistent philosophical system from them, and those who, like William Blake, regard the whole

traditional academic system as absurd. Robert Wark has defined their relationship to Reynolds's art in so satisfactory a manner, that little more need be said about them: 'The positions that Reynolds takes up in the theory and practice of art are closely related and completely consistent one with the other. He stands in both as a figure particularly probable in the late eighteenth century, a man deeply sensitive to the value of a tradition that was waning in popular estimation, but sympathetically aware of the shifts in opinion and outlook taking place around him.'[44]

The unhappy period between the beginning of Reynolds's blindness in July 1789 and his death on 23 February 1792 was marked by some unworthy squabbles at the Royal Academy, in which there were no doubt faults on both sides, but in which Sir Joshua was infinitely the less to blame. The gap in intellectual status and in social position which Reynolds had achieved—more by instinct than by malice—between himself and his fellow Academicians, must no doubt have rankled, especially with Sir William Chambers, who seems always to have been of a jealous temperament and to have hoped from the beginning that, by having the ear of the King, he would be able to dominate the Academy. Sir Joshua's funeral was really very extraordinary indeed. Sir Godfrey Kneller, the last 'Knight of the Brush' (as Walpole described Reynolds), was probably buried in his garden at Whitton, but so little is known about the occasion that even this is not certain. Reynolds was buried in St Paul's with unexampled ceremony for an artist. His ten pall-bearers consisted of three dukes, two marquesses, three earls, a viscount and a mere baron! He had certainly justified his childhood observation to his father 'that he would rather be an apothecary than an *ordinary* painter'.

1. Letter from Charles Carroll of Carollton to his father, in *The Maryland Historical Magazine*, XI, 1916, p. 329.

2. Althorp MSS. Letter of May 24, 1787, from Lavinia, Countess Spencer, to her husband.

3. *Horace Walpole's Correspondence*, edited by W. S. Lewis, Vol. 29, 1955, p. 285.

4. See especially F. W. Hilles, *Gazette des Beaux-Arts*, October 1969, pp. 201ff.

5. In addition to the twenty-three portraits listed in my 1941 *Reynolds*, I have noted a further nineteen in *The Walpole Society*, XLI, 1968, pp. 165–7.

6. A number of concrete examples of this method of adaptation have been indicated in the notes. See the notes to Plates 25 and 118.

7. See Kostis Palamas, *The Twelve Lays of the Gipsy*, translated by George Thomson, 1969, p. 28.

8. For the list of the sitters see *Sir Joshua Reynolds's Notes and Observations on Pictures, etc.*, edited by William Cotton, 1859, p. 9. Of these, Sir Matthew Featherstone (and his family), Lord Charlemont and Mr Woodyeare were all painted by Batoni, 1750–3.

9. For a fuller account of this odd picture see E. K. Waterhouse, *Three Decades of British Art*, American Philosophical Society, Philadelphia, 1965, pp. 27ff.

10. E. K. Waterhouse, *Reynolds*, 1941, plate 19. The best Batonis for comparison are those at Uppark.

11. E. K. Waterhouse, *Three Decades of British Art*, pp. 15ff.

12. *Conversations of James Northcote, R.A., with William Hazlitt*, edited by Edmund Gosse, 1894, p. 179.

13. E. K. Waterhouse, *Three Decades of British Art*, pp. 54ff.

14. It is signed and dated 1756 and it is significant that Reynolds chose it to exhibit at the Society of Artists in 1761. Northcote (*Supplement*, 1815, p. xxii) specifically mentions that it 'attracted much notice by its boldness'—presumably from visitors to the studio when he himself lived there in the 1770s. It was eventually bought by Lord Inchiquin in 1777, much as if it had been an old master.

15. J. T. Smith, *Nollekens and his Times*, edited by W. Whitten, ii, 1920, p. 228.

16. E. K. Waterhouse, *Three Decades of British Art*, pp. 54ff.

17. The 1755 book is in the Cottonian Library at Plymouth. All the others which are known to survive are in the Library of the Royal Academy in London. The missing volumes are those for 1756, 1763, 1774, 1775, 1776, 1778, 1783 and 1785. The 1755 book is the only one to have been published in full, with annotations (*The Walpole Society*, XLI, 1968, pp. 112–64).

18. *Portraits by Sir Joshua Reynolds*, edited by F. W. Hilles, 1952, p. 16.

19. This is sufficiently documented by the letters published in Susan M. Radcliffe, *Sir Joshua's Nephew*, 1930.

20. Reproduced in E. K. Waterhouse, *Reynolds*, 1941, Plate 67.

21. William T. Whitley, *Artists and their Friends in England, 1700–1799*, 1928, i, p. 167.

22. E. K. Waterhouse, *Reynolds*, 1941, Plate 126. The Juno disappeared in the U.S. some sixty years ago; *Hope nursing Love* (ibid., Plate 124) is known in four versions but the original is at Bowood.

23. *Conversations of James Northcote, R.A., with James Ward*, edited by Ernest Fletcher, 1901, p. 121.

24. Quoted in Whitley, op. cit., ii, p. 391.

25. *The Diary of Benjamin Robert Haydon*, edited by Willard Bissel Pope, II, 1960, p. 337.

26. The Glasgow *Achilles* (?) and the New York *Standard Bearer*; see *Letters of Sir Joshua Reynolds*, edited by F. W. Hilles, 1929, pp. 251-2.

27. See Northcote, I, pp. 292ff and Hilles, *Letters of Sir Joshua Reynolds*, 1929, Letter XXII.

28. The picture, now in the National Gallery of Ireland, was first published by A. N. L. Munby, *The Connoisseur*, December 1947, pp. 82ff. The Tate Gallery (T.938) has lately acquired a small sketch which shows the design in its unexpurgated form, but this hardly justifies Angelica's complaint.

29. Sir Cecil Harcourt-Smith, *The Society of Dilettanti, its Regalia and Pictures*, 1932, p. 72.

30. *The Literary Works of Sir Joshua Reynolds*, 1819, pp. 338ff.

31. *The Diary of Benjamin Robert Haydon*, edited by Willard Bissell Pope, II, 1960, p. 332.

32. E. K. Waterhouse, *The James A. de Rothschild Collection at Waddesdon Manor: Paintings*, 1967, No. 33.

33. Sir Joshua Reynolds, *Discourses*, edited by Robert R. Wark, 1959, p. 86.

34. *The Literary Works of Sir Joshua Reynolds*, 1819, p. 423.

35. Letter of December 24, 1785, from the Hon. Mrs Howe to Georgiana, Countess Spencer (Althorp MSS).

36. The *Letters of Sir Joshua Reynolds*, edited by F. W. Hilles, 1929, p. 56 (Letter XL). This contrasts with Reynolds's earlier practice: John Wesley, in his journal under January 5, 1789 (when he had just sat to Romney), referring probably to 1755, says Reynolds had made him sit for ten hours.

37. *The Life of Sir Joshua Reynolds*, II, 1819, p. 211.

38. First published in *Portraits by Sir Joshua Reynolds*, edited by F. W. Hilles, 1952.

39. F. W. Hilles, *The Literary Career of Sir Joshua Reynolds*, 1936, p. 161.

40. At Dalmeny; reproduced in E. K. Waterhouse, *Gainsborough*, 1958, Plate 280.

41. *The Works of James Barry*, 1809, I, pp. 556 and 553-4.

42. William Cotton, *Sir Joshua Reynolds and his Works*, 1856, pp. 174-5.

43. The only satisfactory text, and a variorum edition, is that edited by Robert R. Wark, Huntington Library, San Marino, California, 1959.

44. Wark, op. cit., xxxv.

Procedure and prices

THERE ARE A FEW INSTANCES in which a portrait (more often a group) is of an unusual size because it was commissioned for a particular place in a particular room. A fairly certain example is the *Georgiana, Countess Spencer, and her Daughter* (Plate 21), which measures 48¼ by 45 inches—although the clue to the exact place for which it was originally intended is lost. But normally British eighteenth-century portraits are of standard sizes. The smallest normal size for a commissioned portrait measures roughly 30 by 25 inches; this is what would nowadays be called a 'head' or a 'bust' portrait, for which the technical term (to be found in the Academy catalogues) was 'a three quarters'. It is possible that the term 'a head' was sometimes used for a slightly smaller size, about 24 by 17½ inches, which was normally reserved for crayons but is the size of some oil portraits designed to hang over bookcases in a library. A 'kit-cat', which invariably shows at least one hand, measures 36 by 28 inches; and a half-length 50 by 40 inches. A slightly larger size, known as 'a bishop's half-length'—because of the need for more room for the spreading lawn of bishops' sleeves!—is occasionally found and measures 55 by 44 inches. The full-length measures 94 by 58 inches. All but a very few of Reynolds's portraits are in these standard sizes and he had a remarkable instinctive power for fitting in the masses of his figures into these shapes. Normally he seems to have painted from the model directly onto the canvas, without making preliminary drawings. This seems to have been the method he would have learned with Hudson. He regretted it all his life.

Actual preliminary drawings made for specific portraits are very rare indeed. Northcote said 'he rarely made any drawings, and the very few which he did produce cannot claim notice but from their very great scarcity.'[1] It seems probable, however, that Reynolds studied poses from humble models which he kept by him for use with some of his grander sitters.[2] There is a very sketchy drawing in the Lousada collection for the pose only, which is certainly related to the full-length portrait of the Duchess of Northumberland, but it would seem rather to be for the artist's own guidance than to have been done to secure the preliminary approval of the sitter. There are, however, a few small studies which were probably done as 'models' for the sitters' approval before he embarked on the final pictures, but I know of these only for one or two full-length portraits:[3] a gouache(?) on paper, study for the *Duchess of Ancaster* of 1763; an oil study on paper for the *Philip Gell* of the same date; and a

varnished wash drawing for the *Duchess of Buccleuch and Daughter* of 1772. The curious way in which he could flounder about on the canvas itself for his composition can be seen in the unfinished *Lord Rockingham and Burke* (Figure 7) in the Fitzwilliam Museum, Cambridge. Here some of the accessories have been more or less completed by an assistant, but the work on the portraits themselves still awaits a good deal of revision from the artist himself as well as completion. The most useful—but all too brief—account of Reynolds's technical methods and changes of technique is that by Horace Buttery.[4]

It would appear from a surviving receipt that, in Devonshire, Reynolds charged £3. 10s. for a 30 by 25 inch portrait, and, on first settling in London, he was charging 5 guineas for a head and 12 guineas for a kit-cat. By 1755 he was charging the same prices as Hudson, namely: 12 guineas for a head, 24 for a half-length and 48 for a full-length (but the half-length portrait of Lord Cathcart cost £31, which may have included the frame). A year or two later both Hudson and Reynolds put up their prices to 15, 30 and 60 guineas: and in 1759, just before moving to Leicester Fields, Reynolds raised his to 20, 50 and 100 guineas. The demand was so great that, in 1764, probably partly to reduce the number of sitters, he raised his prices again to 30 guineas for a 30 by 25 inch portrait, 50 for a kit-cat, 70 for a half-length and 150 for a full-length. The last rise was in 1782, when they became 50 guineas for a 30 by 25, 100 guineas for a half-length, and 200 guineas for a whole-length. The normal price for a head-size fancy picture was also 50 guineas. In theory the first payment was made at the time of the first sitting and the second and last after the picture had been sent home, but quite often the full payment was made all at once, either at the beginning or at the completion of the work.

Two ledgers survive,[5] in the Fitzwilliam Museum, Cambridge, the first running from 1760 to 1772, the second from May 1772 until the end of 1791. The sums paid can generally be associated in a quite straightforward manner with existing pictures, and they can also be used for ascertaining the size of portraits which have not been traced. A very substantial number of sitter books[6] also survives, so that Reynolds's work is very well documented.

Contemporary engravings also help to identify most of the more important paintings, and problems of connoisseurship are largely limited to guesswork about how much of a given picture was painted by Sir Joshua's own hand, and to the question of copies. He seems to have been generous in lending old

masters, self-portraits or, sometimes, fancy pictures which had not yet been sold to young painters to copy, although he did not allow unauthorized copies to be made of commissioned portraits. However, in the 1820s, it was the practice for a certain number of the old masters which had been lent to the British Institution to be retained for some weeks so that young painters could copy them. There is a record, for instance,[7] that the portrait of Theophila Gwatkin, lent to the British Institution in 1823, was copied full size by Shepperson, Smart, Pyne, Markes, Fowler, Cunliffe, Drummond, Solomon and Sargeant, as well as by eleven other artists in different sizes or mediums. Early copies, some of them reasonably accomplished, were also made from the engravings after a number of the later fancy pictures.

The problem of how much, apart from the face, was actually executed by Reynolds himself, is usually insoluble. Northcote, for instance, records (II, 25*n*) that he painted the drapery of one of the versions of the portrait of Archbishop Robinson (Plate 95), but whether what he painted was later completed by Sir Joshua himself must be a matter for conjecture. It is very probable that the faithful Marchi, who except for a year or two on his own after 1768 was more or less 'head assistant' in the studio for the whole of Reynolds's active career, had been trained by Reynolds to imitate his own handling and technique with the greatest fidelity. Reynolds's technical notes on the media he employed on a number of given pictures tend to be in Italian[8] and it may well be that these were intended as much for Marchi as for himself. It is recorded that Marchi 'had charge of his books [i.e. his sitter books] for 40 years'[9] and he was also much employed, after Sir Joshua's death, in the restoration of his pictures. Marchi deserves a good deal more study than he has received.

Notes to 'Procedure and prices'

1. *The Life of Sir Joshua Reynolds*, II, 1819, p. 280.

2. For example, Figure 12 in Luke Herrmann's article in the *Burlington Magazine*, CX, December 1968, pp. 650ff., which is the most useful account of Reynolds's drawings.

3. The *Duchess of Ancaster* belongs to Christopher Norris; the *Gell* is reproduced in the catalogue of the Earl of Hardwicke sale, July 7, 1969 (95); the Buccleuch group belongs to the family.

4. On pp. 248–50 of Derek Hudson, *Sir Joshua Reynolds*, 1958.

5. Both ledgers have been published, transcribed by Malcolm Cormack, in *The Walpole Society's Annual*, XLII, 1970. The later one was published by William Cotton in *Sir Joshua Reynolds' Notes and Observations on Pictures, etc.*, 1859.

6. The sitter books survive for the years 1755 to 1789, both inclusive, except for those for the years 1756, 1763, 1774, 1775, 1776, 1778, 1783 and 1785. That for 1755 is among the manuscripts of the Cottonian Library, Plymouth; all the other survivors are in the Library of the Royal Academy in London. Only that for 1755 has been fully published (by myself in *The Walpole Society*, XLI, 1968, with annotations).

7. A. Graves and W. V. Cronin, *A History of the Works of Sir Joshua Reynolds*, I, 1899–1901, pp. 408–9.

8. These tend to be in the sitter books; a characteristic specimen is quoted in C. R. Leslie and T. Taylor, *Life and Times of Sir Joshua Reynolds*, I, 375n.

9. *Catalogue of the Portraits and Pictures in the Different Houses of the Earl of Fife*, 1798, p. 11 (under *Dining Room*, no. 1).

Biographical summary

1723 July 16: born at Plympton (Devonshire), son of the Reverend Samuel Reynolds, sometime Fellow of Balliol and schoolmaster of Plympton Grammar School.

1740 October 13: sets out for London, apprenticed to Thomas Hudson for four years.

1743 July/August: apprenticeship with Hudson cancelled on friendly terms. By August Reynolds is settled at Plymouth Dock (Devonport), practising as a portrait painter.

1744 Before December 1744 to December 1745: in London.

1745 December 25: death of Reynolds's father. Reynolds returns to Devonshire and settles for a time with his unmarried sisters in Plymouth.

1746 Probably mainly in Devonshire.

1747 to April 1749: partly at least (and perhaps mainly) practising painting in London, with visits to Devonshire.

1749 May 11: sails from Plymouth on the *Centurion* as guest of Commodore Keppel. August 18: lands at Port Mahon (Minorca), where he remains until January 25, 1750, and paints a number of portraits of army and naval officers.

1750 January 25: sails for Italy. Settles in Rome by mid-April and remains there for two years until April 1752. (He may have visited Florence on the way.) April 1750 to April 1752: in Rome.

1752 April: short visit to Naples.
May 3: leaves Rome on way homewards (Narni – Terni – Spoleto – Foligno – Assisi – Perugia – Arezzo). May 10 to July 4: at Florence. July 5 to July 16: at Bologna (Modena – Parma – Mantua – Ferrara). July 24 to August 16: at Venice (Milan – Turin – Lyons). September/October: about one month in Paris. October 16: reaches London and goes straight to Devonshire.

1753 Early in the year settles in London in St Martin's Lane. Later in the same year moves to 5 Great Newport Street, with his sister, Frances, as housekeeper.

1754 Meets Edmond Malone (in 1797 to be the editor of Reynolds's literary works). James McArdell makes the first mezzotint engravings after Reynolds's portraits.

1756 Meets Samuel Johnson (probably). Soon afterwards meets Edmund Burke.

1760 The first public exhibition in England held by the newly founded Society of Artists. Reynolds sends four portraits and receives a fulsome press notice (probably inspired by himself) in the *Imperial Magazine* (Whitley, I, p. 167). Buys a house in Leicester Fields (later Leicester Square), where he remains for the rest of his life.
Thomas Beach apprenticed to Reynolds (probably until early 1762).

1762 Meets Oliver Goldsmith.

1764 February: founds the Literary Club ('The Club').

1764 In the summer suffers what was probably a slight stroke.
(about) Hugh Barron apprenticed (until 1766).

1766 Elected member of the Society of Dilettanti.
1766 to 1768: Berridge assistant to Reynolds.

1768 September/October: visit to Paris.
October 23: back in London.
December 10: Royal Academy founded (Reynolds its first President).

1769 April 21: knighted.
April 26: first exhibition of Royal Academy opens.
Meets James Boswell.

1770 Reynolds's niece Theophila (Offie) Palmer comes to live in his house (more or less continuously until her marriage in 1781).

1771 James Northcote established as a resident pupil in Reynolds's house (until 1776).

1773 July: D.C.L. of University of Oxford.
Mayor of Plympton.

1774 Gainsborough leaves Bath and settles in London (summer).

1775 William Doughty moves in as resident pupil (until 1778).

1776 Northcote leaves Reynolds's house.
Romney takes Cotes's house in Cavendish Square.

1777 (about) Fanny Reynolds leaves Leicester Fields for good and Reynolds's niece, Mary Palmer, takes over as housekeeper.

1778 Collects and publishes his first seven *Discourses*.

1781 July 24 to September 14: visit to Holland and Flanders.

1782 Autumn: has a second slight stroke.

1784 December 13: death of Samuel Johnson.

1785 August/September: visit to Brussels.

1789 July 13: loses sight of left eye and more or less gives up painting.

1790 February: resigns as President of R.A. and as an Academician.
March: cancels his resignation.
December 10: gives last Discourse at Royal Academy.

1791 October: too ill to attend Academy meetings.
November: makes will.

1792 February 23: dies.
March 3: funeral in St Paul's Cathedral.

Note on Reynolds's sketchbooks

REYNOLDS did not normally give away or dispose of drawings or sketchbooks during his lifetime, so that all of his work of this kind passed, with the contents of his studio, to his niece, the Marchioness of Thomond, and appeared at her sale of 26 May 1821: the drawings as Lots 52–60 and 66; the sketchbooks as Lots 61–5. The great bulk of the drawings (lots 52, 54, 55, and 58–60) were bought by John Herschel. Some were disposed of, but the great bulk of these were made up into an album and have long been on loan to the Royal Academy from a descendant of Sir John Herschel, Mrs R. A. Lucas (see Luke Herrmann, *Burlington Magazine*, CX, 1968, pp. 650ff.).

The sketchbooks consisted partly of notes on pictures made in Italy, often with notations of composition, etc., or drawings from single figures. They have never been published in detail and deserve careful study.

Lots 61 and 62 were bought by John Herschel for the Gwatkin family and were acquired from them by the British Museum in 1859.

Lot 63 was bought by Sir John Soane and is now in the Soane Museum.

Lot 64 (three small sketchbooks) was also bought by Herschel, presumably for the Gwatkin family. It is likely that these are the ones now in the possession of Mrs Copland-Griffiths and the Ashmolean Museum, Oxford.

Lot 65 (three sketchbooks) was bought by Samuel Rogers. A good deal of confusion has been caused by an incorrect statement in Leslie and Taylor (I, p. 51, note 1) that these were acquired at the Rogers sale in 1856 for a mythical 'Col.' Lenox of New York. Through the kindness of Mr Joseph T. Rankin, Chief of the Art and Architecture Division of the New York Public Library, I am able to give an accurate account of the later history of these. They were bought at the Rogers sale, 28 April 1856 (lots 1275–7), on behalf of Andrew E. Douglas of New York, who sold them as a single lot (2591) at an auction in New York (15 December 1856) to Henry F. Sewall. At the Sewall sale in New York in January 1897 they passed to William A. White, who gave one of them in 1918 to the Metropolitan Museum, New York, and another to the Fogg Art Museum, Cambridge, Massachusetts. The third may have been a book which I saw when it was deposited at Yale by Professor Chauncey B. Tinker, or it may be the notebook used on the Paris trip in 1771, which belongs to Professor Frederick W. Hilles (see Warren Hunting Smith, ed., *Horace Walpole, Writer, Politician and Connoisseur*, 1967, p. 150, *n.*18).

Notes to the plates

1. Perhaps more likely to be pre-Italian (1748–9), rather than, as I formerly believed, 1753–4.

2. The wife of Rear-Admiral Joseph Hamar (died 1774). For its history see *The Walpole Society*, XLI, p. 166.

3. Father of the first Marquess of Abercorn and a personal friend to the painter. He wears the costume of a Russian *boyar*, with which a moustache, absent in his other portraits, was thought appropriate. The date of 1746 is vouched for by Malone, I, 1819, p.x.

4. Signed *Js Reynolds pinxit Nov.* and dated *1747* on the book.

5. The sitter was conceivably a niece of John Hamilton (Plate 3), who married, in 1754, John Cameron of Glenkindy. The picture was stolen from Montacute in 1962.

6. Probably one of the last portraits painted before Reynolds sailed for Italy.

8. The eminent sculptor and a foundation R.A. Painted in Florence on the way home from Rome.

9. Painted in Paris in 1752.

10. See p. 18.

11. He wears what is apparently a Hungarian Hussar uniform.

14. Signed *J. Reynolds pinxit 1756*, but exhibited S.A. 1761 (84).

16. Signed *J. Reynolds pinxit 1757*. For the various versions see *The Walpole Society*, XLII, 1970, pp. 15–16.

17. Perhaps an exercise in deliberate imitation of Lely.

18. The boy was born in 1742 and died young, before 1768. This was a present to the boy's father on his sixteenth birthday; see the story in Cotton, 1856, p. 82.

20, 21. The little girl could well be two years older in the final picture at Althorp. Presumably a change of size was decided upon after the first sketch was made.

23. See Plate 29.

24, 25. She sat very often in 1759 to 1761, and later up to 1766. Plate 24 may well be one of the latest and Plate 25 one of the earliest. The pose derives from Trevisani (E. Wind, *Journal of the Warburg Institute*, II, p. 182).

26. No sittings seem to be recorded, but the picture was paid for in 1761 and the engraving is dated 1762. Horace Walpole saw it at Lord Royston's house (*The Walpole Society*, XVI, p. 40) on a visit dated 1761, but more probably 1762, as he mentions the mezzotint.

27. It bears an incorrect date of 1753, but was mainly painted in 1759, since Reynolds's notebook of that year records a three-quarter-length copy (probably that now at Sauchieburn).

28. Signed *J. Reynolds pinxit. 1760*.

29. Sittings range from 1760 to 1767 and one picture (there is no evidence which) was exhibited in 1763; I presume it to be that in the Wallace Collection. The other main picture of her (without a hat) has lately been bequeathed to the University of Glasgow.

30. Sittings in 1757, but exhibited 1760, when Walpole noted that 'the attitude' was taken from van Dyck.

31. See p. 22.

32. See catalogue of R.A. bicentenary exhibition, 1968 (86). The dress is documented as painted by Peter Toms.

33. The first idea for the pose seems to come from a drawing, probably after Salvator Rosa, in the Herschel Album.

34. A receipt (at present mislaid) for £84, dated June 28, 1763, is recorded. A finished study (20 × 13 in.) was in the Earl of Hardwicke sale, July 7, 1967 (95).

35. For date and history see my *Three Decades of British Art*, 1965, p. 55.

36. The children are Elizabeth (1752–1816), Sarah (1754–1807) and Edward Holden Cruttenden jun. (born 1756, died young).

37. See catalogue of exhibition, *Romantic Art in Britain*, Detroit/Philadelphia, 1968 (6).

38. Paid for and exhibited in 1763 (no sitter book).

40. See catalogue of R.A. bicentenary exhibition, 1968 (129).

41. No sittings are recorded, so they were presumably in 1763. It was paid for and sent home in 1766.

43. There are four portraits of Selwyn: (1) the 1759 picture with Lord Edgcumbe and Gilly Williams (Figure 5); (2) this picture, of 1764–5; (3) the picture at Castle Howard, with Lord Carlisle, 1770; (4) that in the Marsham-Townshend sale, 1946, which must be about 1783.

44. See catalogue of R.A. exhibition, 1956–7 (300).

45. A variation on the *Et in Arcadia Ego* motif; see E. Panofsky, *Meaning in the Visual Arts*, 1957, p. 310.

47. The part is in Ben Jonson's *Every Man in his Humour*. On the back is the date *1768* and *J.R. pinx*. An early replica is in the National Portrait Gallery (4504).

48. Probably 1767–9, when known as 'Mrs. Horton'.

49. The motif is supposedly derived from the Sistine ceiling.

52. A variation on the Apollo Belvedere pose; cf. Plate 10.

54. Mrs Abington first played this part in London in December 1769. There are no sittings for 1769 and 1770, so this must have been painted in 1771.

55. This was shown at the R.A. simply as 'A Girl reading', but 'Clarissa' was visible on the spine of the book.

56. It is a curious fact that there is no record of when this was given to the R.A. It was not engraved until 1780, but a date close to 1773, when he received his D.C.L. (Oxford), is likely.

58. See catalogue of R.A. bicentenary exhibition, 1968 (122).

59. Signed *Jo. Reynolds Equ. pnxt / 1773.*

61. Not quite finished. It was probably intended to be shown as a companion to Plate 60 at the R.A. in 1776, but the sitter died.

62. See p. 26.

63. This appears to me to be the prime original: the version at Bowood is the first replica, painted for Lord Carysfort.

67. Exhibited in 1774 as 'The Triumph of Truth with the Portrait of a Gentleman'. The Angel of Truth is beating down figures of Sophistry, Scepticism and Infidelity, who have (to a greater or lesser degree) the features of Voltaire, Gibbon and Hume.

70. For the history of this pattern see E. Wind, *Journal of the Warburg Institute*, I, 322.

71. This unfinished picture was formerly in the Cook collection and was much repainted. See my article in the *Minneapolis Institute of Arts Bulletin*, LVII, 1968, p. 51.

75. See Chauncey B. Tinker, *Painter and Poet*, 1938.

79. See catalogue of R.A. bicentenary exhibition, 1968 (115) for probable date of 1777.

80. First engraved in 1777; bought by Lord Warwick in 1779 for the Library at Warwick Castle.

81. See p. 29. The sitters are: back row: Sir John Taylor (1745–86), Richard Thompson (1745–1820), Walter Spencer-Stanhope (1749–1821); front row: Sir Watkin Williams Wynn (1749–89), Stephen Payne-Gallwey (1750–1803), Sir William Hamilton (1730–1803), John Smyth (1748–1812).

82. Back row: Lord Dundas (1741–1820), The Hon. Charles Greville (1749–1809), John Charles Crowle (died 1811), Sir Joseph Banks (1743–1820); front row: Lord Mulgrave (1744–92), Lord Seaforth (1744–81) and the fifth Duke of Leeds (1751–99).

83. She is wearing a riding habit formed from the uniform of her husband's regiment, the Hampshire militia.

85. See my Waddesdon catalogue, 1967, No. 29.

88. The payment was in 1786 and there is no sitter book for 1785. The 1777 and 1779 sittings may be irrelevant.

89. Begun 1778–9 but signed and dated *Sr J. Reynolds / 1781.*

90. The subject also occurs in the circle of Boucher.

91. Begun at the time of her marriage, 1770–1, but not shown until 1774.

95. There seem to be two originals, the other in the Musée de Bordeaux. There is some reason to think the Bordeaux one may be that exhibited in 1775.

99. See my Waddesdon catalogue, 1967, No. 33.

100. Signed on the hem of the skirt, in capitals, *Joshua Reynolds pinxit 1784.* There is a replica of about 1789 at Dulwich.

104. See Major A. McK. Annand in *Journal of the Society for Army Historical Research,* XLVIII, 1.H.

109. See p. 35.

118. The girl in the foreground is derived from Bernini's *David.*

121. The picture from the Peel collection, long lent by the National Gallery to the National Portrait Gallery, was considered to be the battered original until the actual original turned up and was bought for the National Portrait Gallery in 1965.

122. Cholmondeley and William Windham exchanged portraits by Reynolds. The Windham is on loan from the National Gallery to the National Portrait Gallery.

127. The Prince Regent acquired at the Burke sale of 1812 a version of this portrait, which Reynolds's niece and heiress, the Marchioness of Thomond, did not believe was an original, so she presented this to the Prince Regent on June 20, 1812.

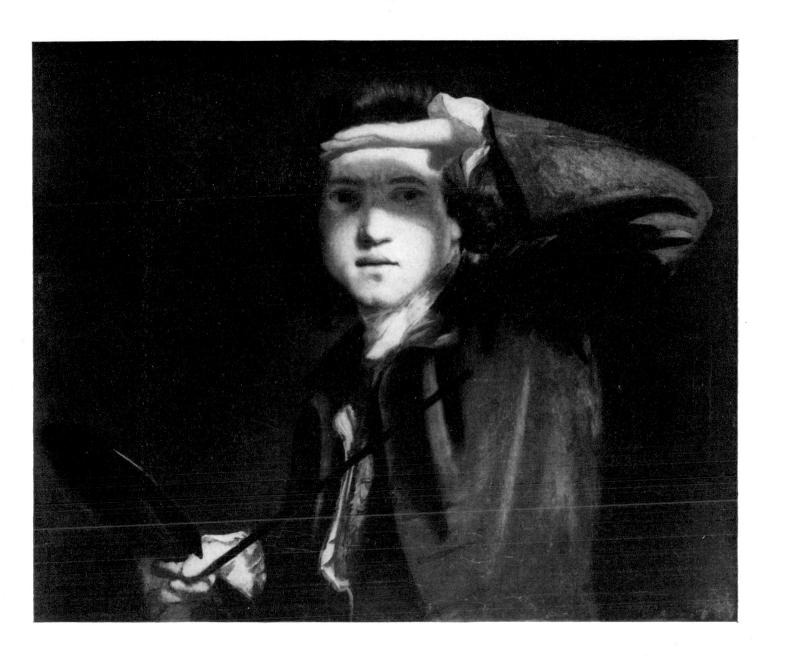

1 SELF–PORTRAIT
About 1748–9? Canvas, 63 × 74 cm.
London, National Portrait Gallery

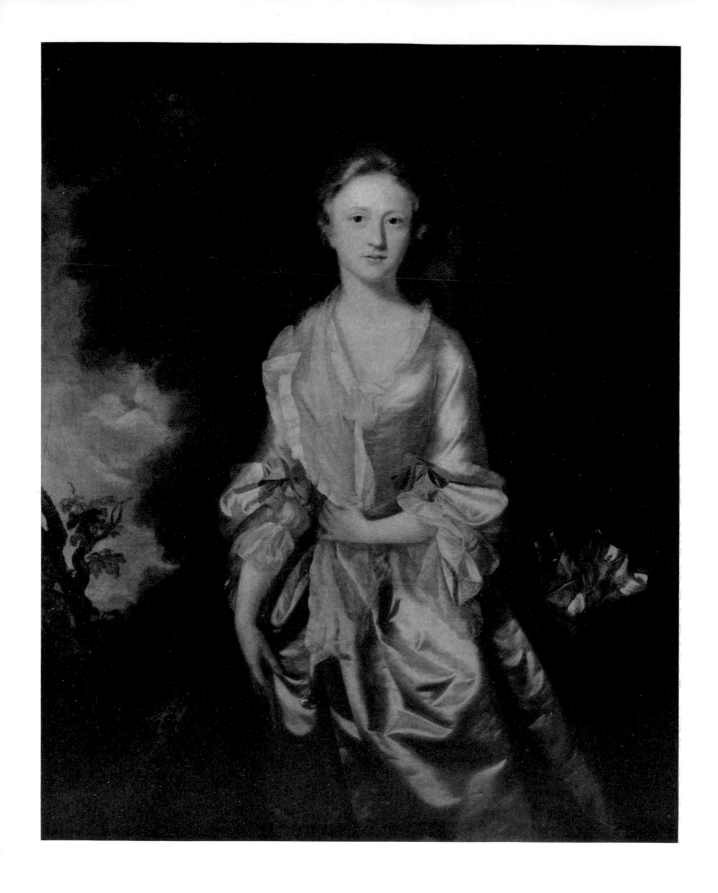

2 MRS JOSEPH HAMAR (*d.*1760)
 About 1747. Canvas, 122 × 101 cm.
 Plymouth, City Museum and Art Gallery

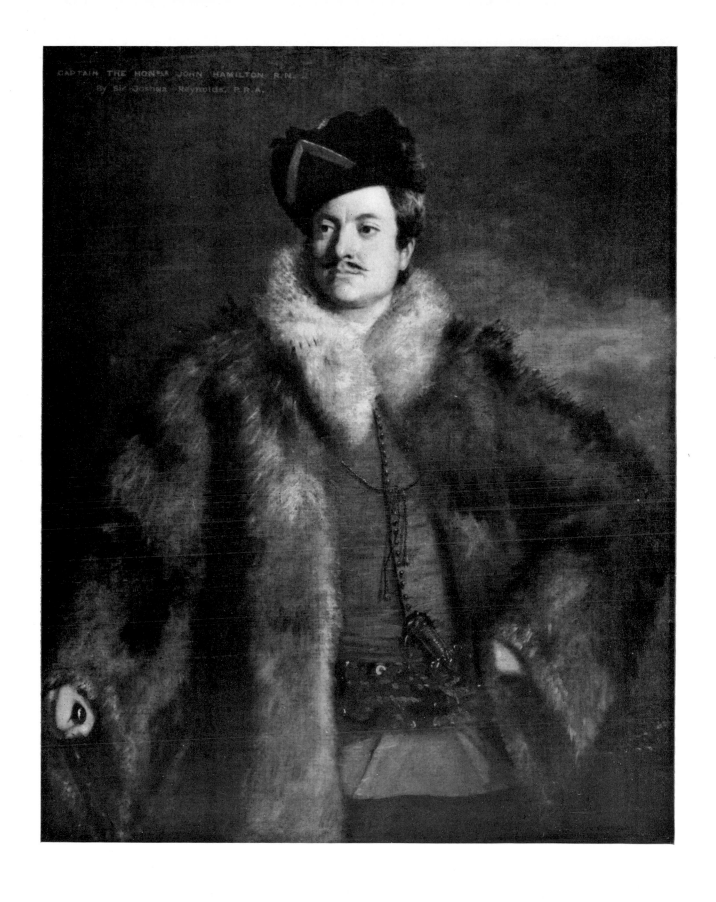

3 CAPTAIN THE HON. JOHN HAMILTON (1713/14–55)
1746. Canvas, 127 × 110 cm.
Northern Ireland, Private Collection

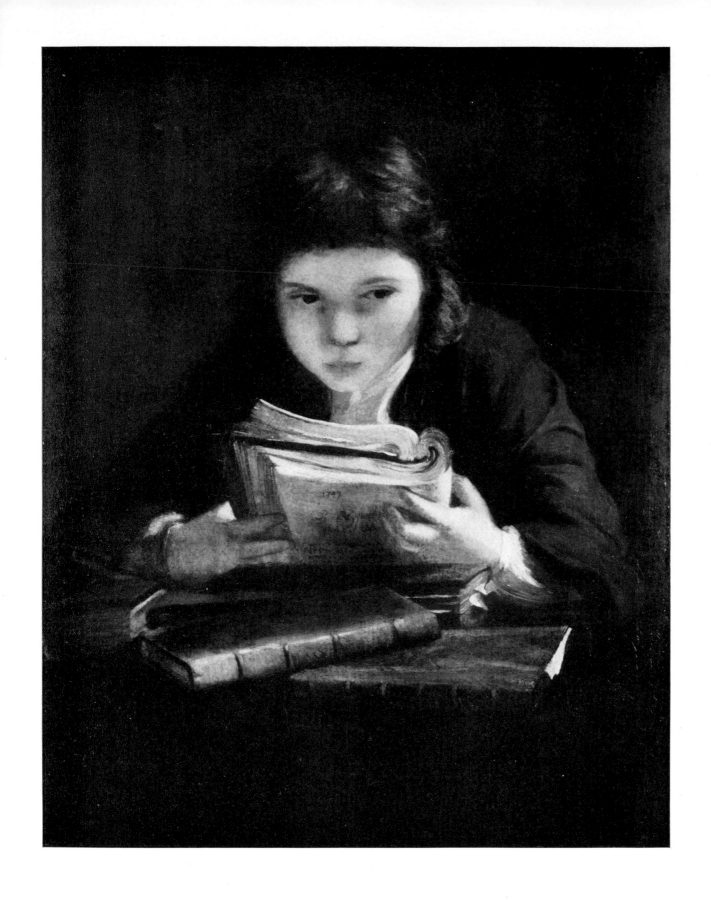

4 BOY READING
1747. Canvas, 76 × 60 cm.
England, Private Collection

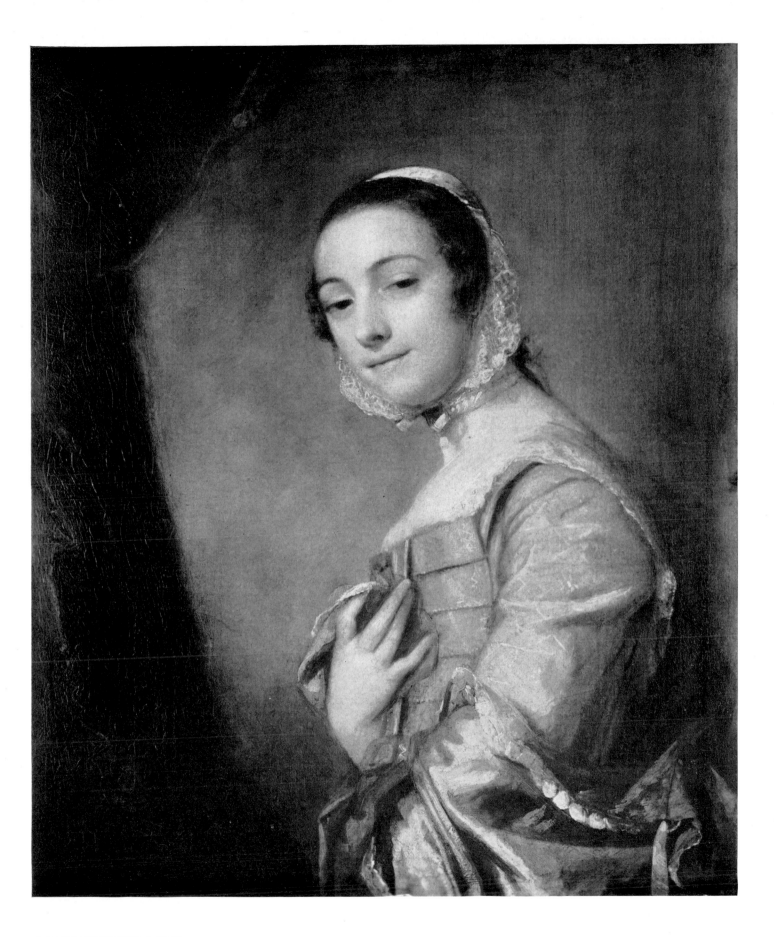

5 UNIDENTIFIED LADY
About 1746. Canvas, 76 × 64 cm.
Formerly Montacute House, The National Trust (stolen)

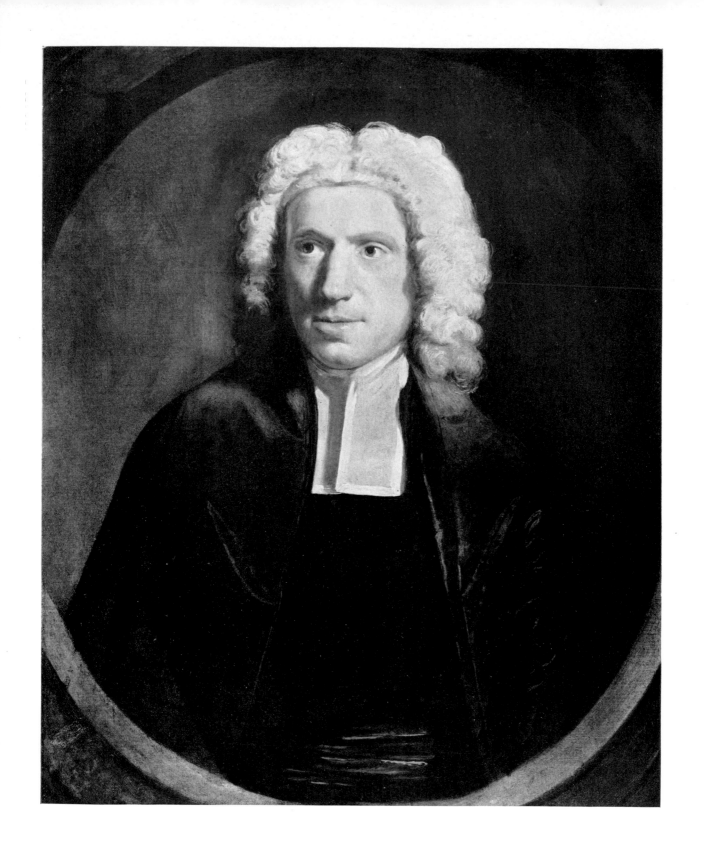

6, 7 THE REVEREND WILLIAM BEELE (1704–57). *Chaplain to the
Dockyard, Plymouth. About 1749. Canvas, 76 × 64 cm.
Birmingham University, The Barber Institute of Fine Arts*

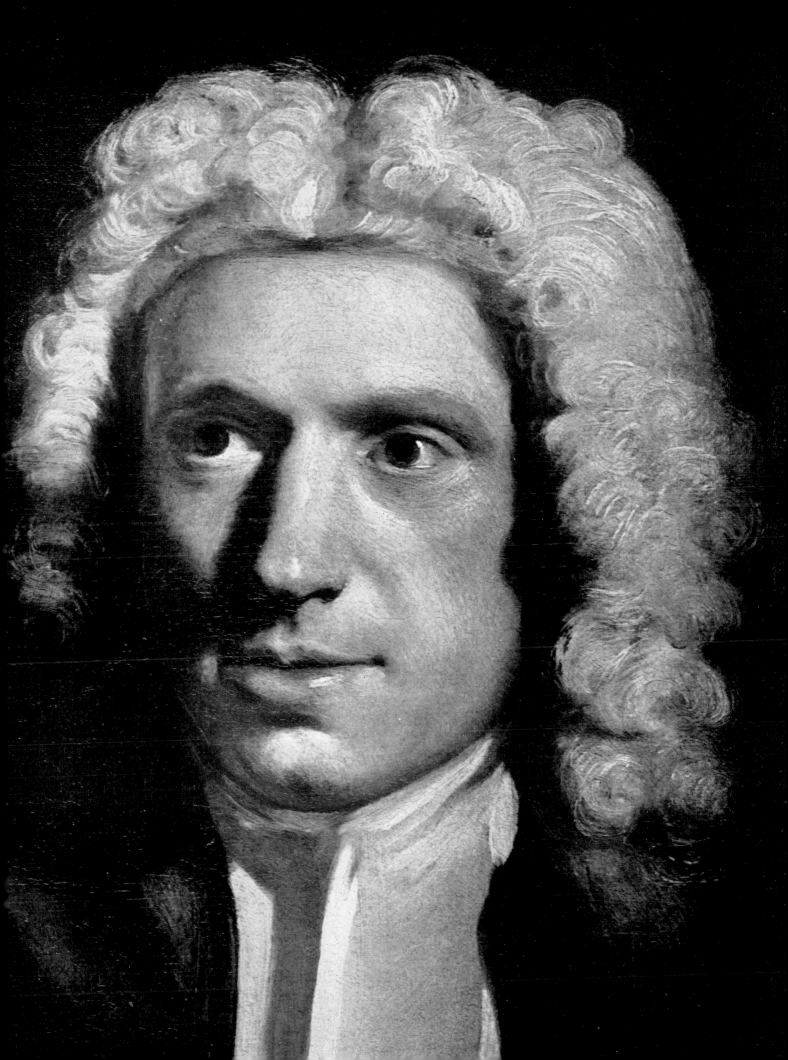

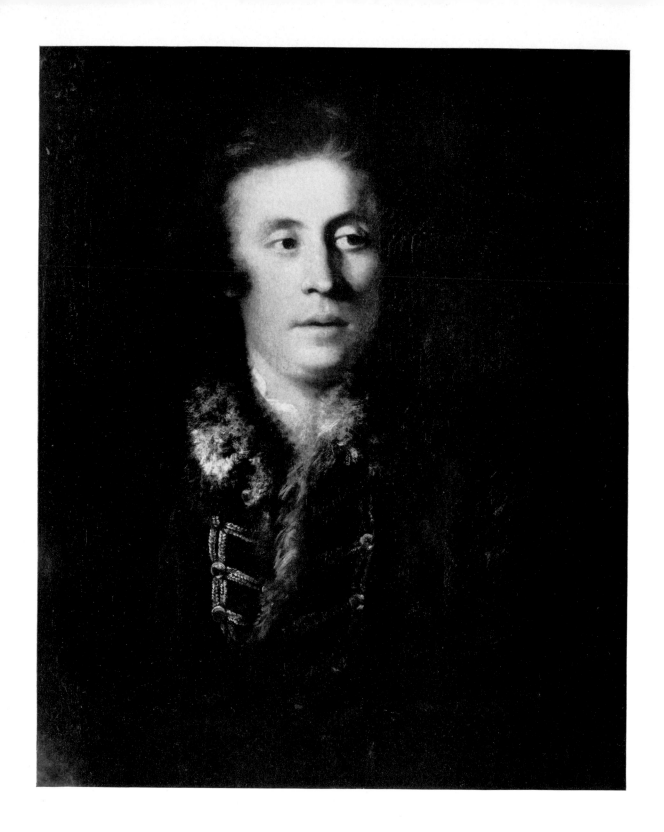

8 JOSEPH WILTON, R.A. (1722–1803)
1752. Canvas, 76 × 60 cm.
London, National Portrait Gallery

9 ANGELICA (MOORE), LADY CHAMBERS (*d.*1797)
Wife of Sir William Chambers, R.A.
1752. Canvas, 70 × 57 cm. London, Kenwood House (Iveagh Bequest)

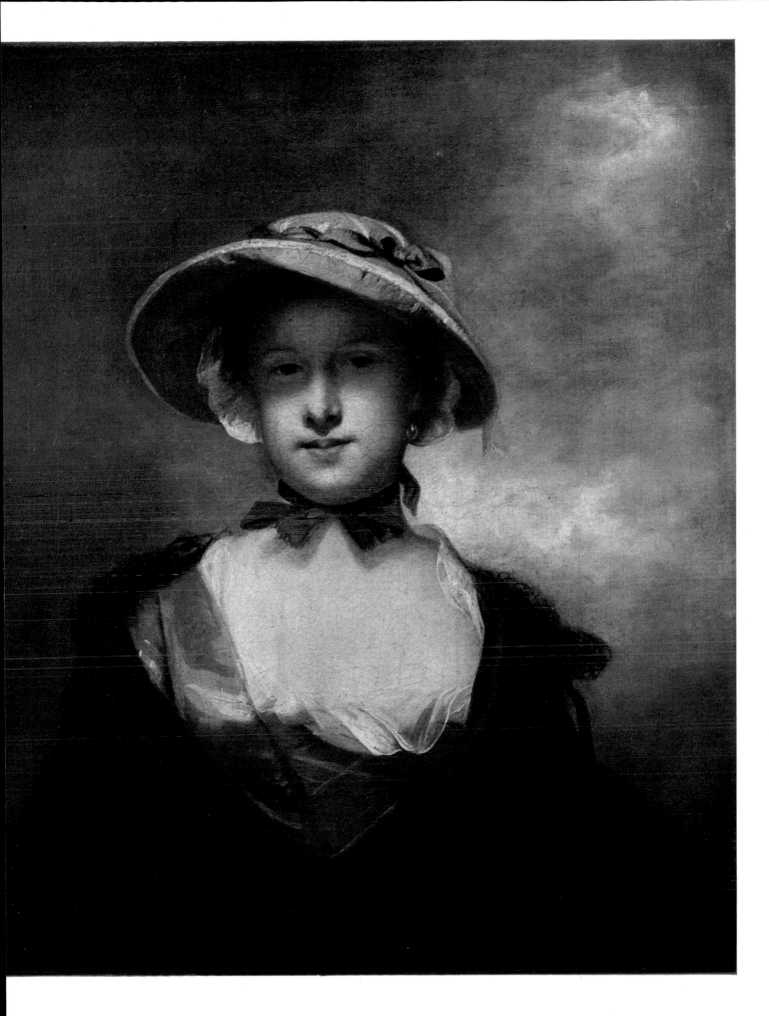

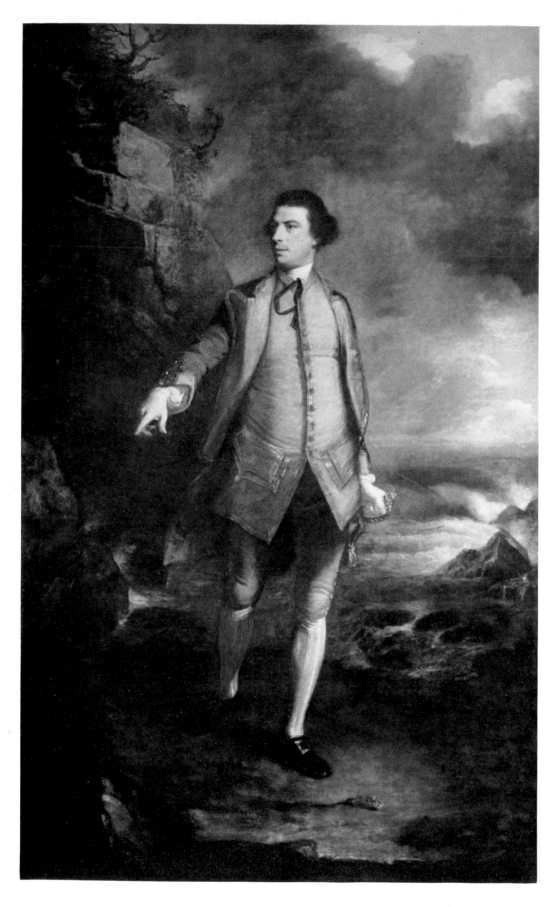

10 THE HON. AUGUSTUS (LATER VISCOUNT) KEPPEL (1725–86)
1753–4. Canvas, 233 × 146 cm.
Greenwich, National Maritime Museum

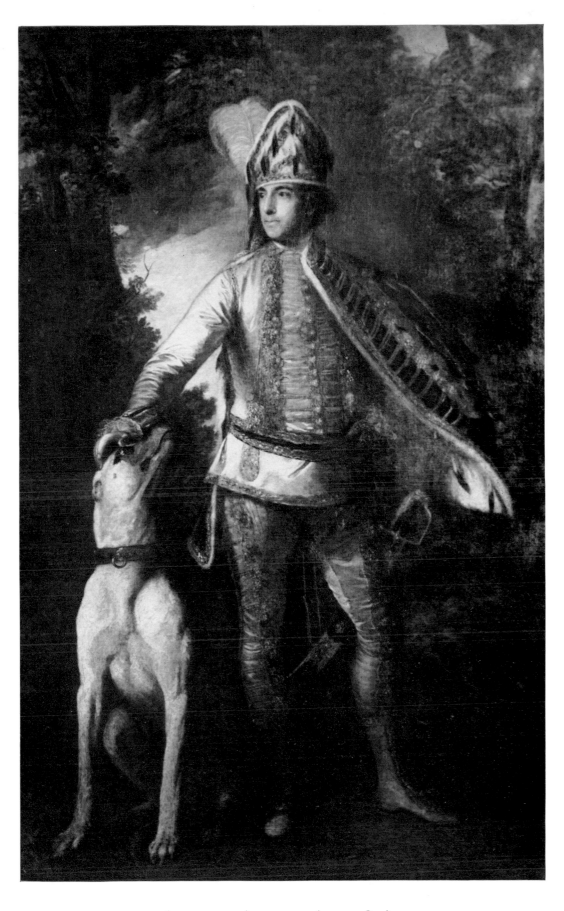

11 PETER, 1ST BARON (LATER EARL) LUDLOW (1730–1803)
1755. Canvas, 236 × 146 cm.
Woburn Abbey Collection

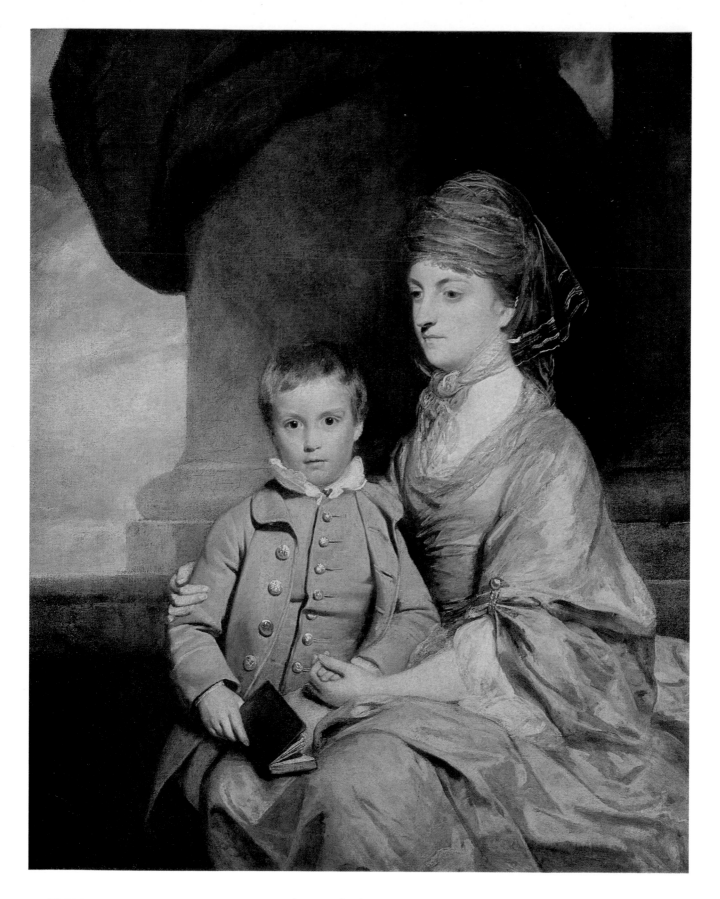

12 ELIZABETH, COUNTESS OF PEMBROKE (1737–1831), AND HER SON,
GEORGE, LORD HERBERT (1759–1827)
1764–5. Canvas, 127 × 101 cm.
Wilton House, Earl of Pembroke

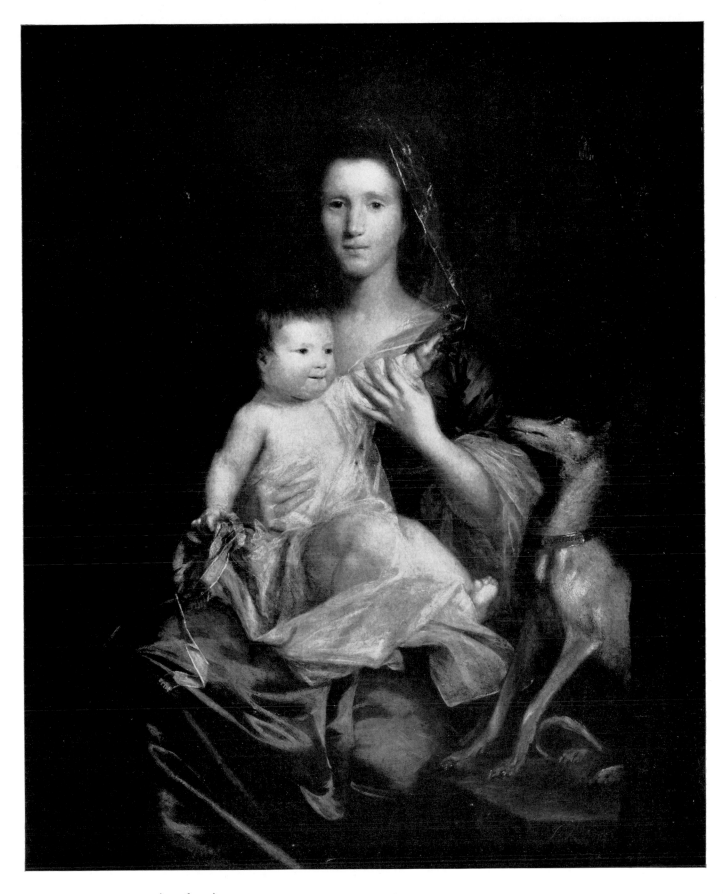

13 JANE HAMILTON (1726–71), LADY CATHCART, AND HER
DAUGHTER JANE, LATER DUCHESS OF ATHOLL (1754–91)
Signed and dated 1755. Canvas, 124 × 99 cm.
Manchester, City Art Gallery (on loan from Earl Cathcart)

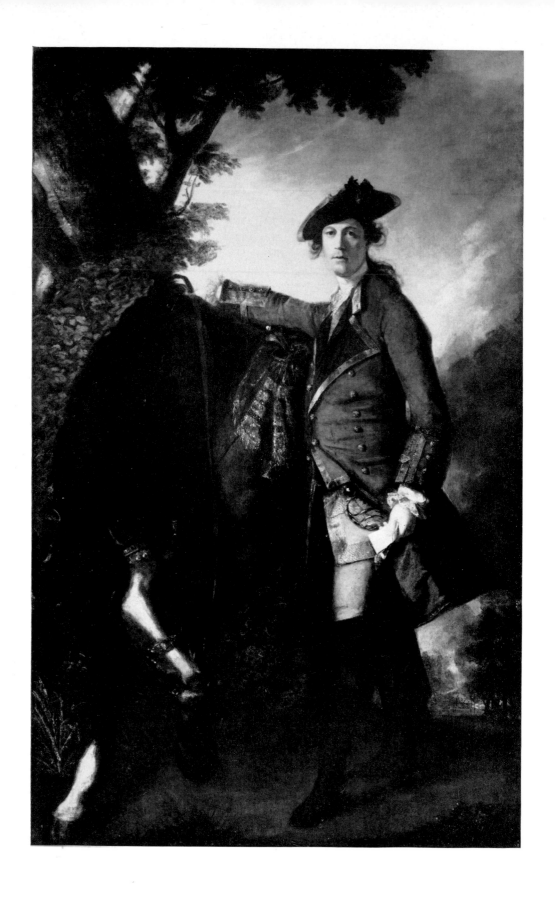

14, 15 CAPTAIN ROBERT ORME (1725–90)
*Signed and dated 1756. Canvas, 240 × 147 cm.
London, National Gallery*

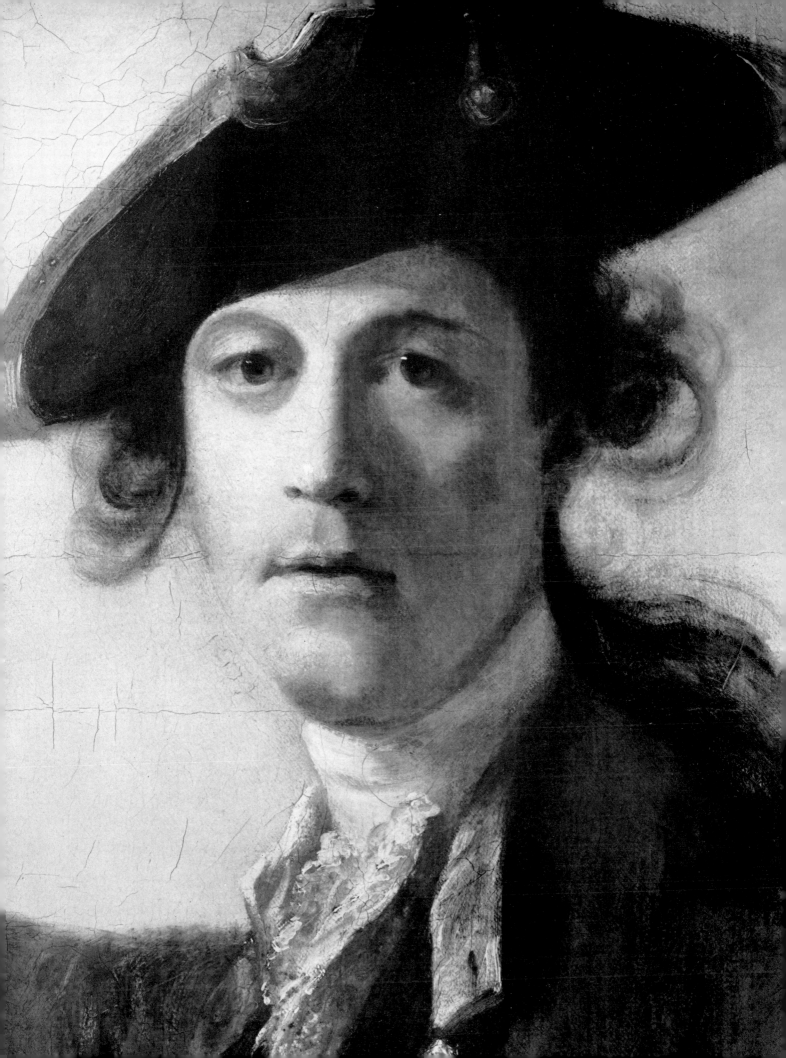

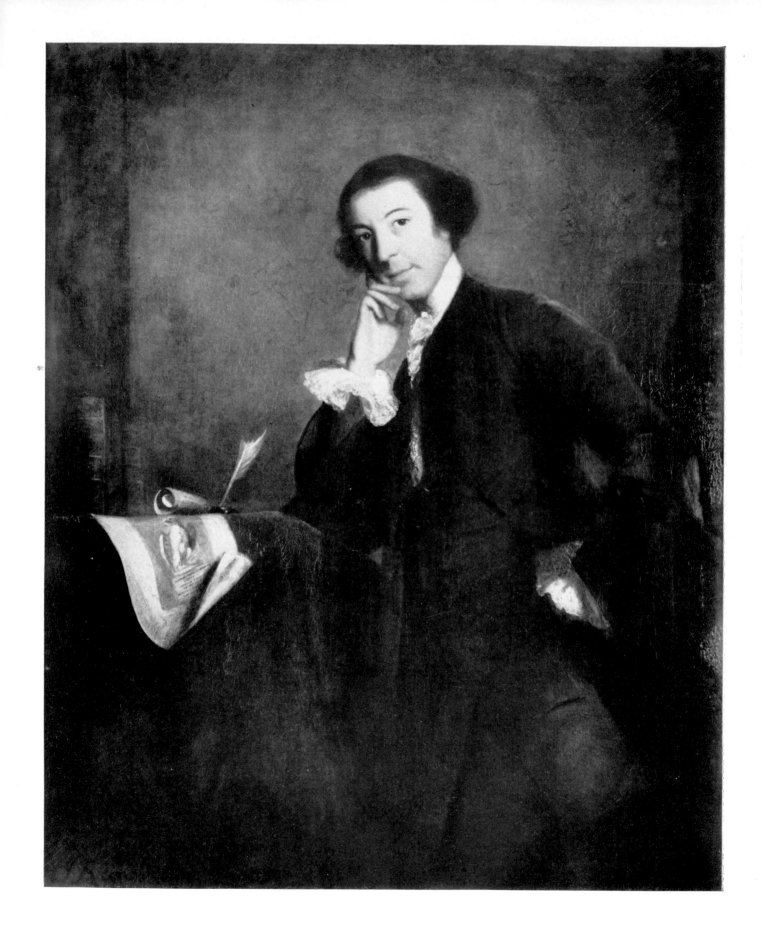

16 HORACE WALPOLE, LATER 4TH EARL OF ORFORD (1717–97)
 Signed and dated 1757. Canvas, 127 × 102 cm.
 Ragley, Marquess of Hertford

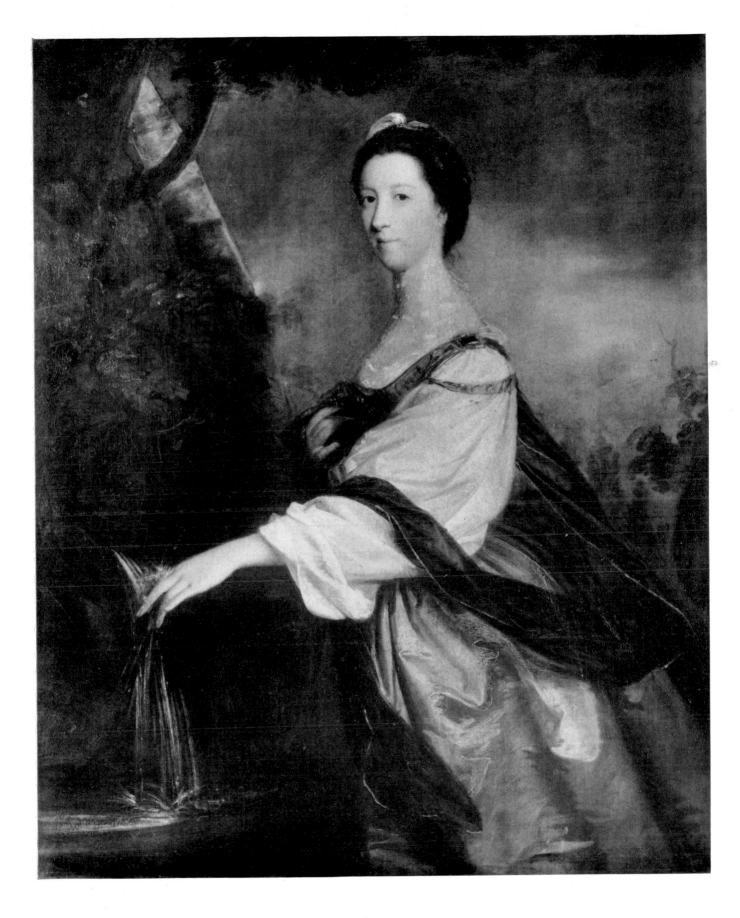

17 THE HON. HARRIOT (FORRESTER), MRS EDWARD WALTER (d.1786)
1757. Canvas, 127 × 102 cm.
Gorhambury, Earl of Verulam

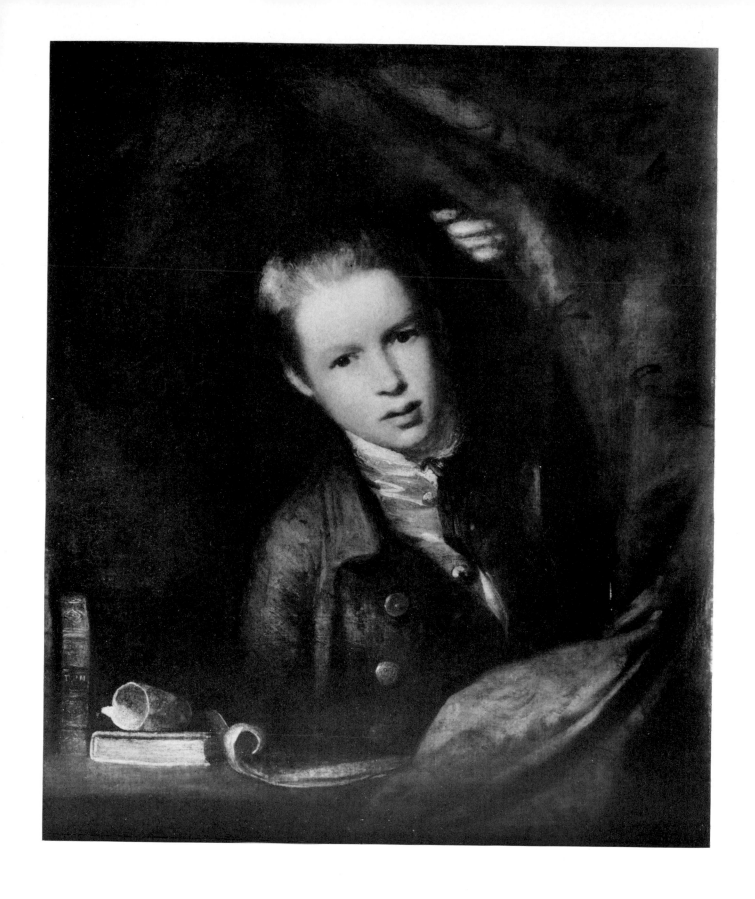

18 MASTER JOHN MUDGE (1742–*c*.1760)
1758. Canvas, 76 × 63 cm.
London, Hugh Overton

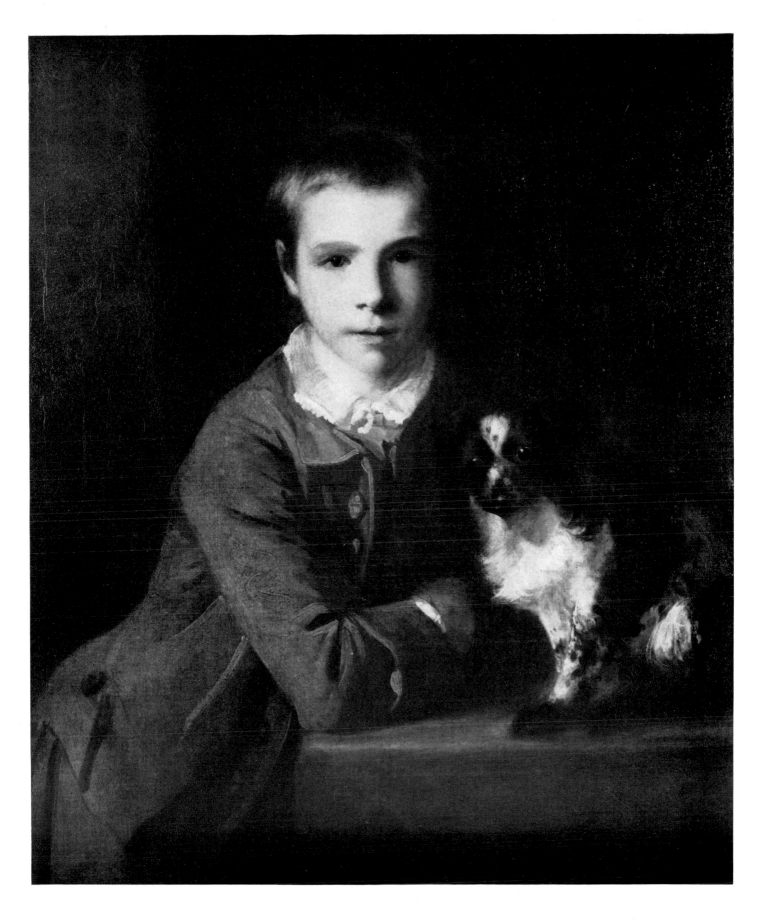

19 WILLIAM CHARLES, LORD MILSINGTON, LATER EARL OF PORTMORE (1745–1823)
1759. Canvas, 75 × 62 cm.
Turville Court, Mrs C. J. Conway

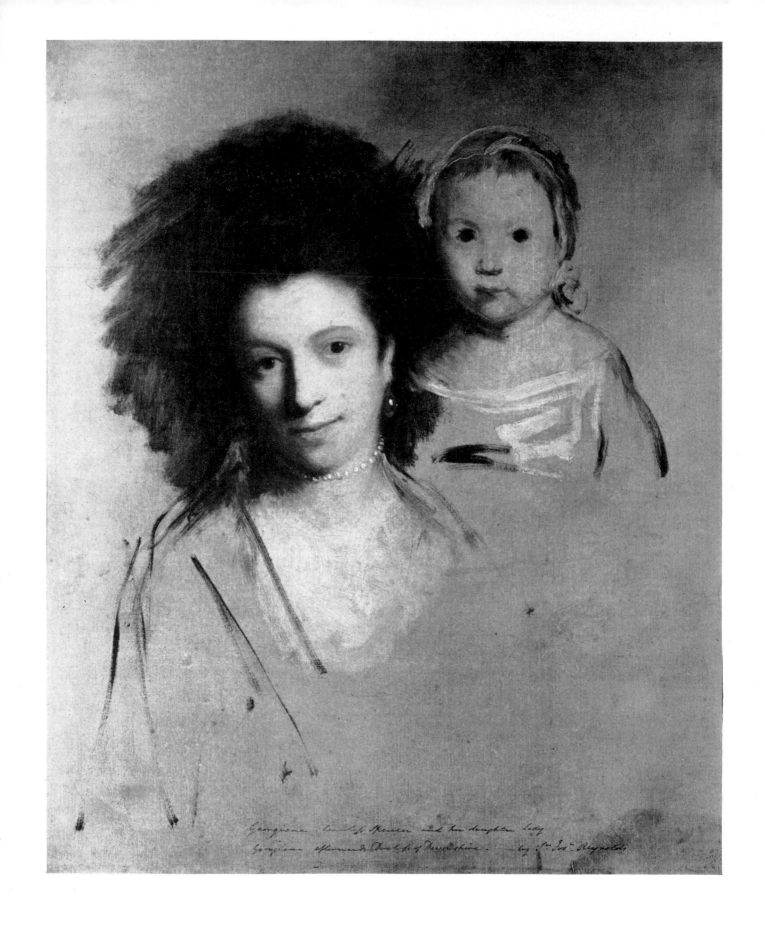

20 GEORGIANA, COUNTESS SPENCER (1737–1814), AND HER DAUGHTER
GEORGIANA (1757–1806), LATER DUCHESS OF DEVONSHIRE
1759. Canvas, 76 × 63 cm. Chatsworth, Devonshire Collection

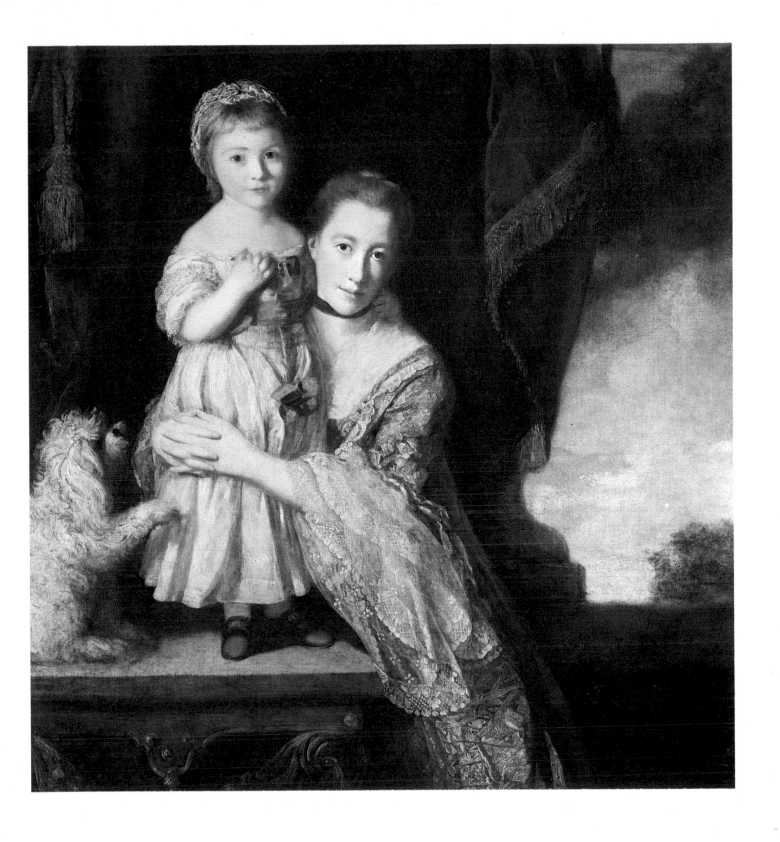

21 GEORGIANA, COUNTESS SPENCER (1737–1814), AND HER DAUGHTER
GEORGIANA (1757/1806), LATER DUCHESS OF DEVONSHIRE.
1760–1. Canvas, 122 × 115 cm. Althorp, Earl Spencer

23 (*above*) NELLY O'BRIEN (*detail of Plate 29*)

22 GEORGIANA, COUNTESS SPENCER (*detail of Plate 21*)

24 KITTY FISHER (1740?–67)
About 1766. Canvas, 73 × 61 cm.
Elton Hall, Sir Richard Proby, Bt.

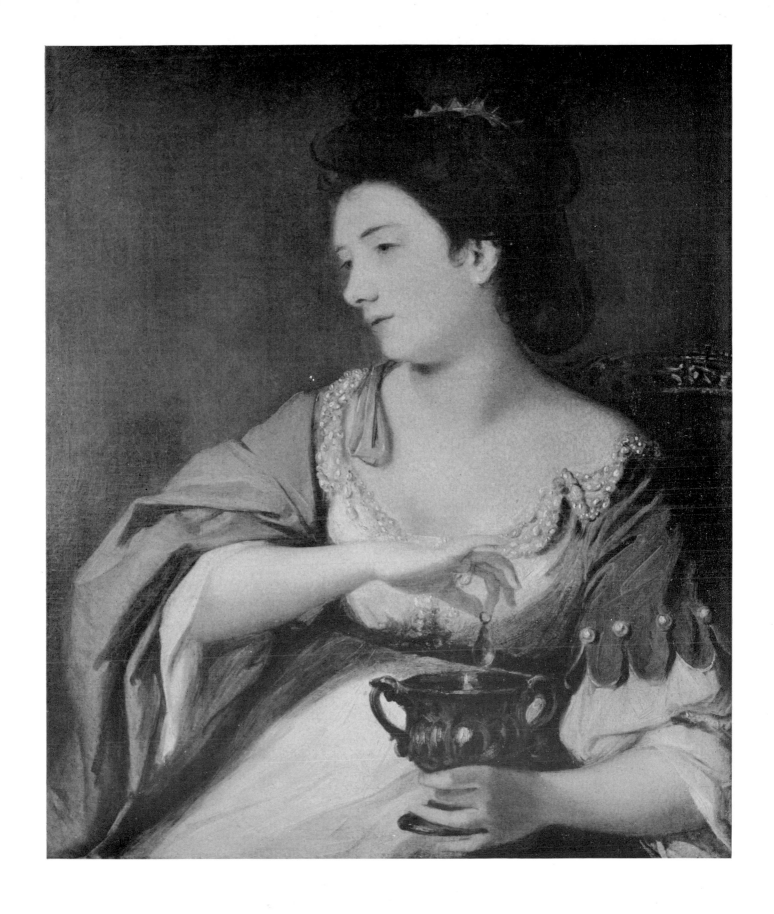

25 KITTY FISHER (1740?–67) AS CLEOPATRA
About 1759. Canvas, 76 × 63 cm.
London, Kenwood House (Iveagh Bequest)

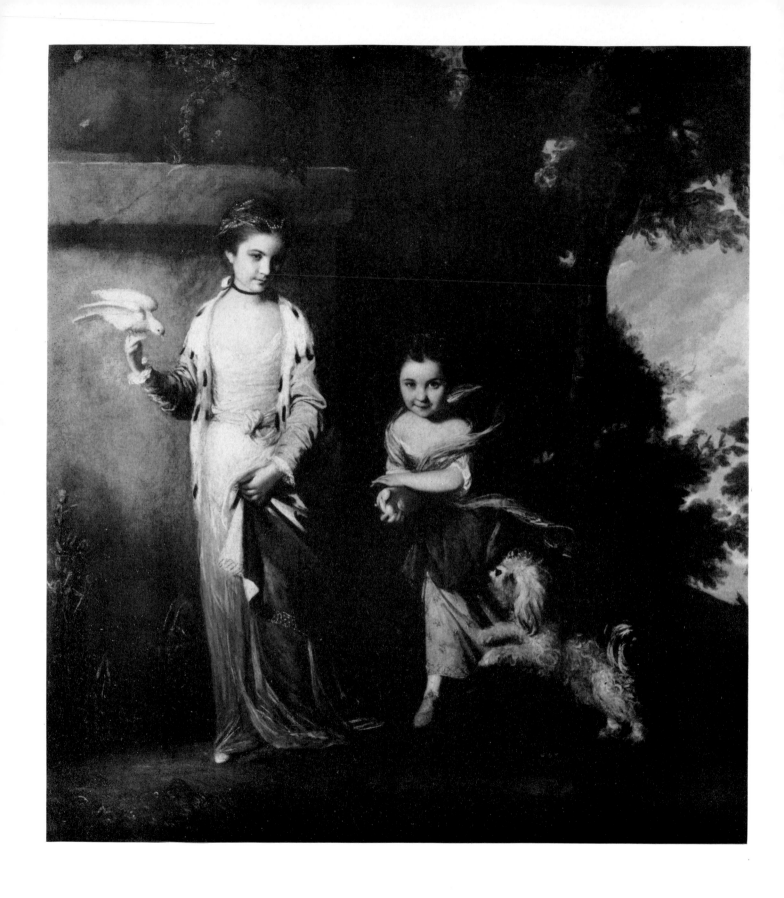

26 LADY AMABEL YORKE, LATER BARONESS LUCAS (1751–1833),
AND LADY MARY JEMIMA YORKE (1756–1830)
1760. Canvas, 195 × 170 cm.
Cleveland, Ohio, The Cleveland Museum of Art

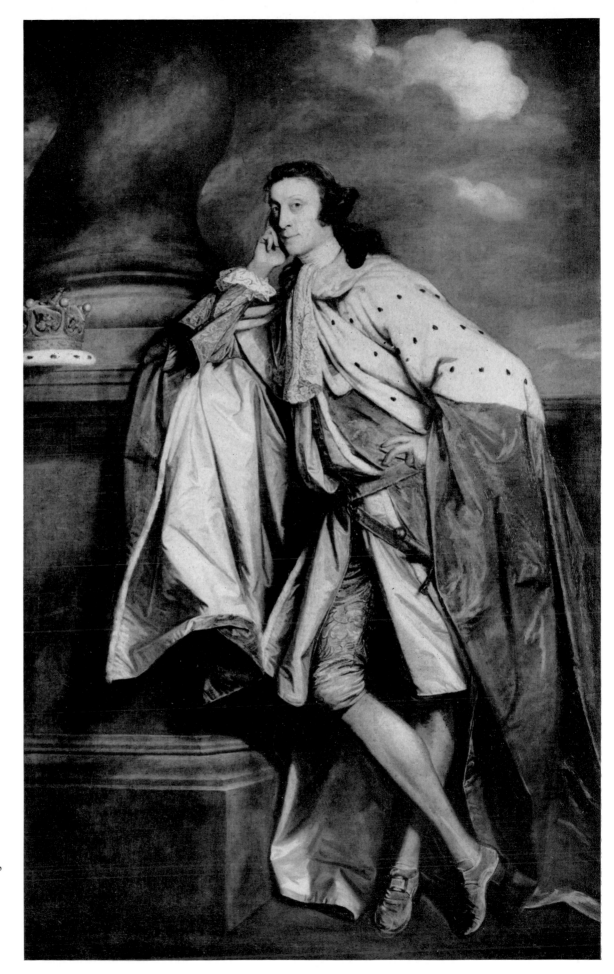

27
JAMES, 7TH
EARL OF
LAUDERDALE
(1718–89).
1759–61. Canvas,
239 × 145 cm.
Thirlestane
Castle, Heirs of
the late Countess
of Lauderdale

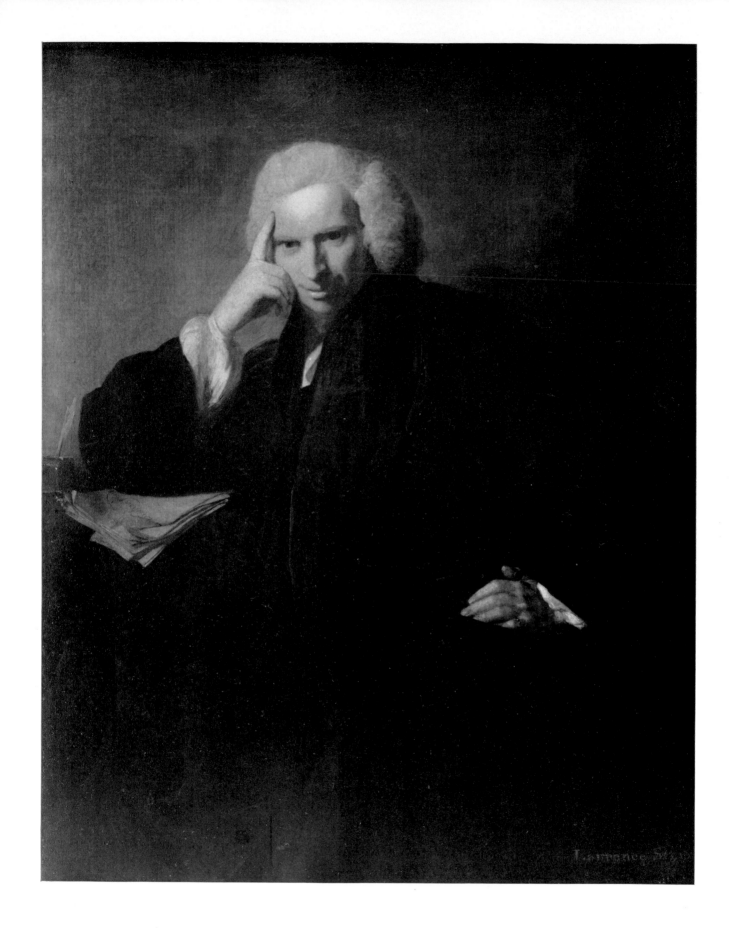

28 LAURENCE STERNE (1713–68)
 1760. Exhibited S.A. 1761 (82). Canvas, 127 × 112 cm.
 England, Private Collection

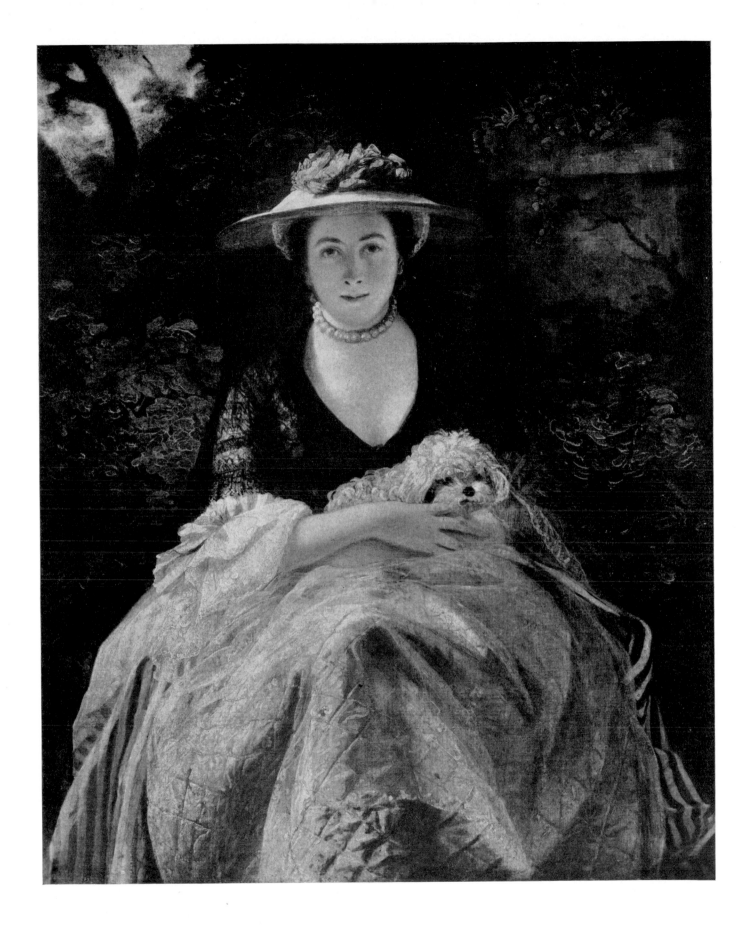

29 NELLY O'BRIEN (*d.*1768). *See detail, Plate 23.*
1760–2. Canvas, 127 × 100 cm.
London, Wallace Collection

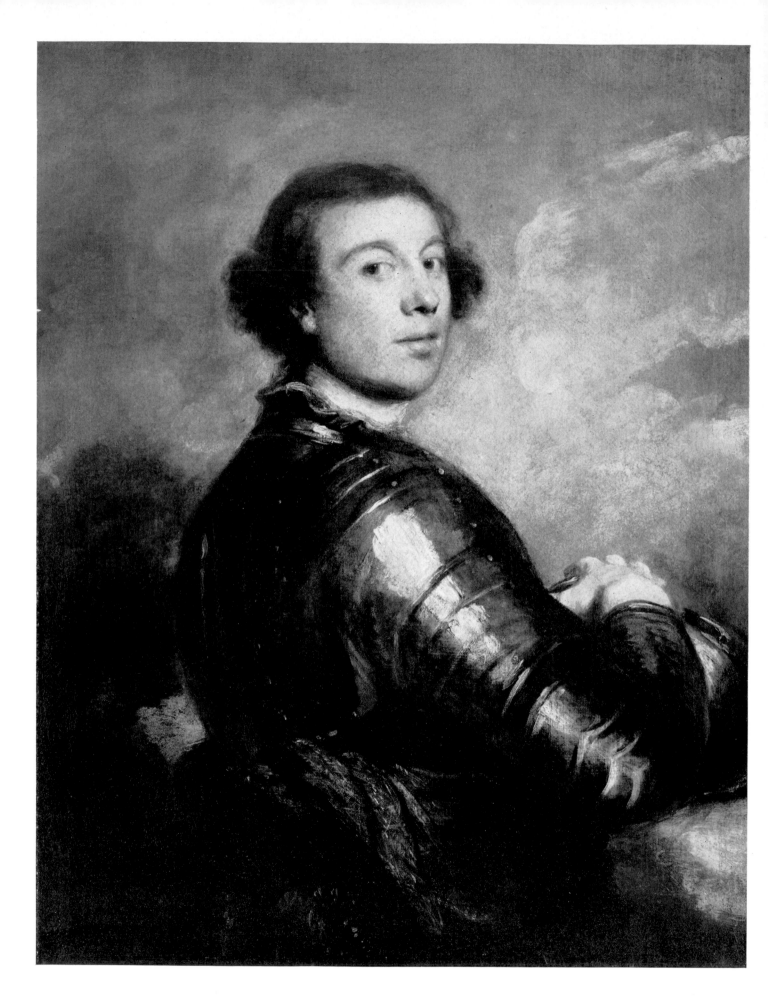

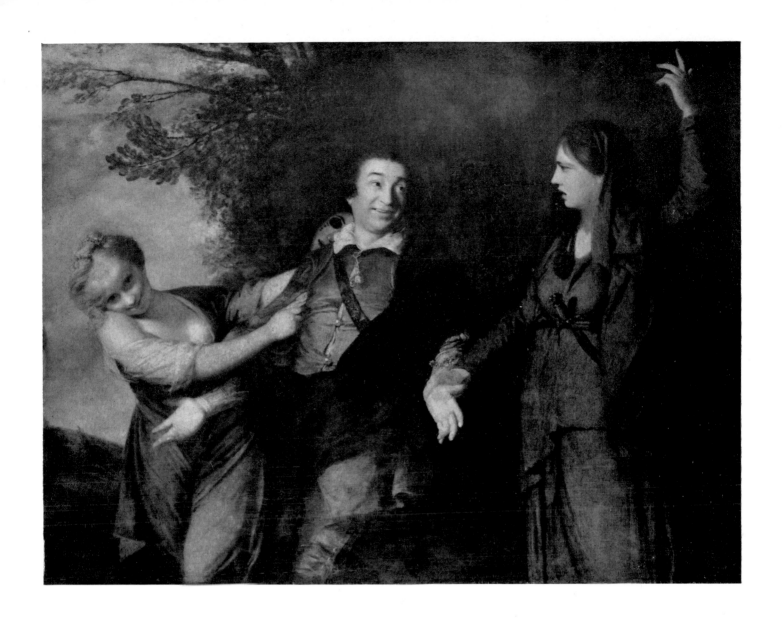

31 (*above*) GARRICK BETWEEN TRAGEDY AND COMEDY. *See detail, Plate 46.*
 Exhibited S.A. 1762 (87). Canvas, 148 × 183 cm.
 England, Private Collection

30 GENERAL CHARLES VERNON (1719–1810)
 Exhibited S.A. 1760 (50). Canvas, 90 × 70 cm.
 Ponce, Puerto Rico, Ponce Museum of Art

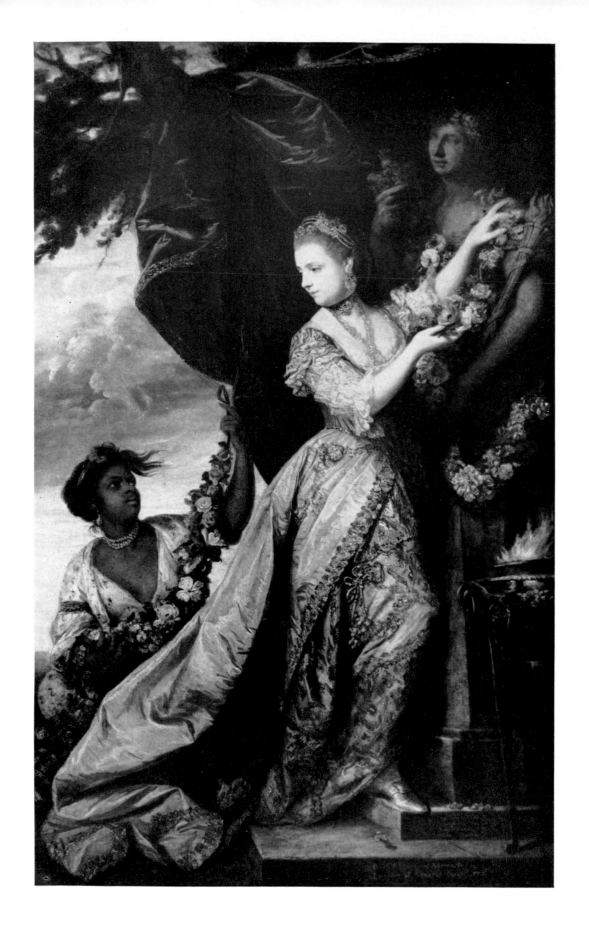

32 LADY ELIZABETH KEPPEL, MARCHIONESS OF TAVISTOCK (1739–68)
Exhibited S.A. 1762 (88). Canvas, 256 × 146 cm.
Woburn Abbey Collection

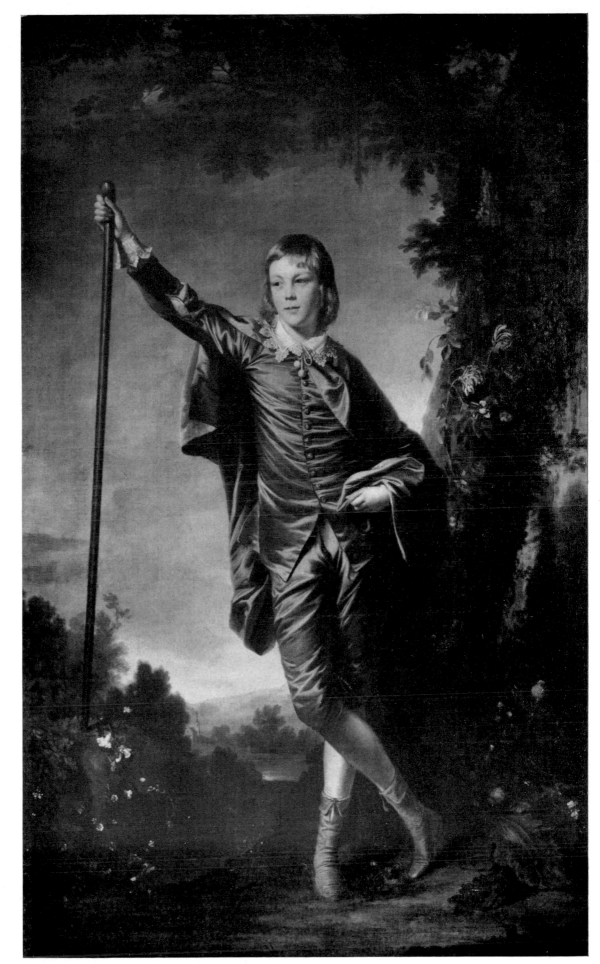

33
MASTER
THOMAS
LISTER, LATER
1ST LORD
RIBBLESDALE
(1752–1826)
'*The Brown
Boy*'. *1764.
Canvas,
231 × 139 cm.
Swinton Park,
Countess of
Swinton*

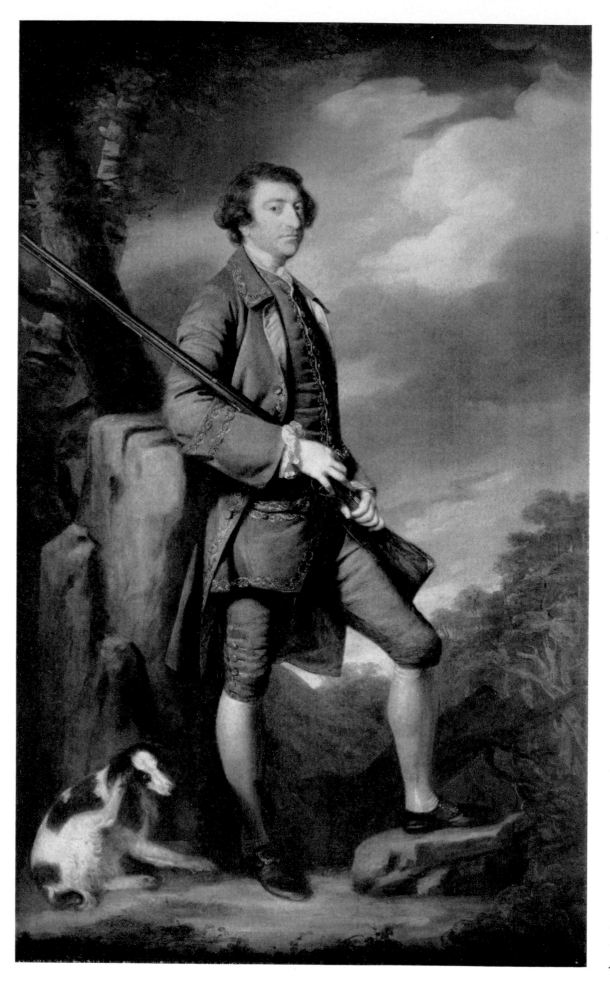

34
PHILIP GELL
(1723–95)
1763. Canvas,
231 × 138 cm.
Newnham
Hall, Lt.-Col.
J. Chandos-Pole

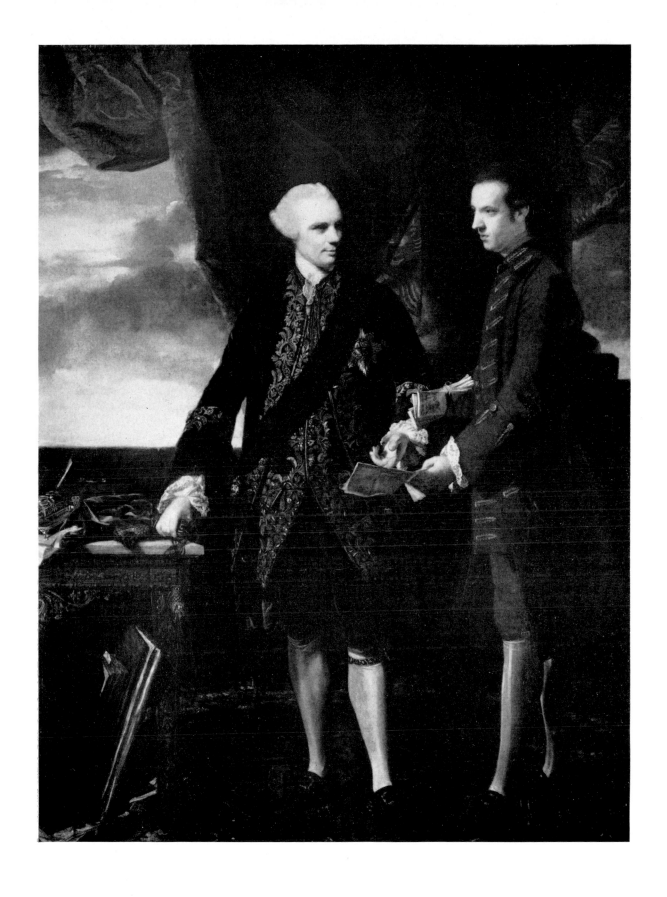

35 JOHN, 3RD EARL OF BUTE (1713–92), AND HIS SECRETARY,
CHARLES JENKINSON (1729–1808), LATER EARL OF LIVERPOOL
1763. Canvas, 244 × 211 cm.
Dumfries House, Marquess of Bute

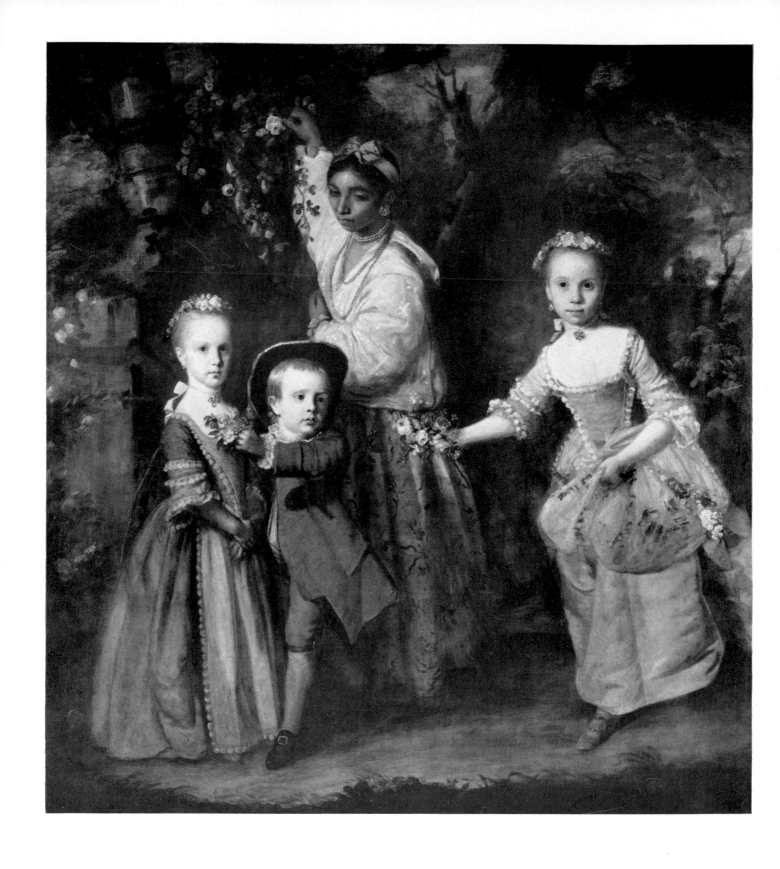

36 THE CHILDREN OF EDWARD HOLDEN CRUTTENDEN
1759 (or later). Canvas, 180 × 172 cm.
São Paulo (Brazil), Museum of Art

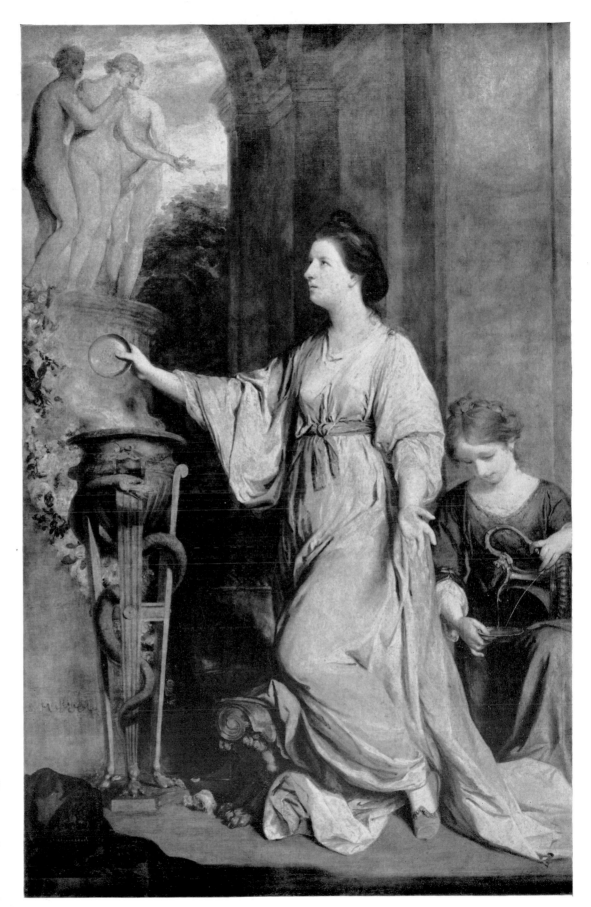

37
LADY SARAH
BUNBURY (1745–
1826) SACRIFICING
TO THE GRACES
Exhibited S.A.
1765 (104). Canvas,
239 × 152 cm.
Chicago, The Art
Institute of Chicago

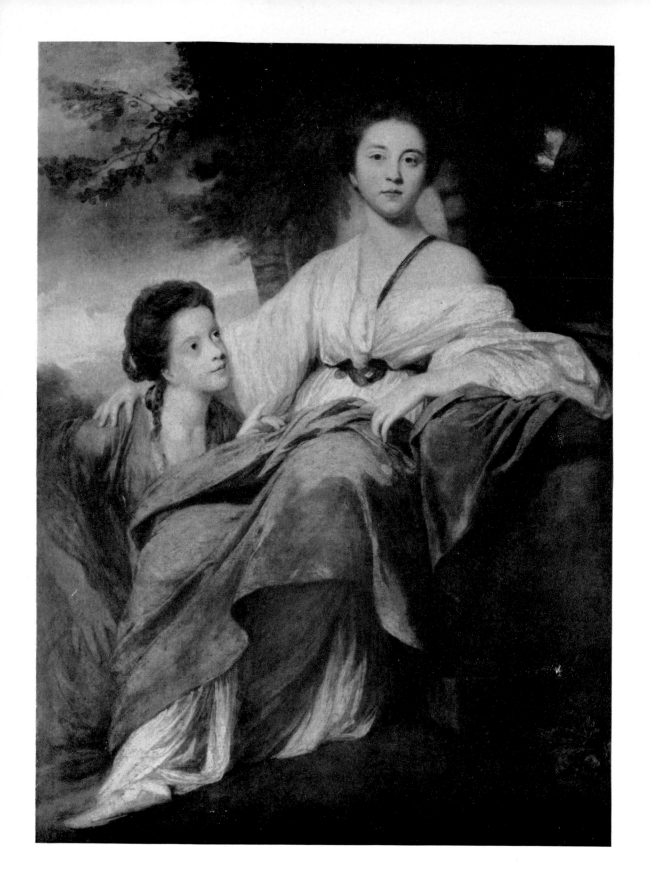

38 THE LADIES ELIZABETH (1743–1827) AND HENRIETTA (1750–66) MONTAGU
Exhibited S.A. 1763 (96). Canvas, 152 × 112 cm.
Bowhill, Duke of Buccleuch

39 WARREN HASTINGS (detail of Plate 40)

40 WARREN HASTINGS (1732–1818). *See detail, Plate 39.*
1766–8. Canvas, 125 × 100 cm.
London, National Portrait Gallery

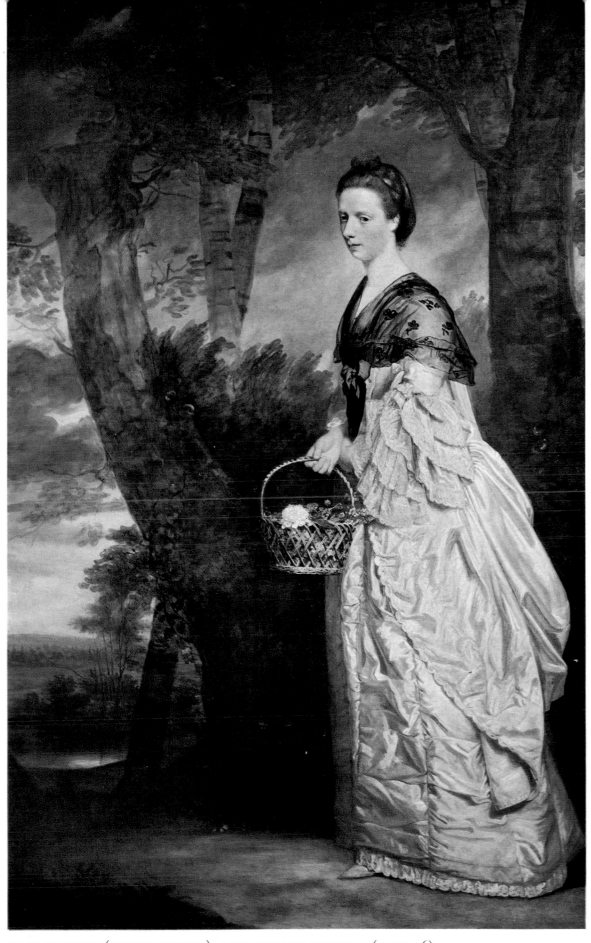

41 ELIZABETH (WIDDRINGTON), MRS THOMAS RIDDELL (1730–96)
1763. Canvas, 239 × 152 cm.
Newcastle upon Tyne, Laing Art Gallery and Museum

42 MARY (BRUCE), DUCHESS OF RICHMOND (1740–96)
1765–7. Canvas, 76 × 63 cm.
Goodwood House

43 GEORGE AUGUSTUS SELWYN (1719–91)
1764–5. Canvas, 99 × 76 cm.
Dalmeny House, Lord Primrose

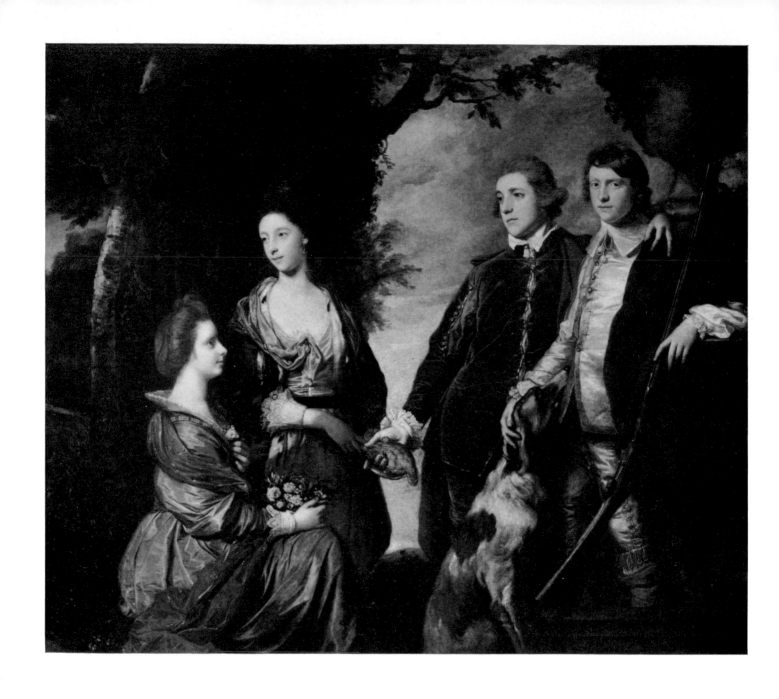

44 FOUR CHILDREN OF THE 2ND VISCOUNT GRIMSTON
1767–9. Canvas, 214 × 241 cm.
Gorhambury, Earl of Verulam

45 THE HON. MRS EDWARD BOUVERIE (1750–1825) AND MRS CREWE (1744–1818)
'*Et in Arcadia Ego.*' Exhibited R.A. *1769 (91).*
Canvas, 100 × 127 cm. Private Collection

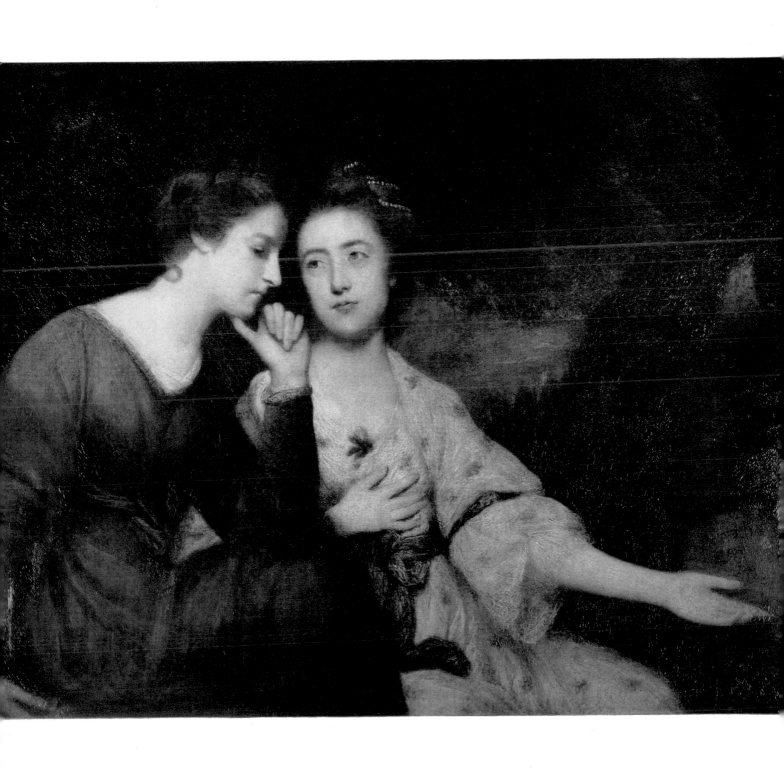

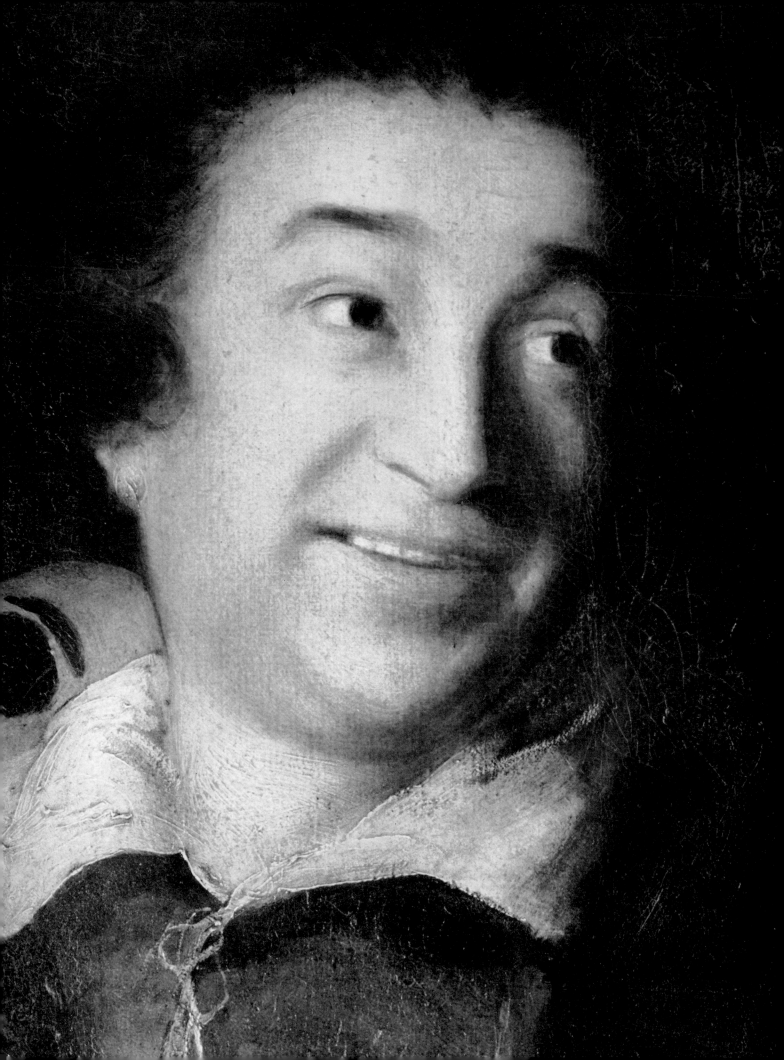

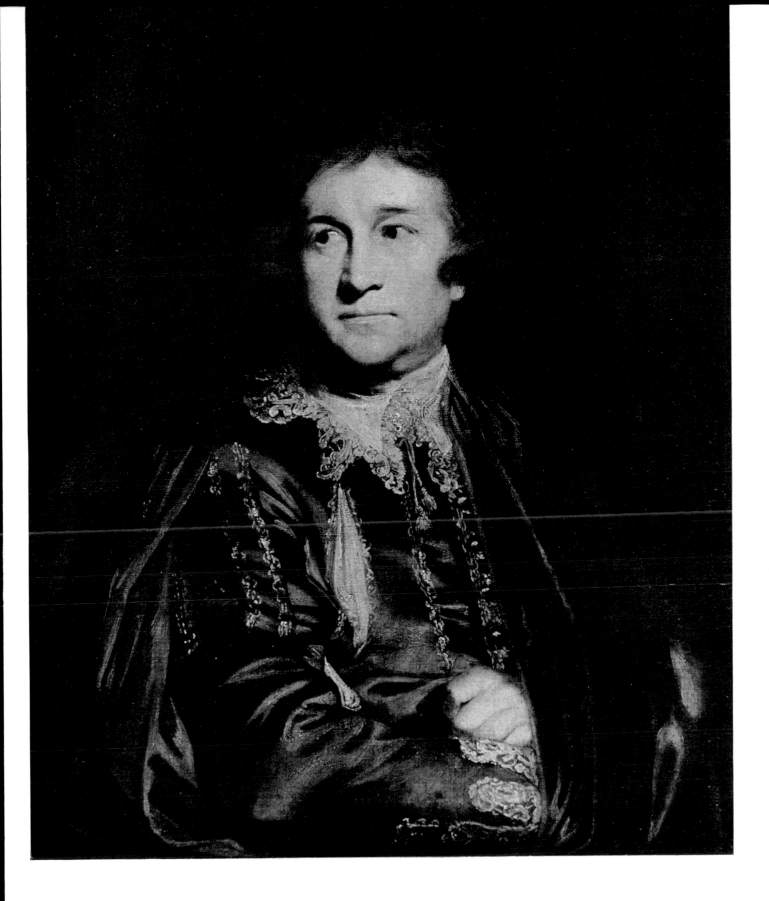

47 (*above*) DAVID GARRICK (1717–79) AS 'KITELEY'
1768. Canvas, 74 × 63 cm.
Royal Collection

46 DAVID GARRICK (*detail of Plate 31*)

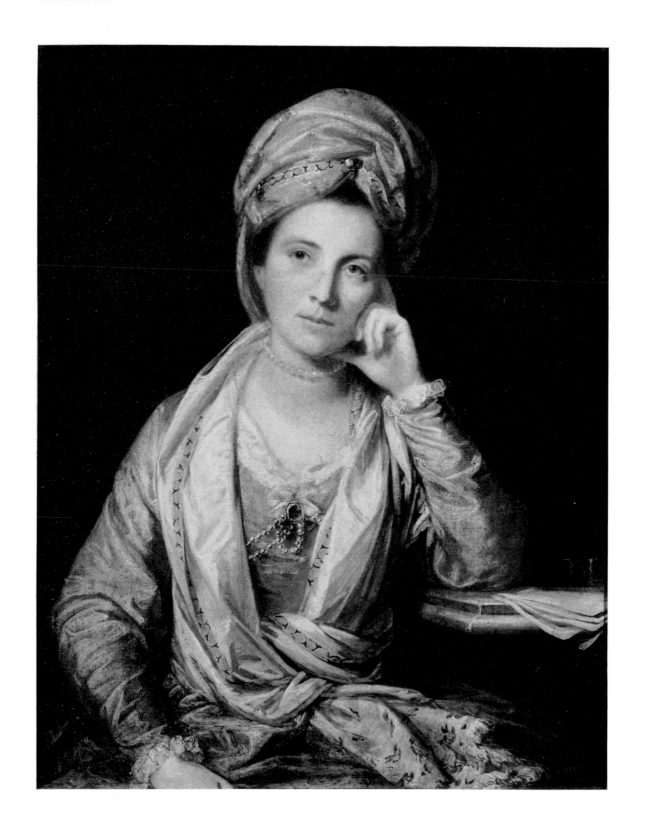

48 NANCY (PARSONS), MRS HORTON, LATER VISCOUNTESS MAYNARD (d.1814/15)
1767–9. Canvas, 125 × 99 cm.
New York, The Metropolitan Museum of Art

49 CAROLINE, DUCHESS OF MARLBOROUGH (1743–1811),
AND LADY CAROLINE SPENCER (1763–1813)
1764–5. Canvas, 127 × 101 cm.
Blenheim Palace, Duke of Marlborough

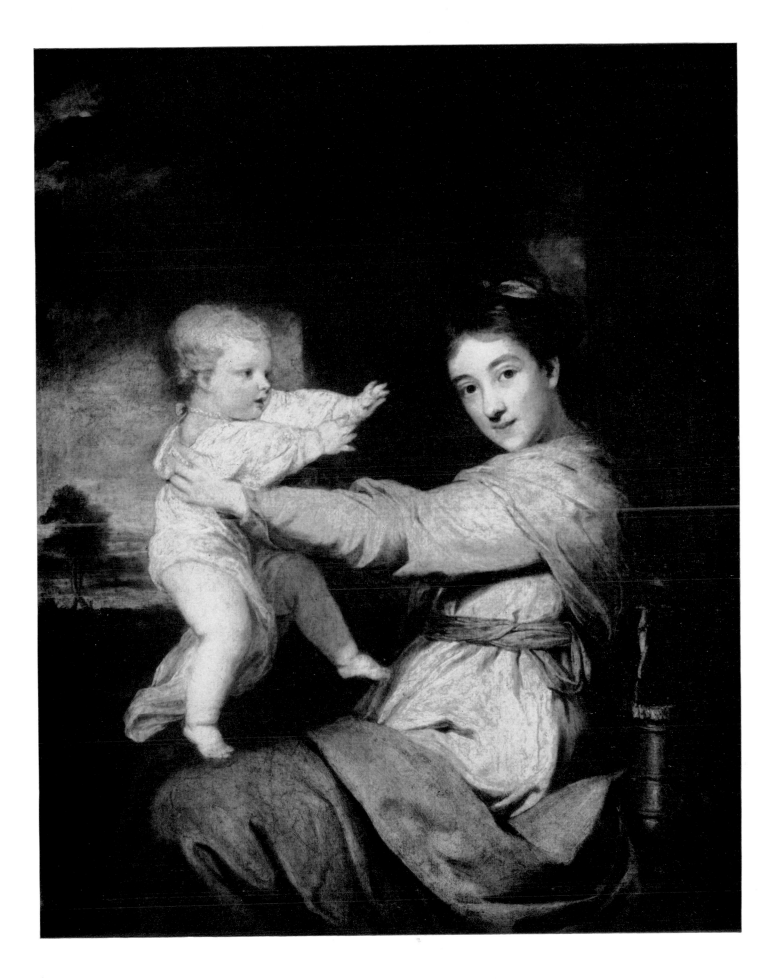

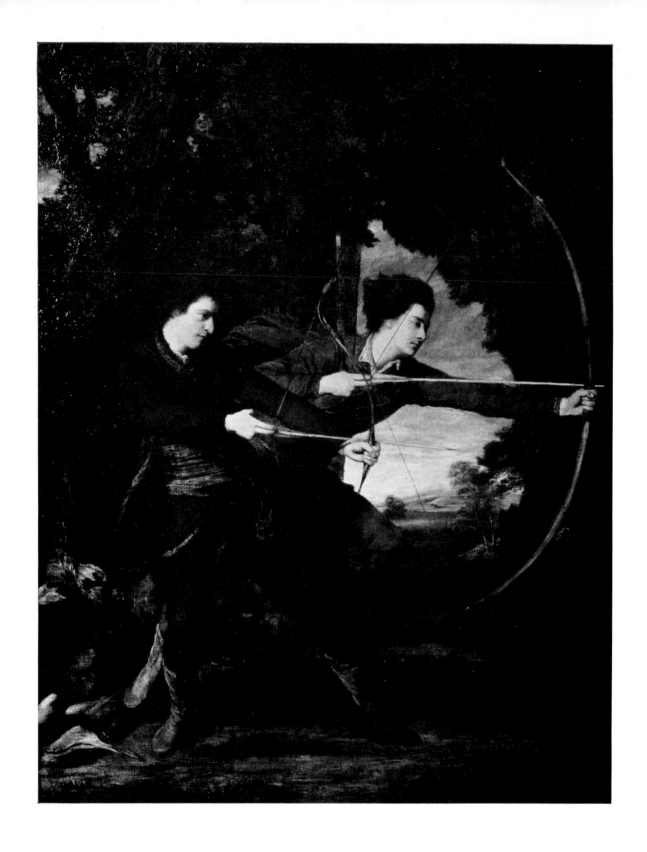

50, 51 COLONEL JOHN DYKE ACLAND (1746–78) AND THOMAS, VISCOUNT SYDNEY
(1733–1800), SHOOTING RED DEER. '*The Archers.*'
Exhibited R.A. 1770 (145). Canvas, 236 × 180 cm.
Tetton House, E.A.M.H.M. Herbert

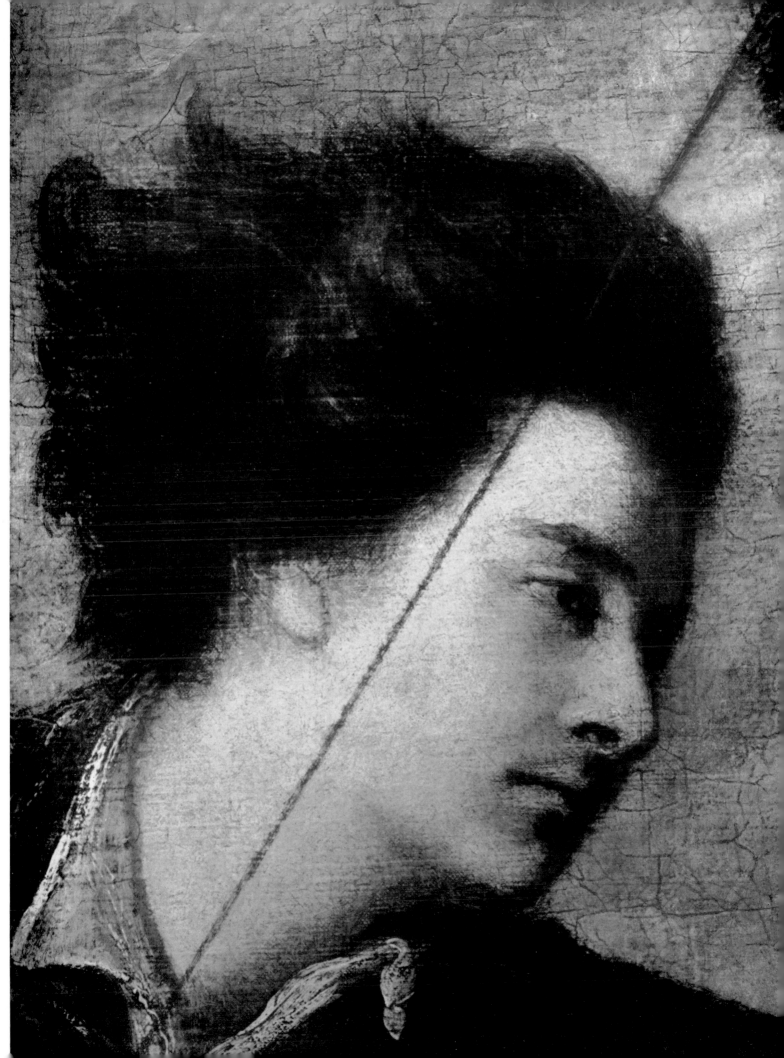

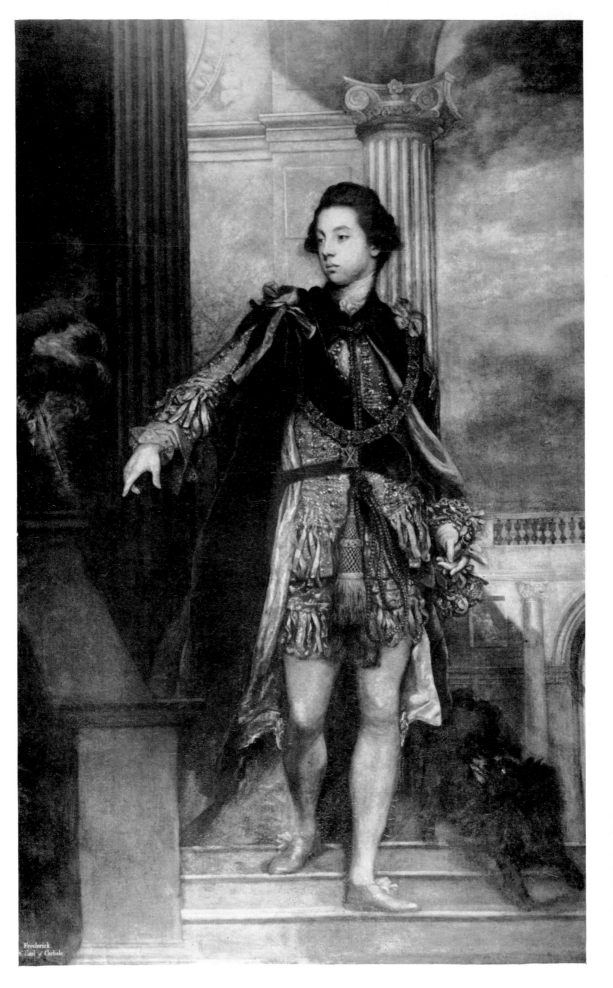

52
FREDERICK,
5TH EARL OF
CARLISLE, K.T.
(1748–1825)
*1769. Canvas,
236 × 146 cm.
Castle Howard,
George Howard*

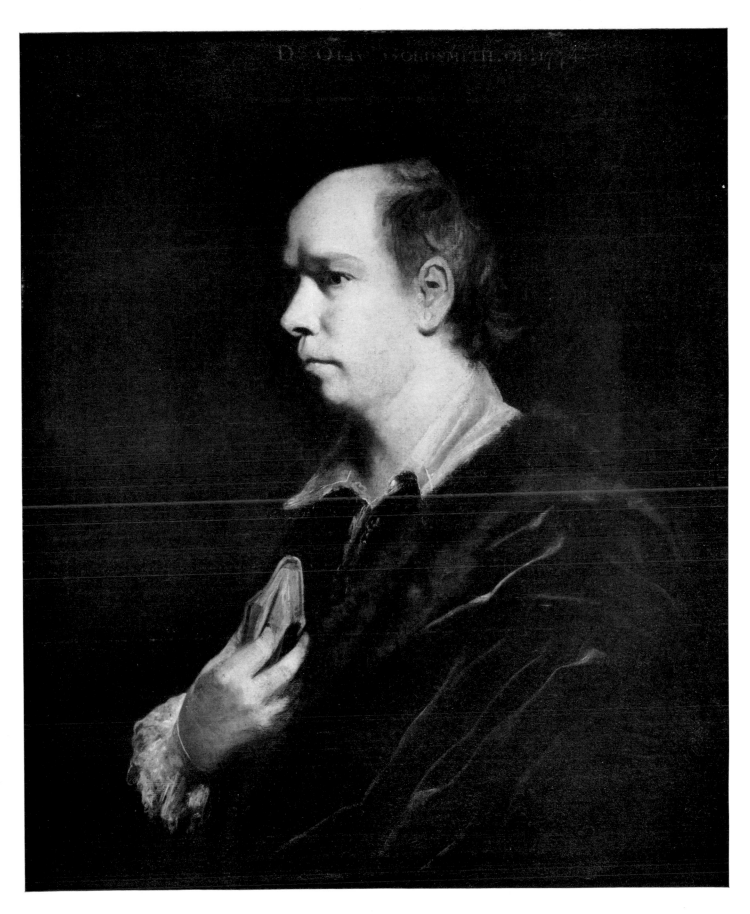

53 OLIVER GOLDSMITH (1728–74)
Exhibited R.A. 1770 (151). Canvas, 76 × 63 cm.
Knole, Lord Sackville

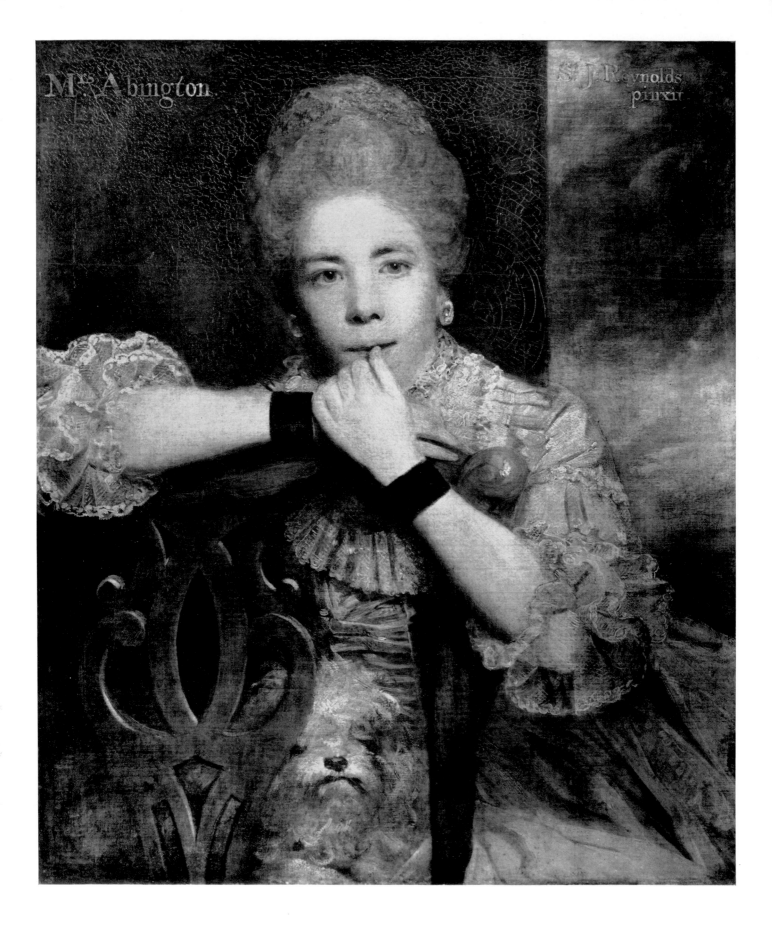

54 MRS ABINGTON (1737–1815) AS MISS PRUE IN 'LOVE FOR LOVE'
Exhibited R.A. 1771 (161). Canvas, 74 × 62 cm.
Mr and Mrs Paul Mellon

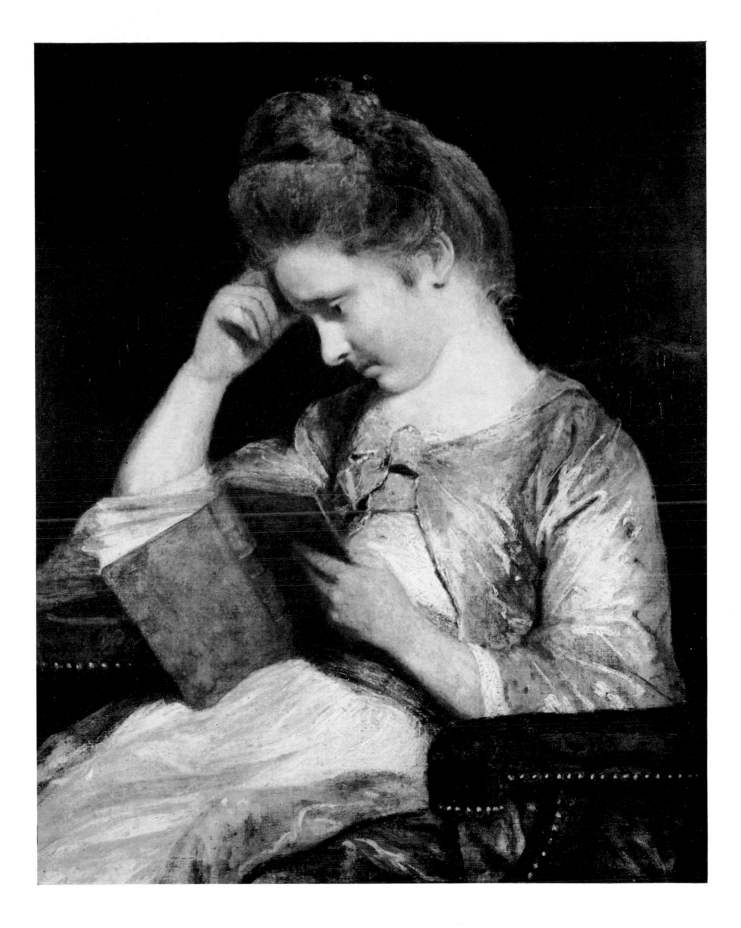

55 MISS THEOPHILA ('OFFIE') PALMER READING 'CLARISSA HARLOWE'
Reynolds's niece. Exhibited R.A. 1771 (158)
Canvas, 74 × 62 cm. Messing Park, Lord Hillingdon

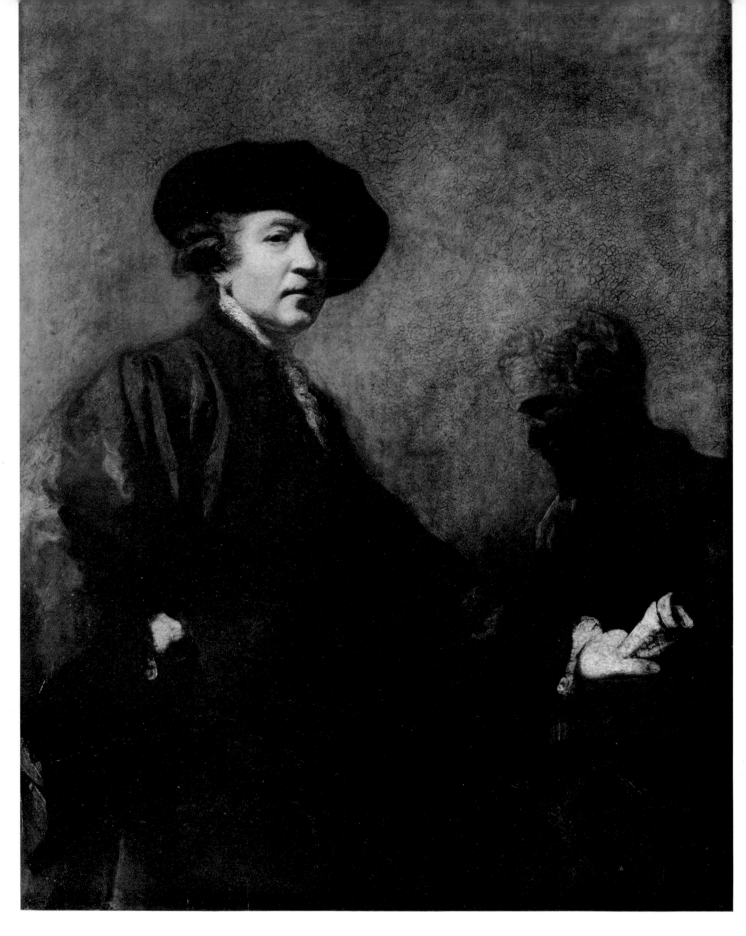

56 SELF-PORTRAIT AS D.C.L.
1773? Panel, 127 × 101 cm.
London, Royal Academy of Arts

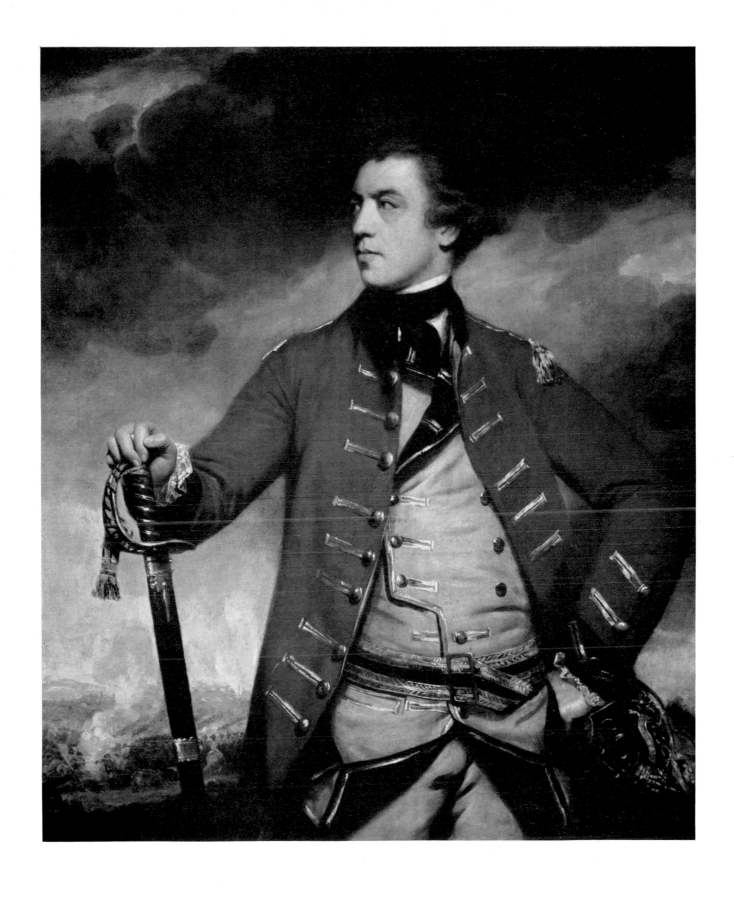

57 GENERAL JOHN BURGOYNE (1722–92)
1766. Canvas, 127 × 101 cm.
New York, The Frick Collection

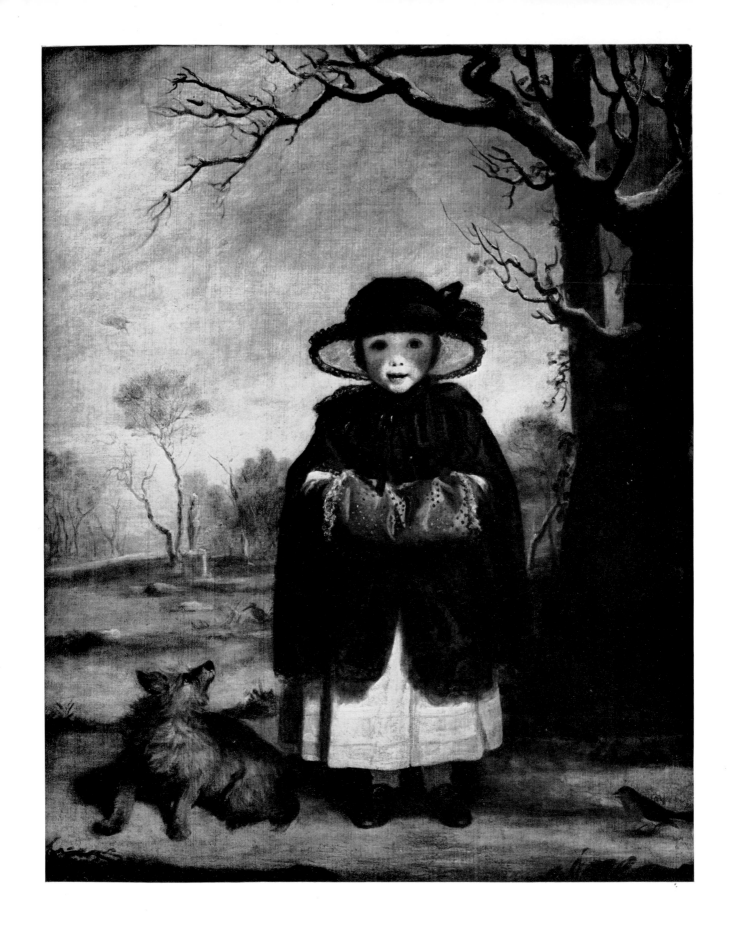

58 LADY CAROLINE SCOTT (1774–1854)
Exhibited R.A. 1777 (288). Canvas, 141 × 112 cm.
Bowhill, Duke of Buccleuch

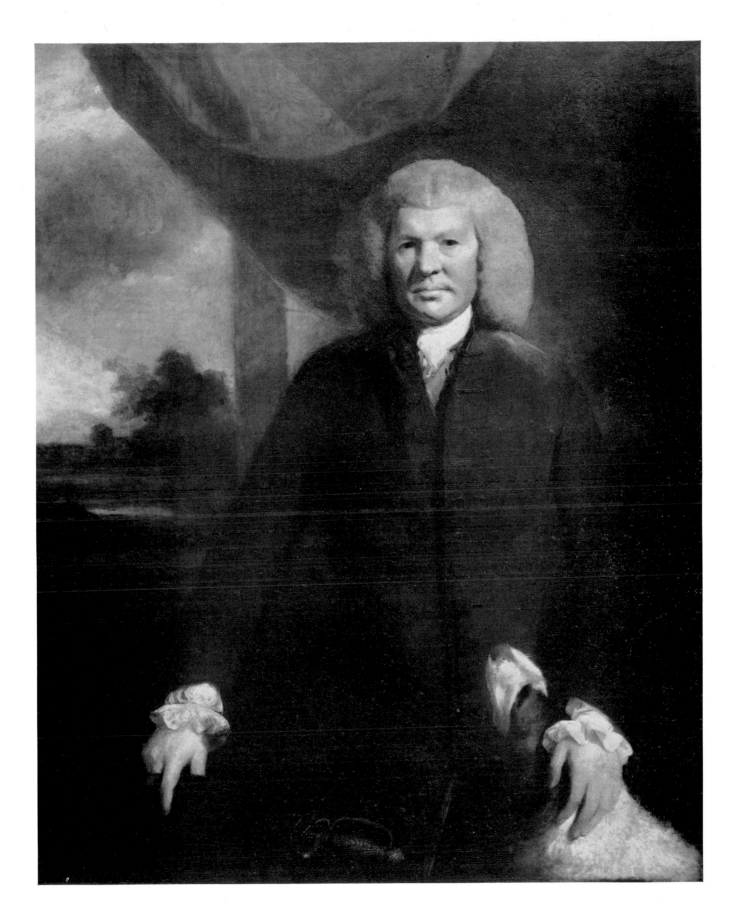

59 JAMES CALTHORPE
Exhibited R.A. 1773 (240). Panel, 127 × 101 cm.
Elvetham, Sir Richard Anstruther-Gough-Calthorpe, Bt.

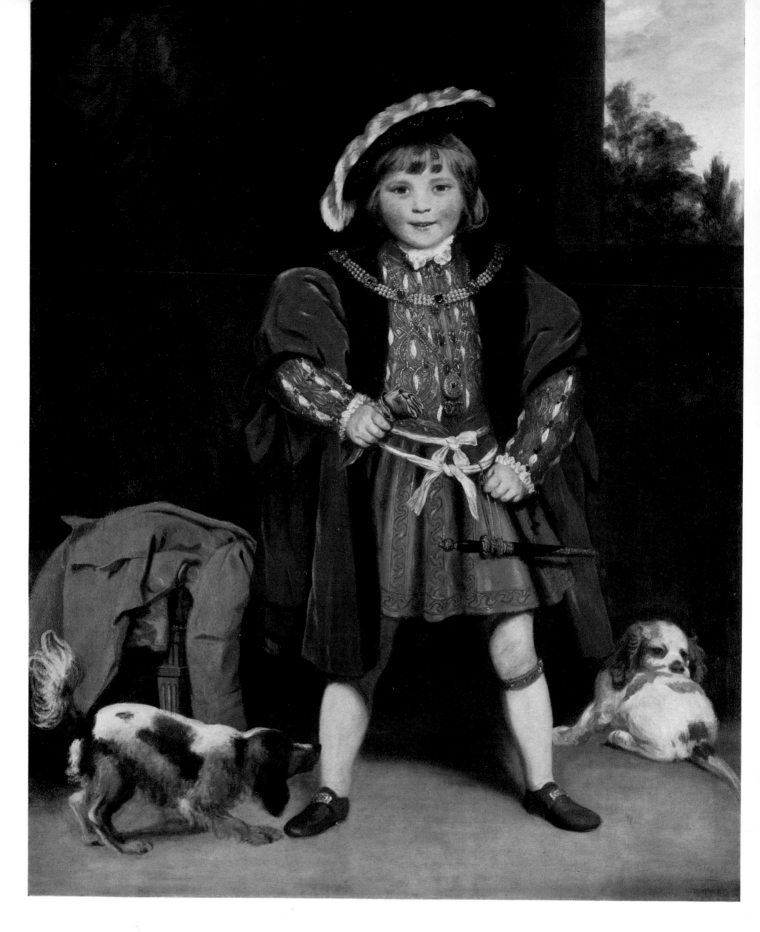

60 MASTER CREWE (1772–1835) AS HENRY VIII
Exhibited R.A. 1776 (239). Canvas, 137 × 112 cm.
Private Collection

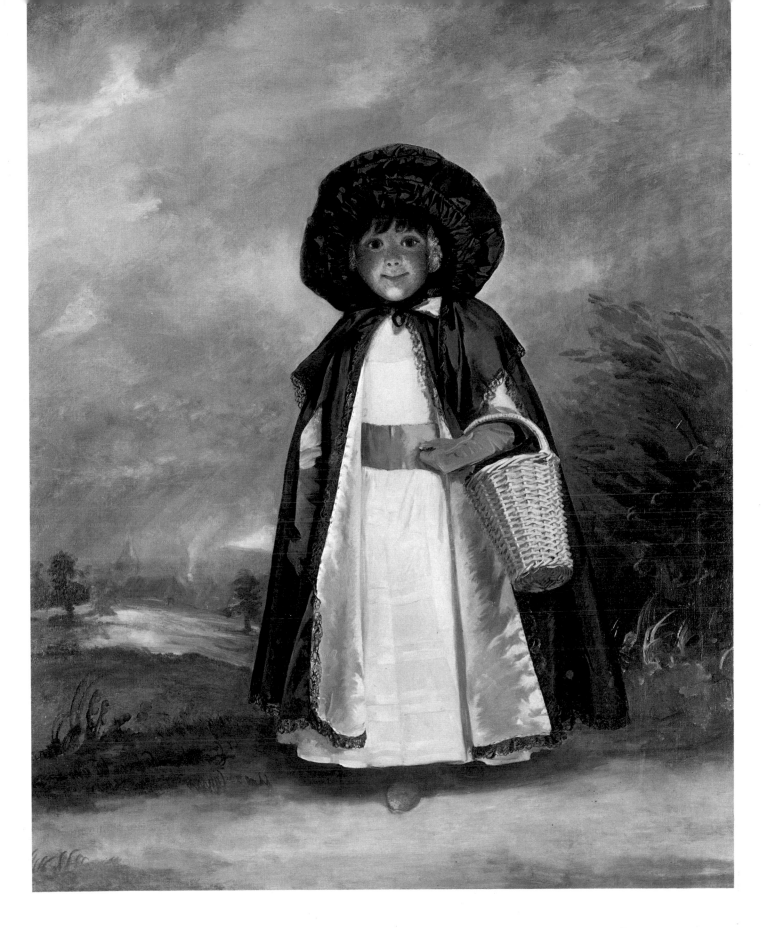

61 MISS FRANCES CREWE (1767–75?)
1775. Canvas, 137 × 112 cm.
Private Collection

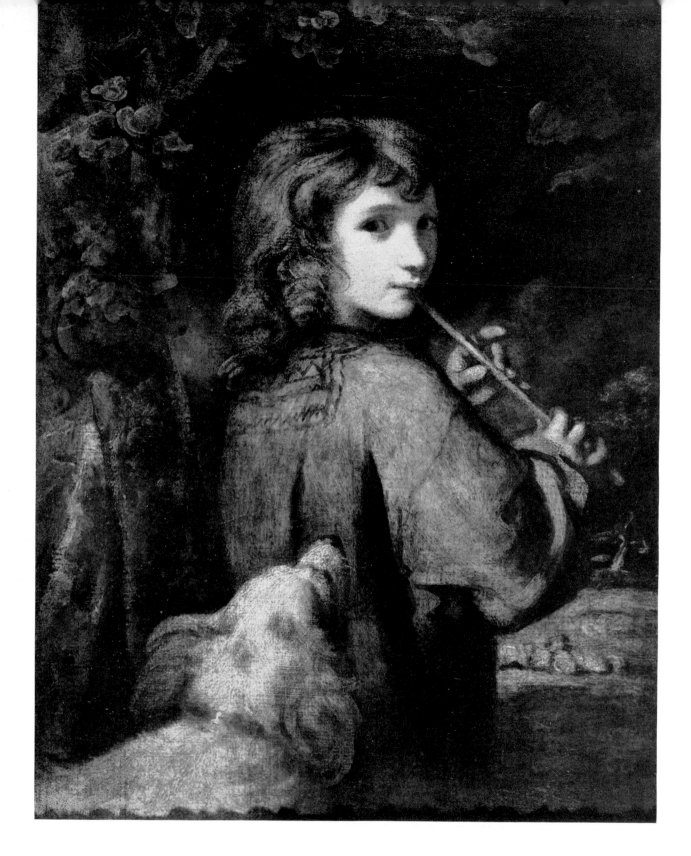

62 THE PIPING SHEPHERD BOY
1773. Canvas, 74 × 63 cm.
Antony House, Sir John Carew Pole, Bt.

63 THE STRAWBERRY GIRL
Exhibited R.A. 1773 (242). Canvas, 74 × 63 cm.
London, The Wallace Collection

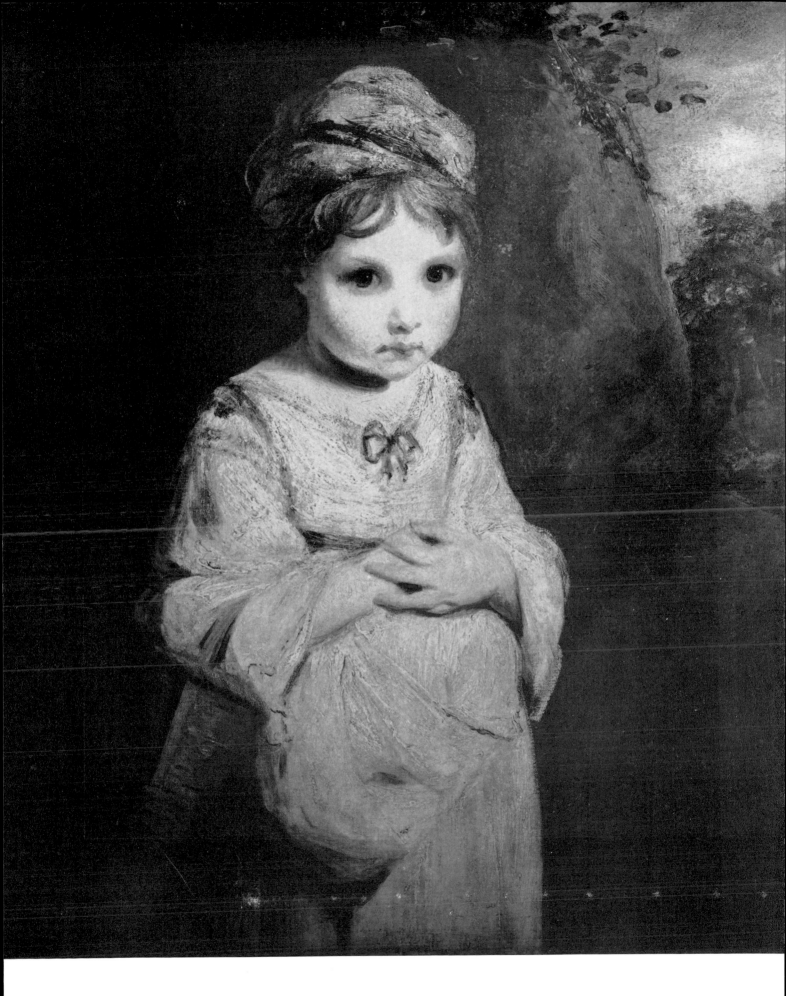

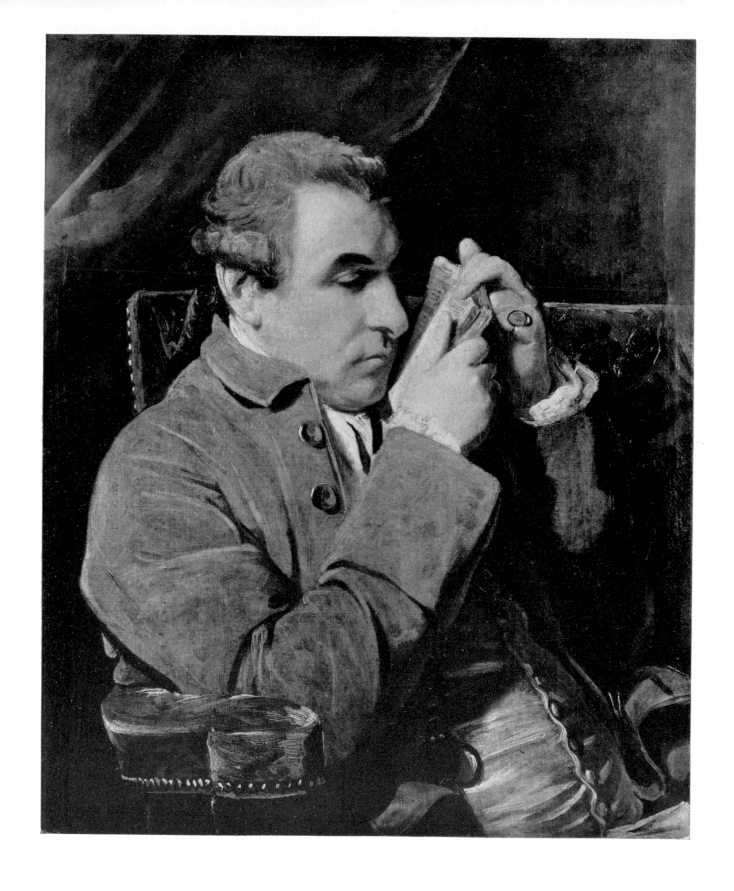

64 GIUSEPPE BARETTI (1719–89)
Exhibited R.A. 1774 (223). Canvas, 74 × 62 cm.
London, Lady Teresa Agnew

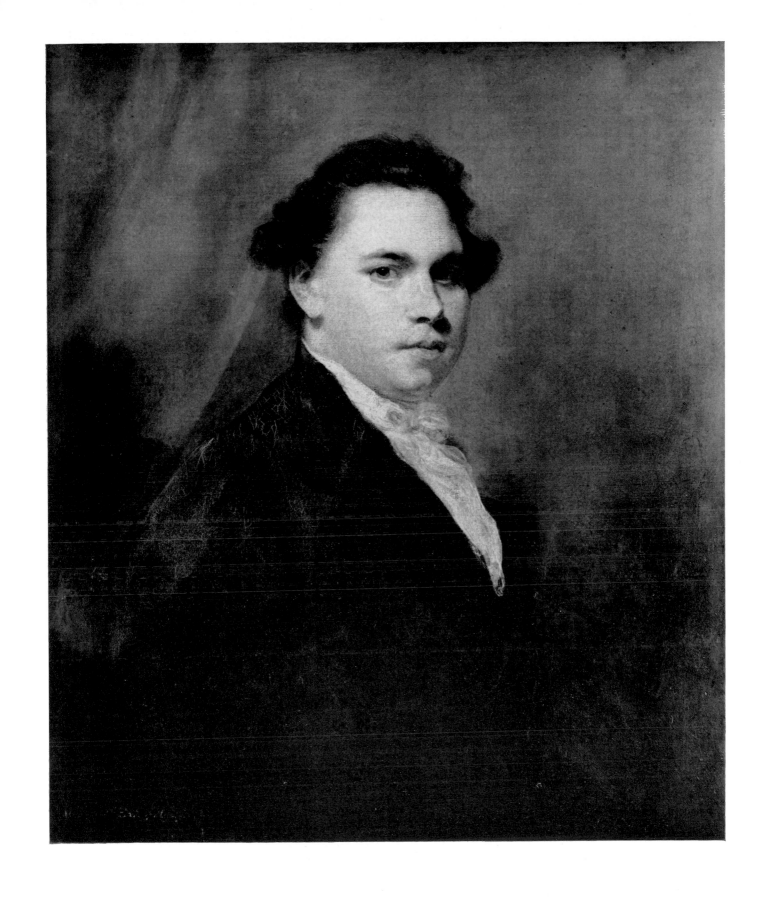

65 HENEAGE, LORD GUERNSEY, LATER 4TH EARL OF AYLESFORD (1751–1812)
1776. Canvas, 74 × 63 cm.
England, Private Collection

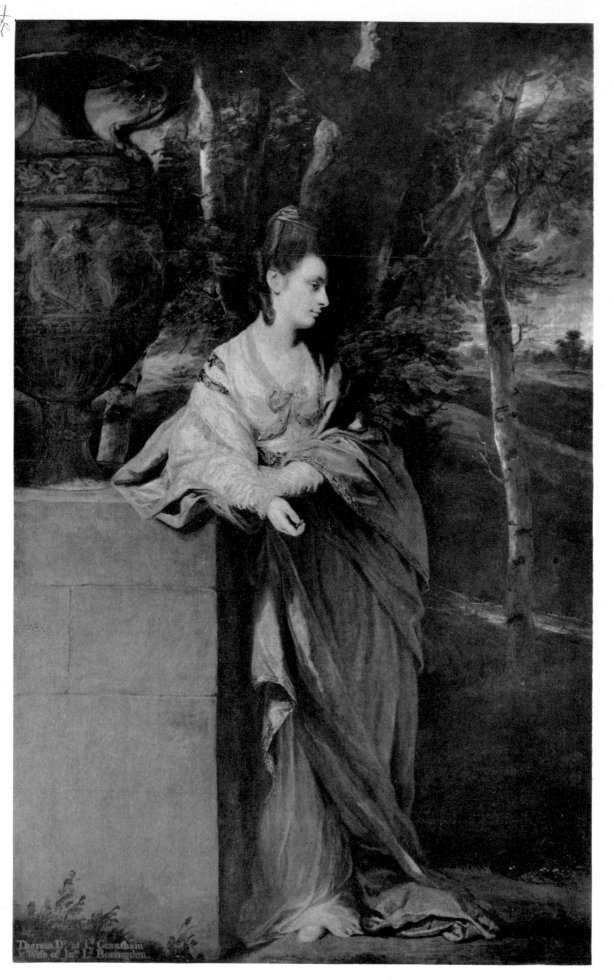

66
THE HON.
MRS THERESA
PARKER (1744–
75). *Exhibited
R.A. 1773
(382). Canvas,
236 × 142 cm.
Saltram, The
National Trust*

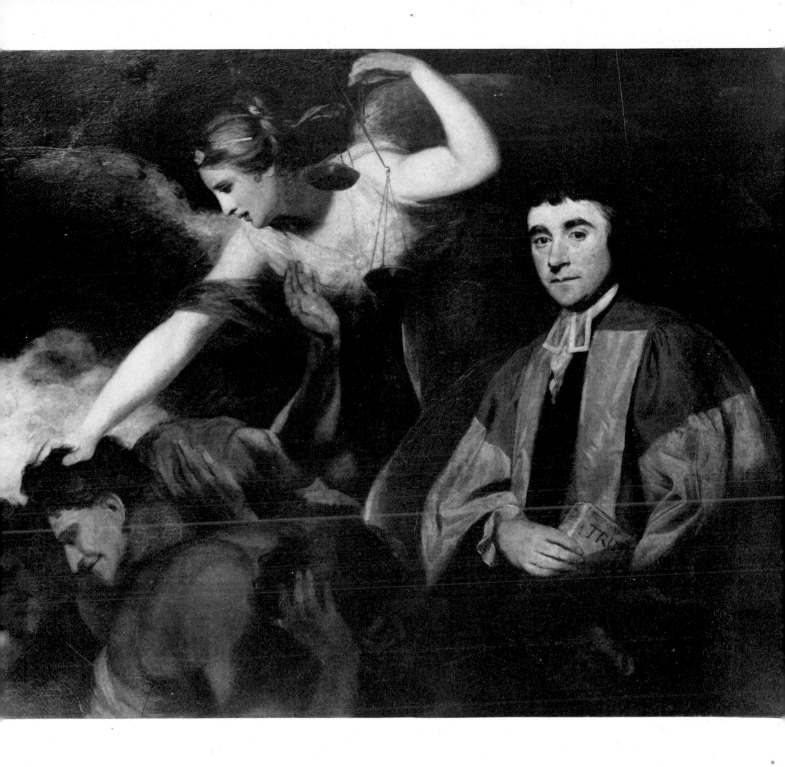

67 DR JAMES BEATTIE (1735–1803). *'The Triumph of Truth.'*
Exhibited R.A. 1774 (221). Canvas, 117 × 142 cm.
Aberdeen University, Marischal College

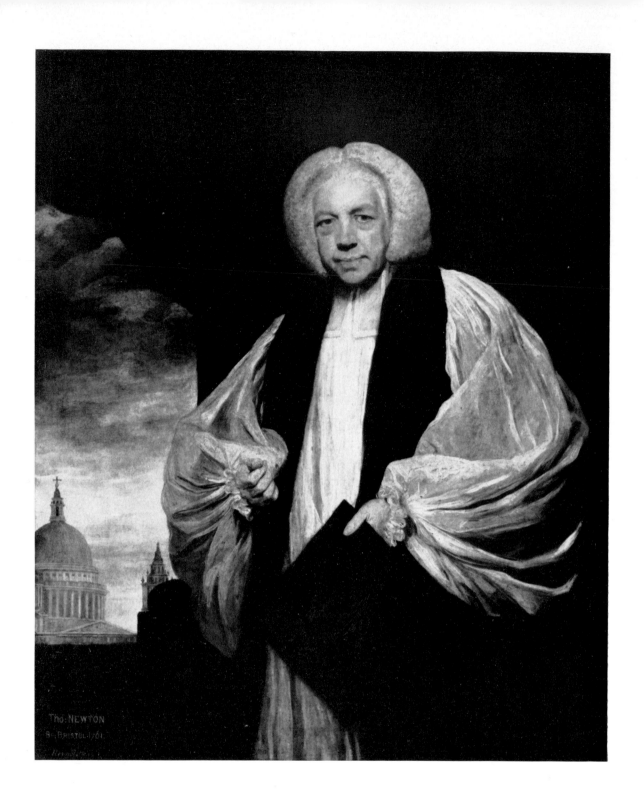

68, 69 DR THOMAS NEWTON, BISHOP OF BRISTOL (1704–82)
Exhibited R.A. 1774 (220). Canvas, 127 × 102 cm.*
London, Lambeth Palace

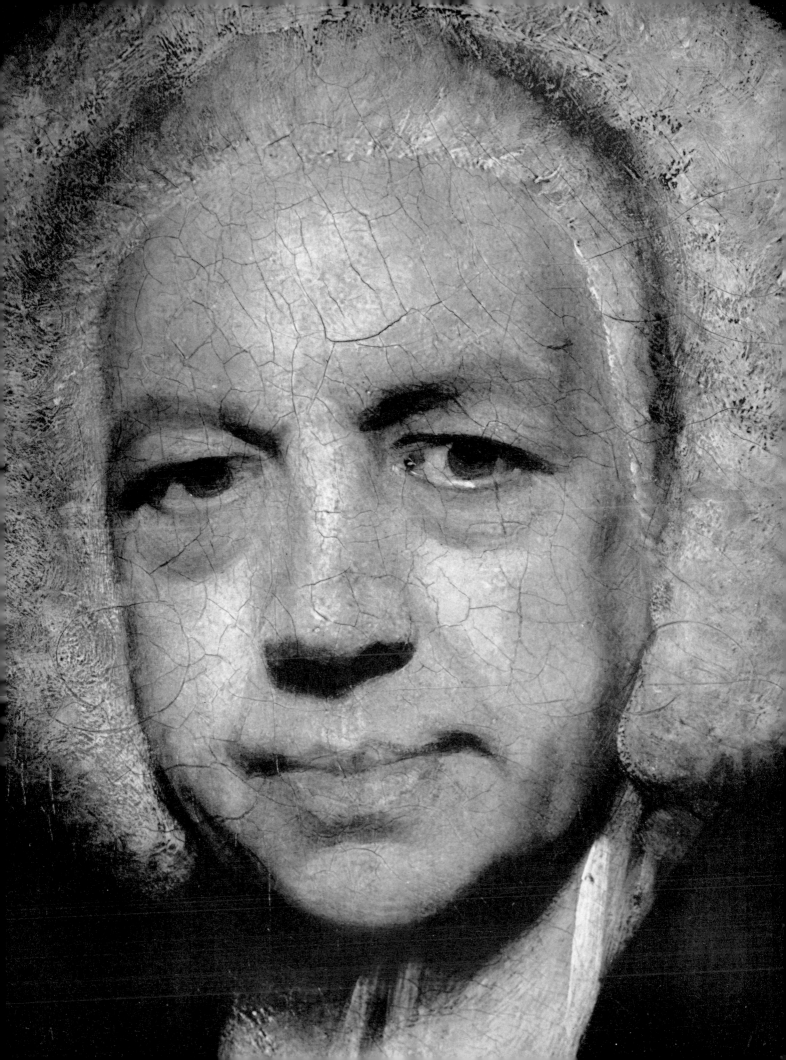

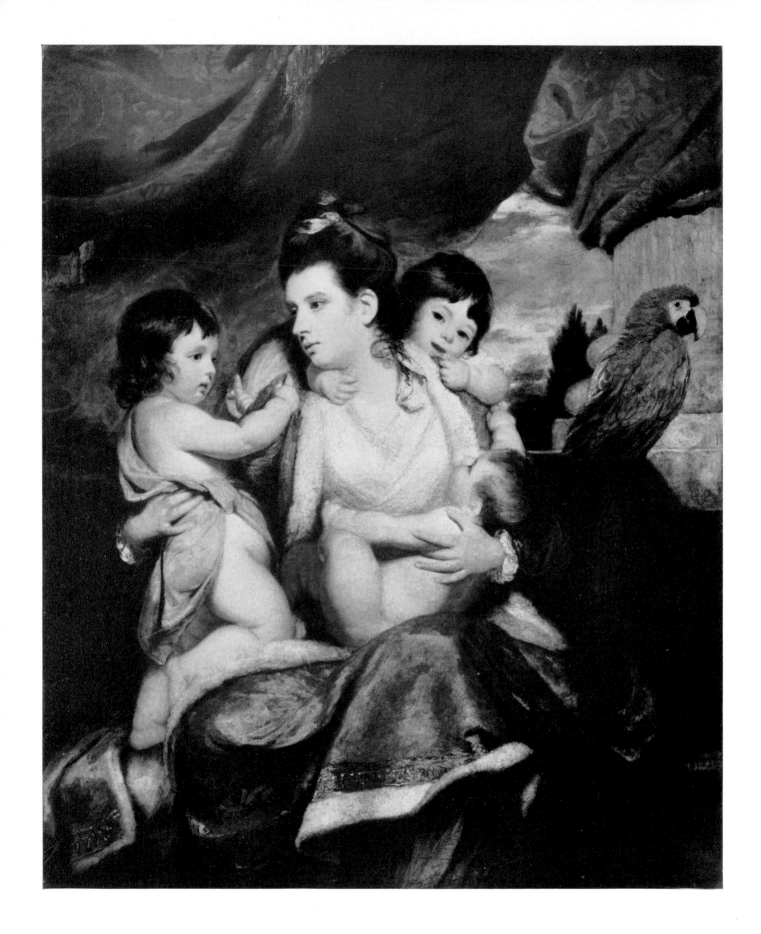

70 LADY COCKBURN (1749–1837), AND HER THREE ELDEST SONS
Exhibited R.A. 1774 (220). Canvas, 142 × 113 cm.
London, National Gallery

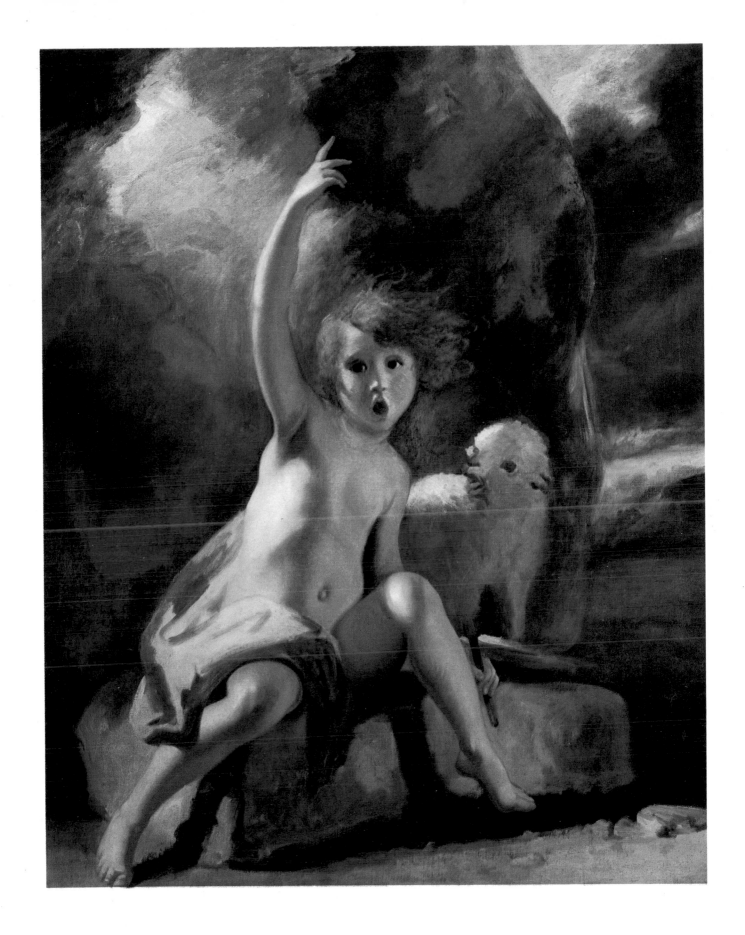

71 ST JOHN
About 1776. Canvas, 127 × 100 cm.
Minneapolis, Minneapolis Institute of Arts

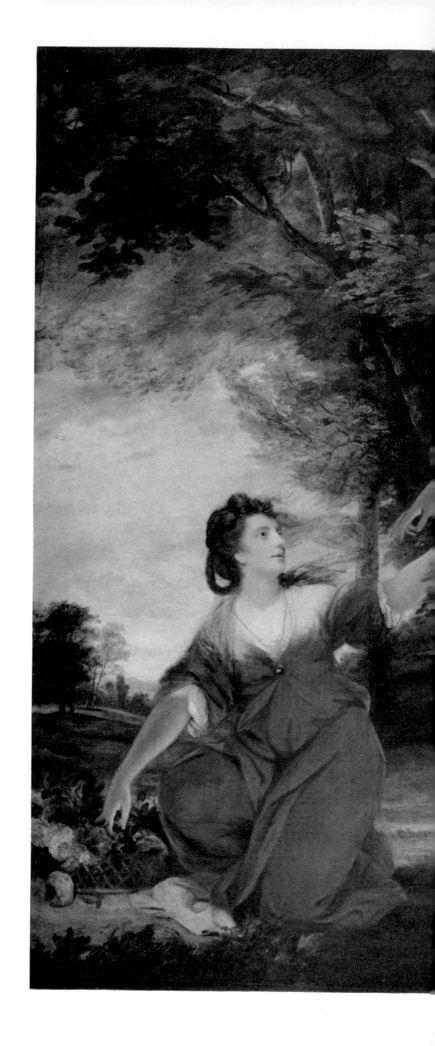

72
THREE LADIES ADORNING A TERM OF HYMEN
The Montgomery Sisters: Elizabeth (1751–83),
Mrs Luke Gardiner ; Anne (1752–1819),
Marchioness Townshend ; Barbara (1757–88),
Mrs Beresford.
Exhibited R.A. 1774 (216).
Canvas, 234 × 295 cm.
London, The Tate Gallery

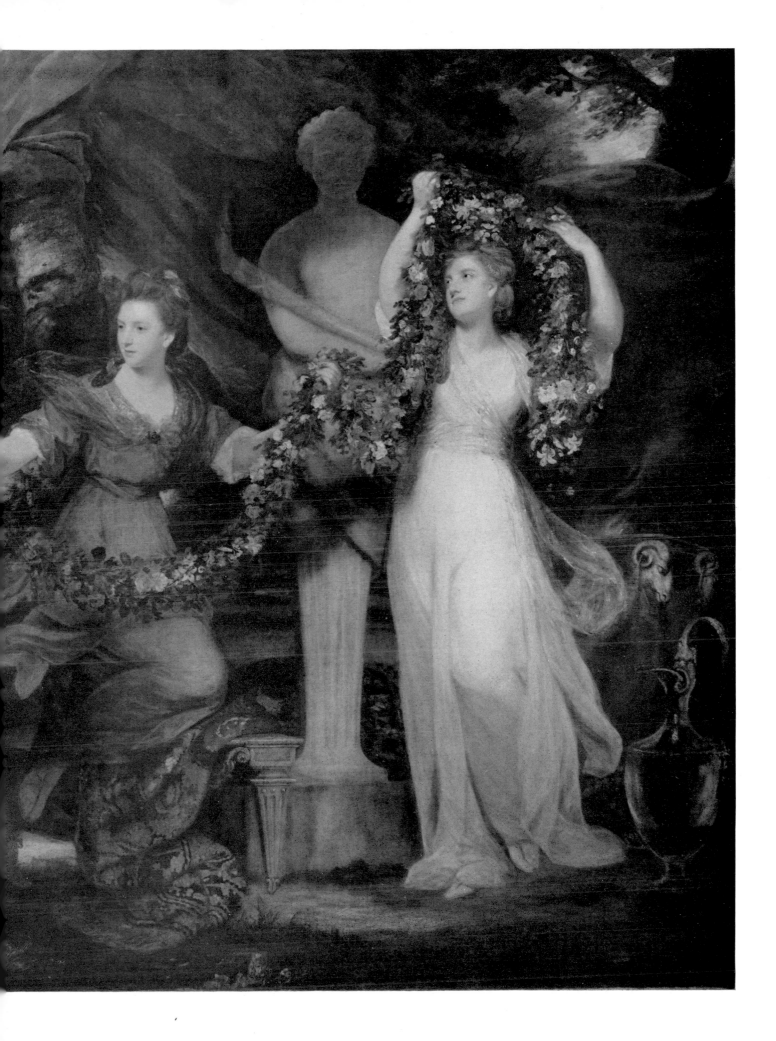

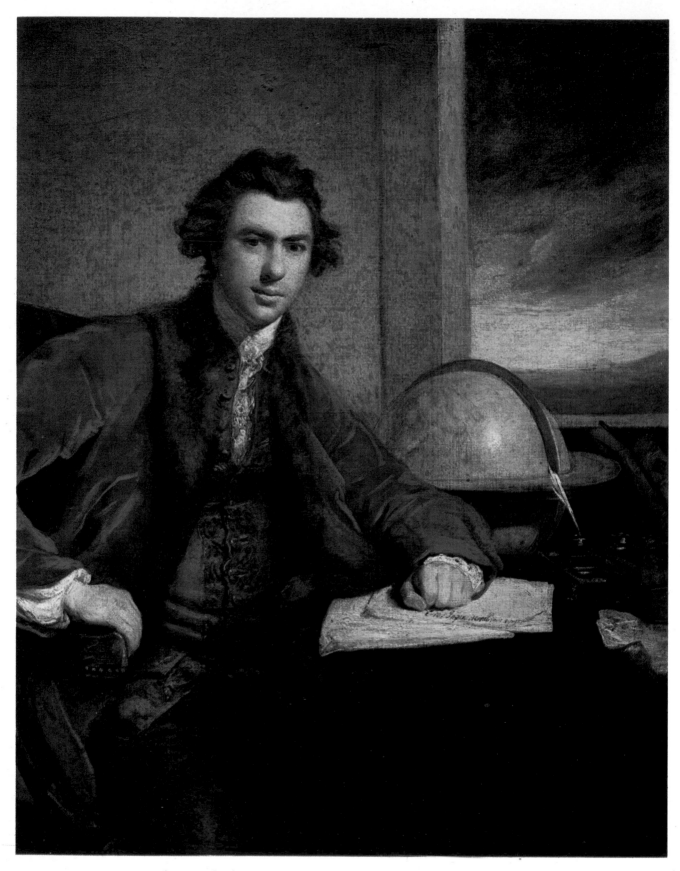

73 SIR JOSEPH BANKS (1743–1820)
Exhibited R.A. 1773 (239).
Parham Park. The Hon. Mrs Clive Pearson

74 *Detail of Plate 72*

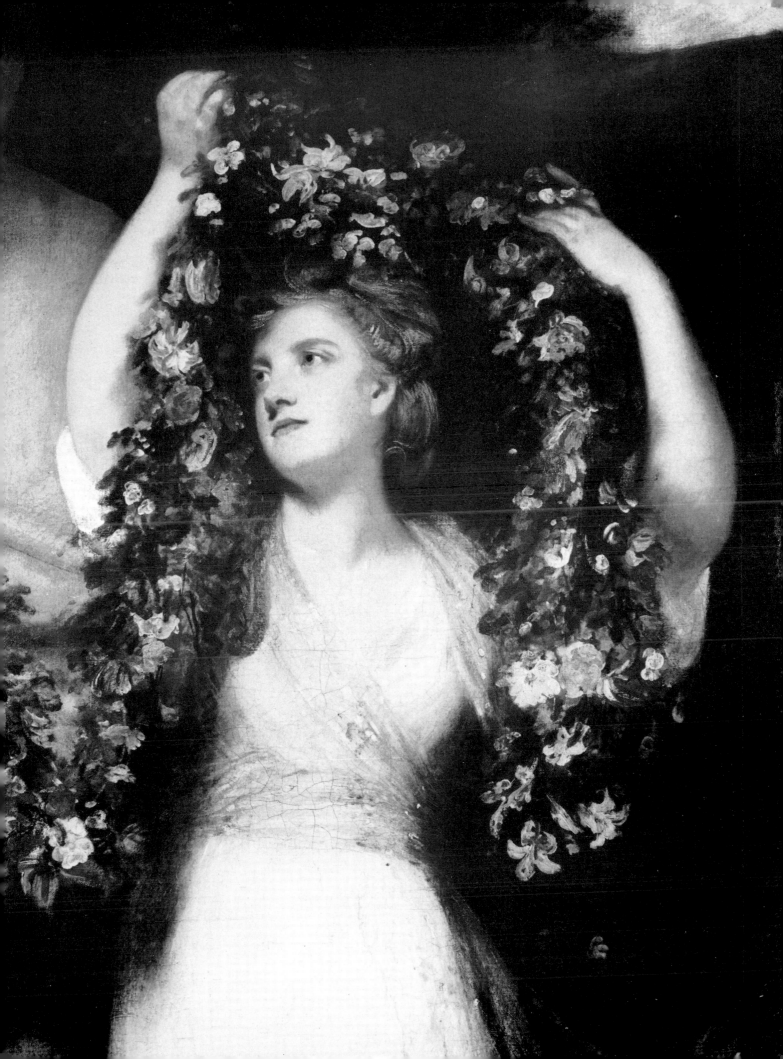

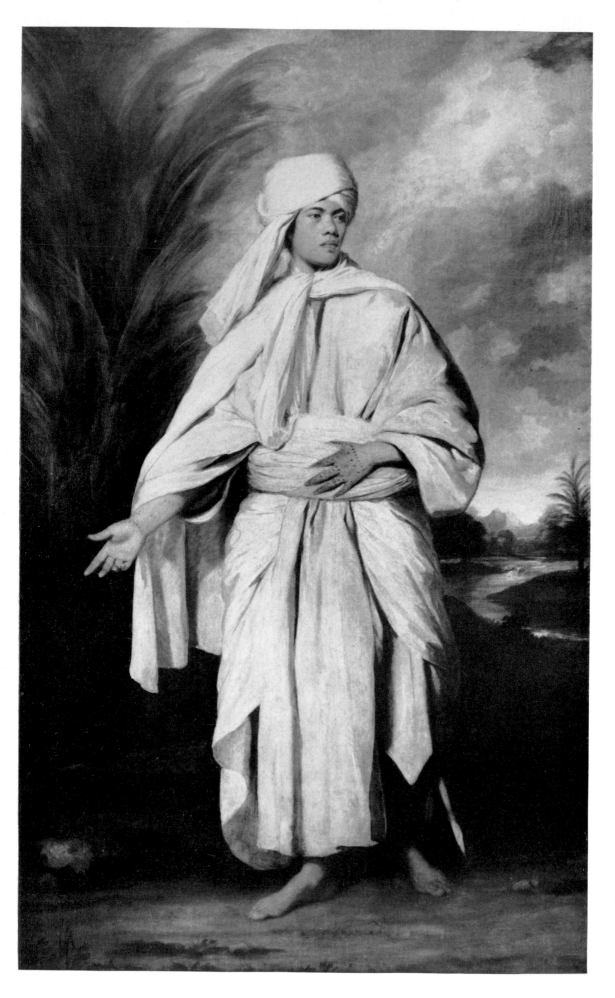

75, 76
OMAI
*The first
native
of the
South Sea
Islands to
visit England.
Exhibited
R.A. 1776 (236).
Canvas,
236 × 146 cm.
Castle Howard,
George Howard*

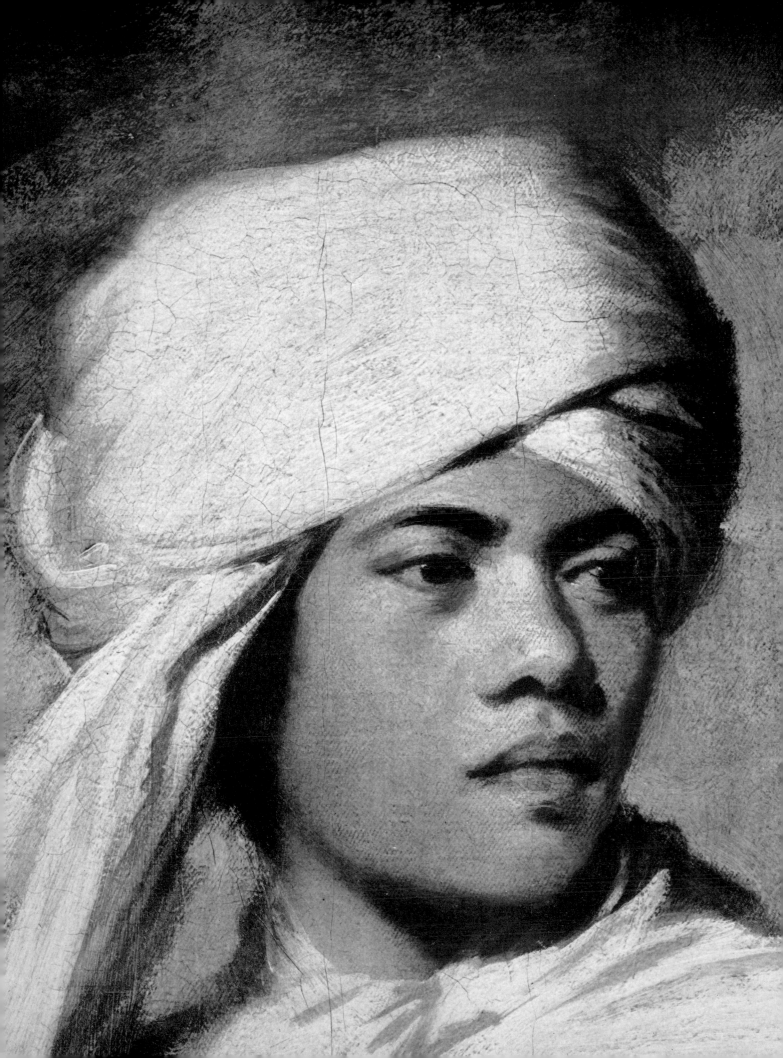

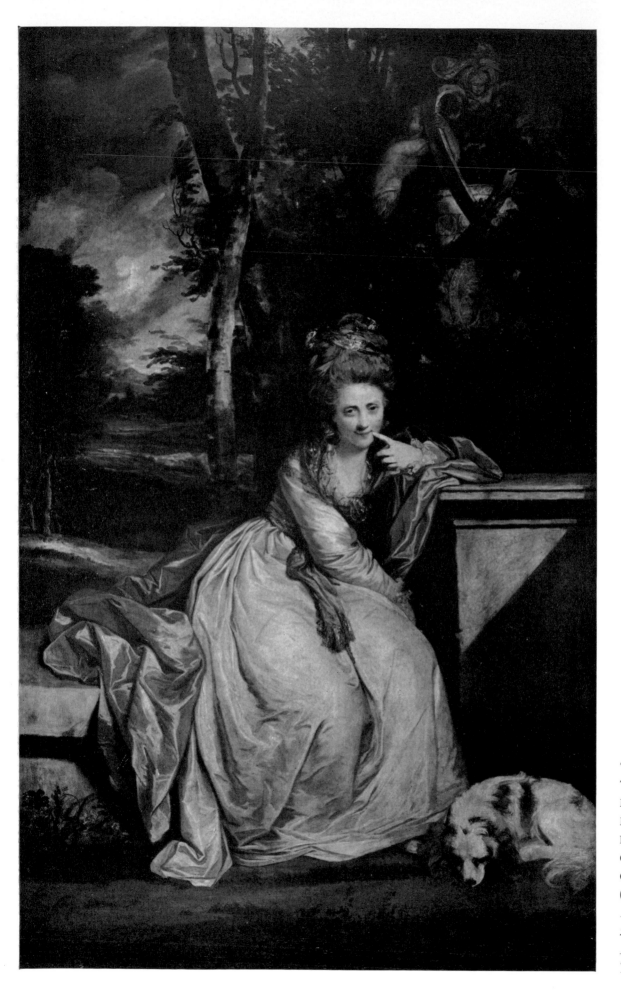

77
THE HON.
MARY
MONCKTON,
LATER
COUNTESS
OF CORK
(1745–1840)
1777. Canvas,
236 × 146 cm.
London,
The Tate Gallery

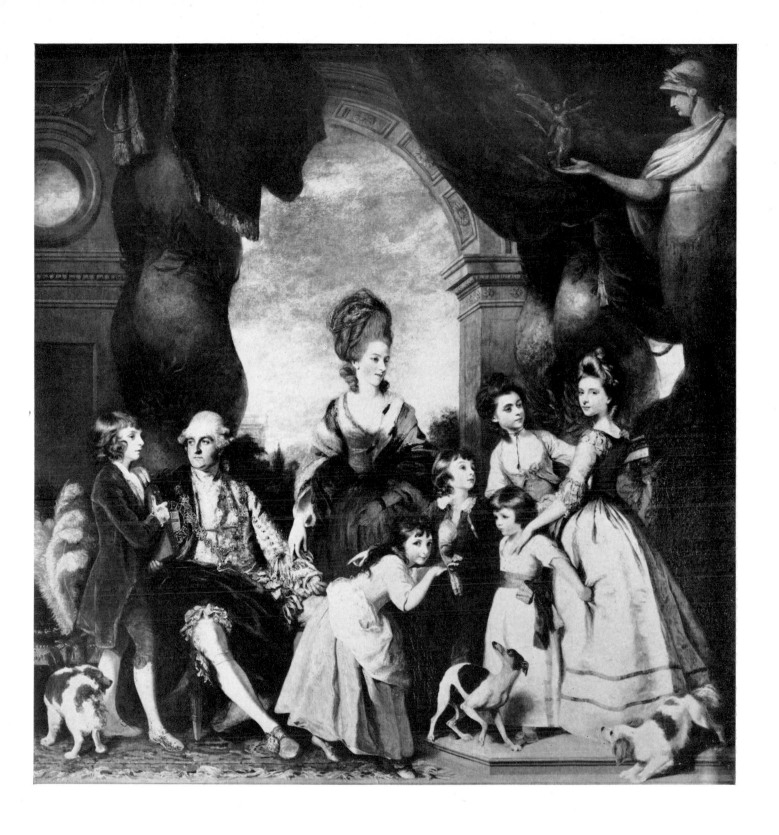

78 THE FAMILY OF GEORGE, 4TH DUKE OF MARLBOROUGH
Exhibited R.A. 1778 (246). Canvas, 318 × 289 cm.
Blenheim Palace, Duke of Marlborough

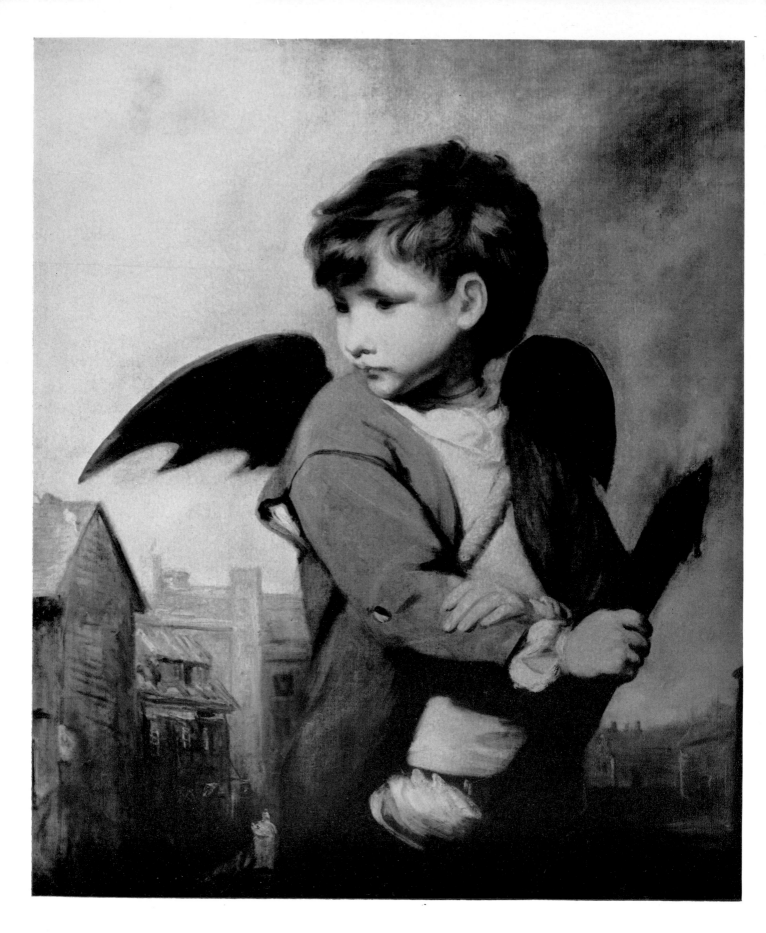

79 CUPID AS LINK BOY
1777. Canvas, 76 × 63 cm.
Buffalo, New York, Albright-Knox Art Gallery

80 THE STUDENT
1777? Canvas, 90 × 70 cm.
Warwick Castle, Trustees of Warwick Castle Resettlement

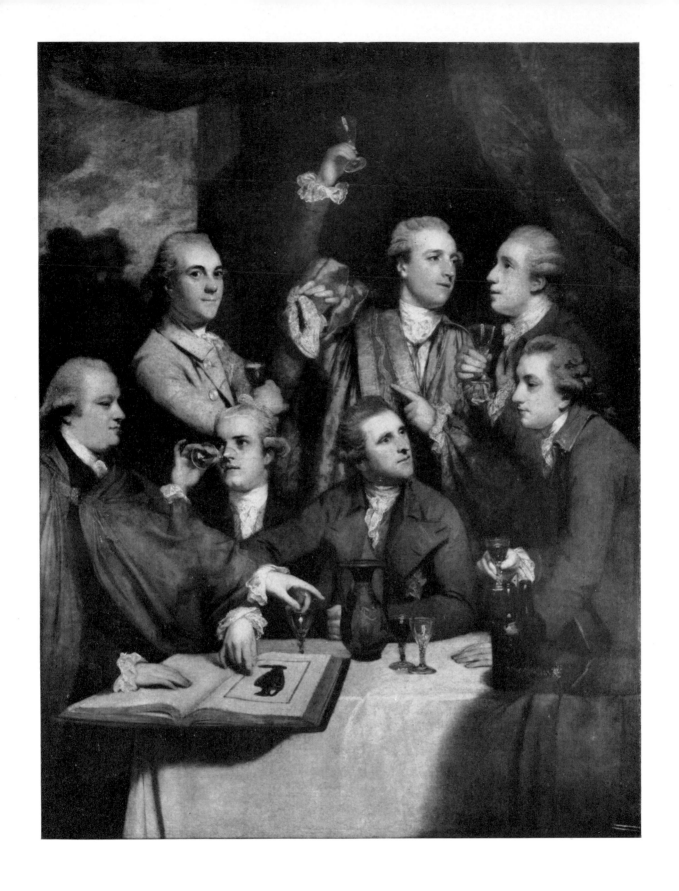

81 THE SOCIETY OF DILETTANTI I
1777–9. Canvas, 198 × 150 cm.
London, Society of Dilettanti

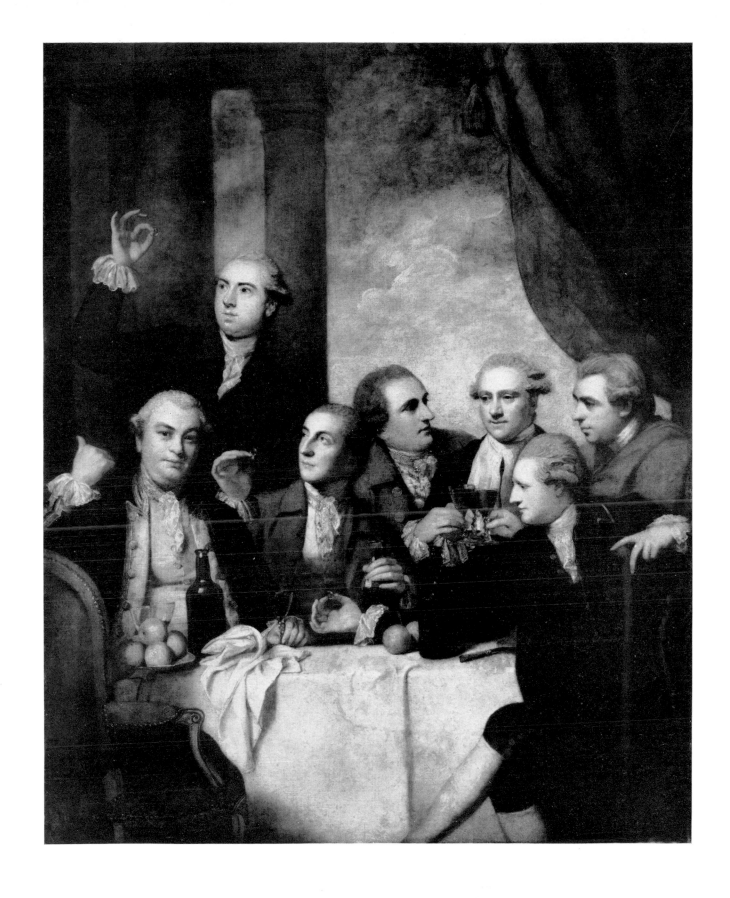

82 THE SOCIETY OF DILETTANTI II
1777–9. Canvas, 198 × 150 cm.
London, Society of Dilettanti

83
LADY WORSLEY
Exhibited R.A. 1780.
Canvas,
236 × 144 cm.
Harewood,
Earl of Harewood

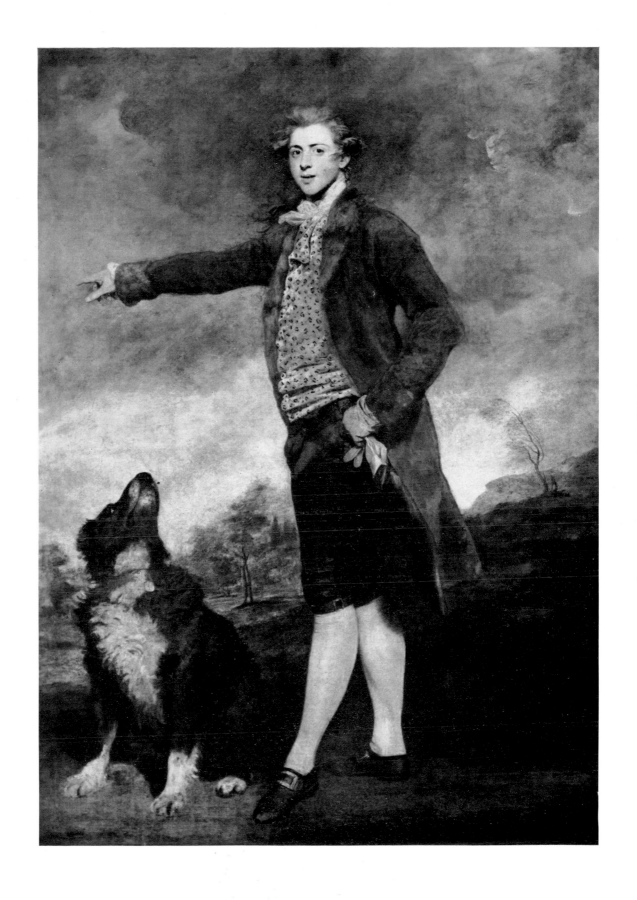

84 JOHN CAMPBELL, 1ST LORD CAWDOR (*c.*1753–1821)
Exhibited R.A. 1778 (248). Canvas, 239 × 146 cm.*
Golden Grove House, Earl Cawdor

85, 86
CAPTAIN JOHN
HAYES ST LEGER
(1756–99)
*1778. Canvas,
240 × 147 cm.
Waddesdon
Manor, The
National Trust*

87 LADY JANE HALLIDAY (1750–1802)
Exhibited R.A. 1779 (250). Canvas, 239 × 149 cm.
Waddesdon Manor, The National Trust

88 MARY, COUNTESS OF BUTE (1718–94)
1777–9? Canvas, 236 × 145 cm.
Mount Stuart, Marquess of Bute

89 JOHN PARKER, LATER 1ST EARL OF MORLEY (1772–1840),
AND THE HON. THERESA PARKER (1775–1856)
Signed and dated 1781. Canvas, 142 × 111 cm. Saltram, The National Trust

90 THE INFANT ACADEMY
Exhibited R.A. 1782 (72). Canvas, 114 × 142 cm.
London, Kenwood House (Iveagh Bequest)

91 MRS PELHAM (1752–86) FEEDING POULTRY
Exhibited R.A. 1774 (218). Canvas, 241 × 144 cm.
Brocklesby Park, Earl of Yarborough

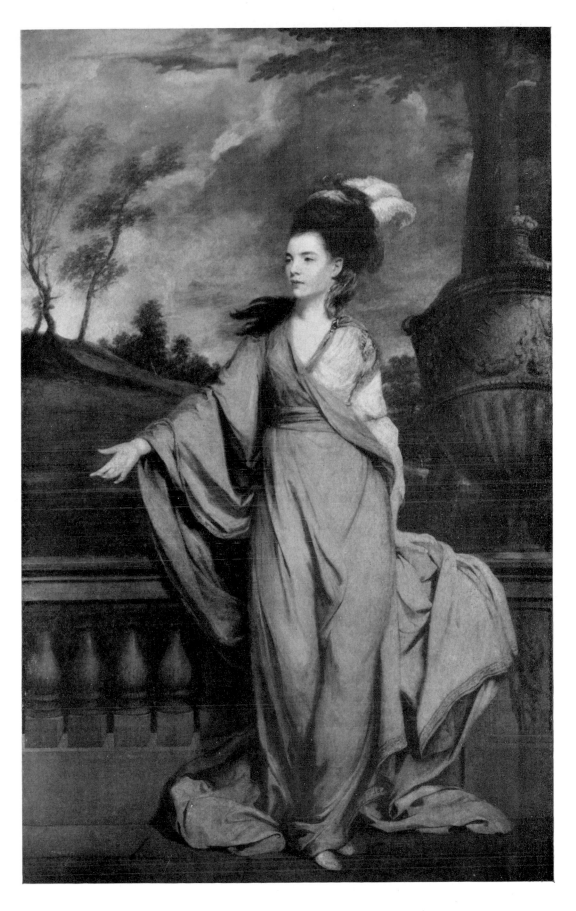

92 JANE FLEMING, COUNTESS OF HARRINGTON (1755–1824)
1777–9. Canvas, 235 × 145 cm.
San Marino, California, Henry E. Huntington Library and Art Gallery

93 MRS THOMAS MEYRICK (*d.*1821)
1782. Canvas, 94 × 74 cm.
Oxford, Ashmolean Museum

94 LAVINIA, VISCOUNTESS ALTHORP, LATER COUNTESS SPENCER (1762–1831)
 Exhibited R.A. 1782 (157). Canvas, 74 × 63 cm.
 Althorp, Earl Spencer

95 RICHARD ROBINSON, D.D. (1709–94). *Archbishop of Armagh.*
Exhibited (or a replica) R.A. 1775 (233). Canvas, 142 × 115 cm.
Birmingham University, The Barber Institute of Fine Arts

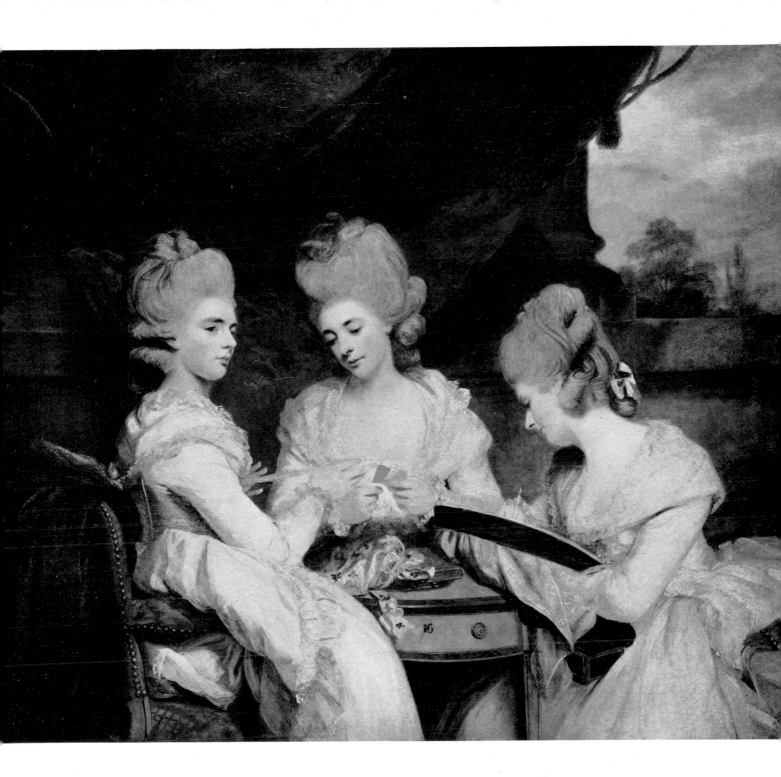

96 THE LADIES WALDEGRAVE

Elizabeth Laura (1760–1816), later Countess Waldegrave ;
Charlotte Maria (1761–1808), later Duchess of Grafton ;
Anna Horatia (1762–1801), later Lady Hugh Seymour.
Exhibited R.A. 1781 (187). Canvas, 144 × 168 cm.
Edinburgh, National Gallery of Scotland

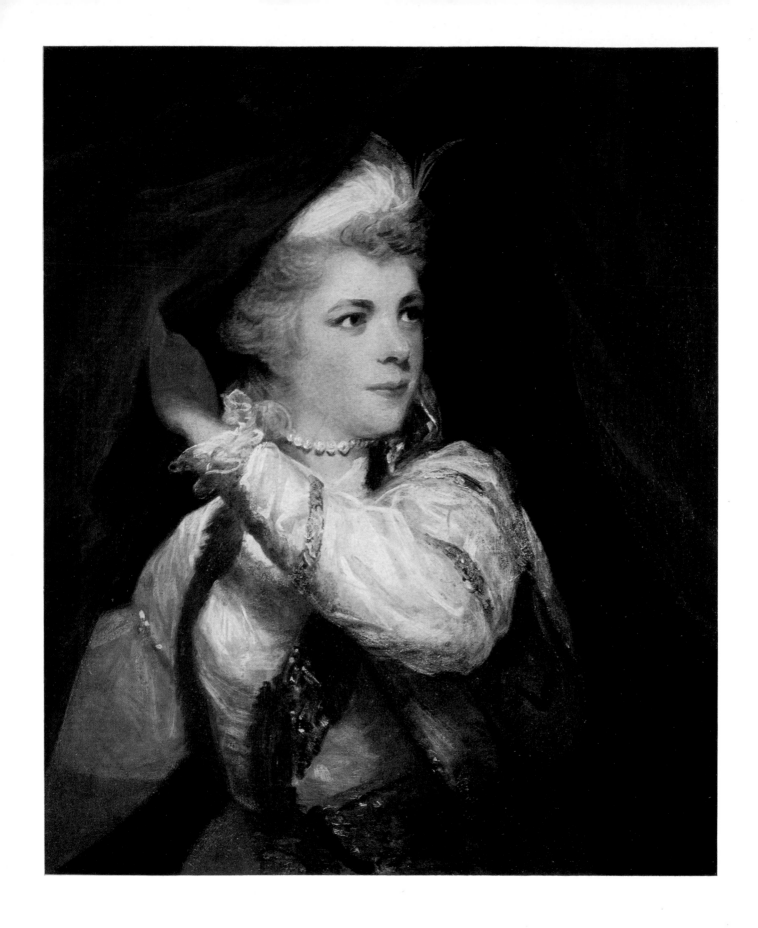

97 MRS ABINGTON (1737–1815) AS ROXALANA IN 'THE SULTAN'
Exhibited R.A. 1784 (14). Canvas, 74 × 65 cm.
London, Private Collection

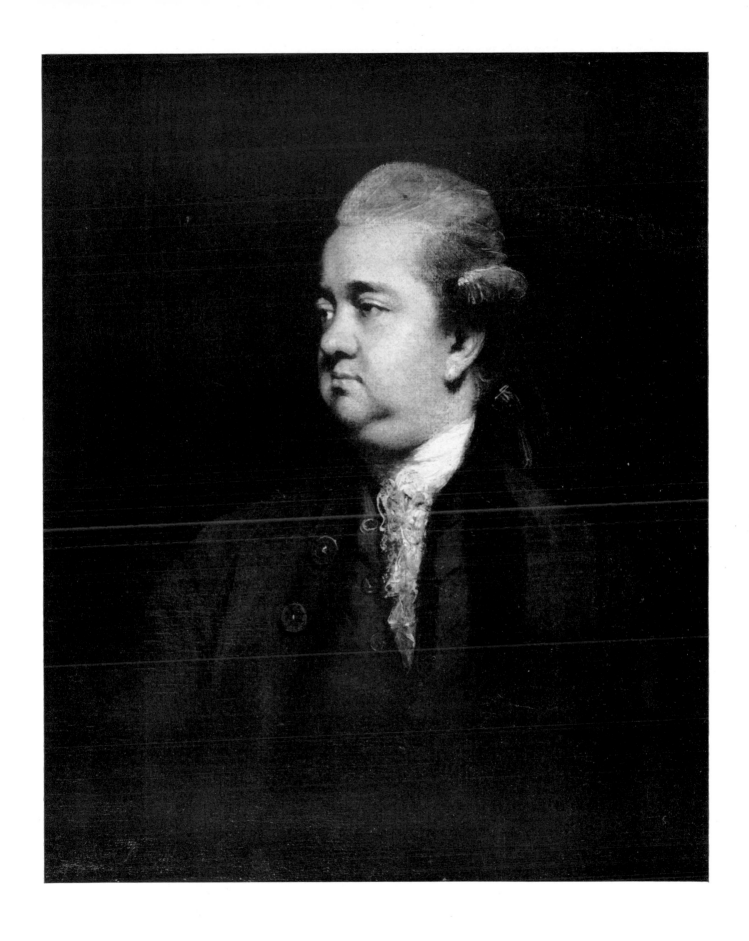

98 EDWARD GIBBON (1737–94)
 Exhibited R.A. 1780 (18). Canvas, 76 × 65 cm.
 Dalmeny House, Lord Primrose

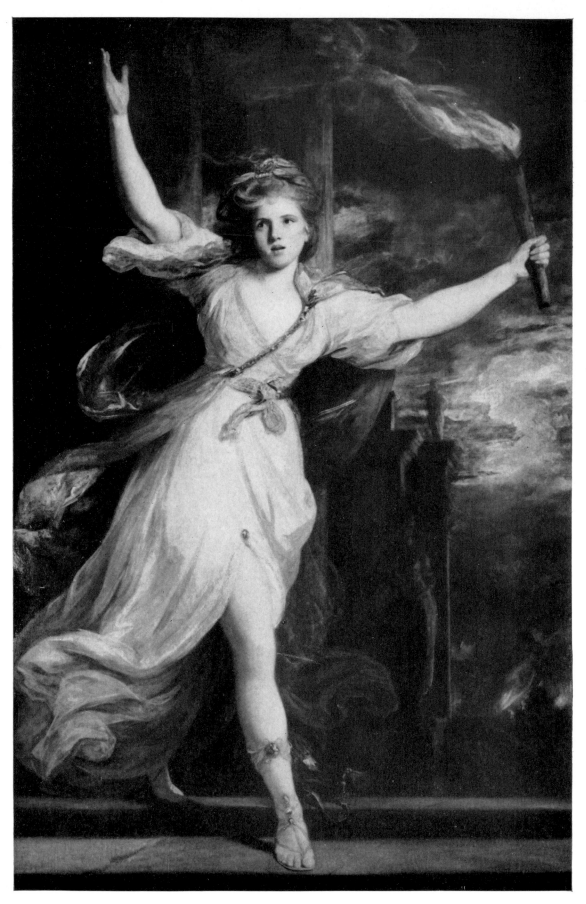

99 MISS EMILY POTT (*d.*1782) AS THAÏS
Exhibited R.A. 1781 (10). Canvas, 229 × 145 cm.
Waddesdon Manor, The National Trust

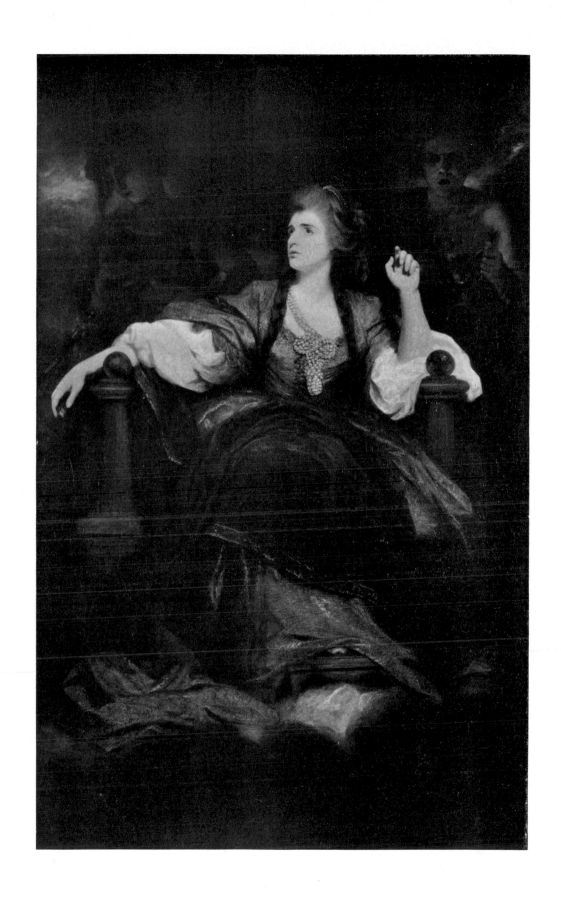

100 SARAH SIDDONS (1755–1831) AS THE TRAGIC MUSE
Exhibited R.A. 1784 (190). Canvas, 236 × 146 cm.
San Marino, California, Henry E. Huntington Library and Art Gallery

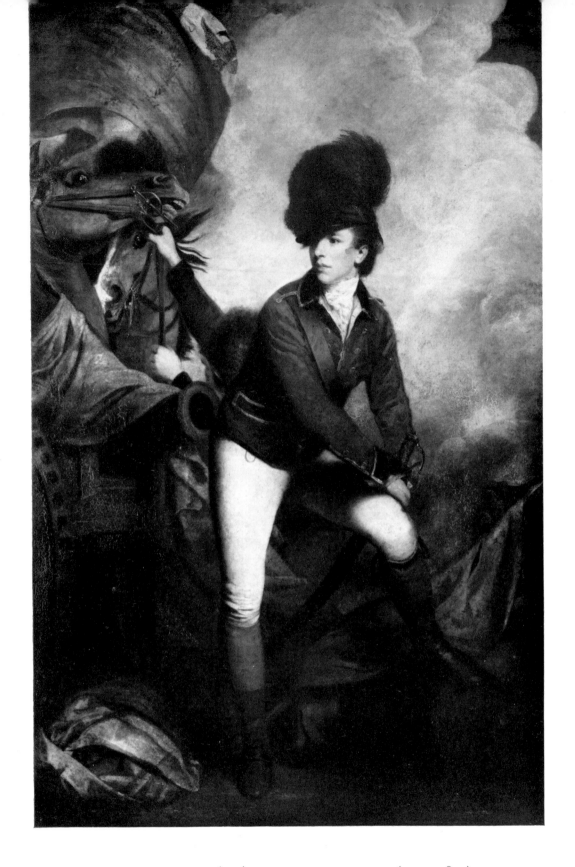

101 LIEUTENANT-COLONEL (SIR) BANASTRE TARLETON (1754–1833)
Exhibited R.A. 1782 (149). Canvas, 236 × 145 cm.
London, National Gallery

102 CHARLES, 3RD EARL OF HARRINGTON (1753–1829)
Exhibited R.A. 1783 (193). Canvas, 236 × 146 cm.
From the collection of Mr and Mrs Paul Mellon

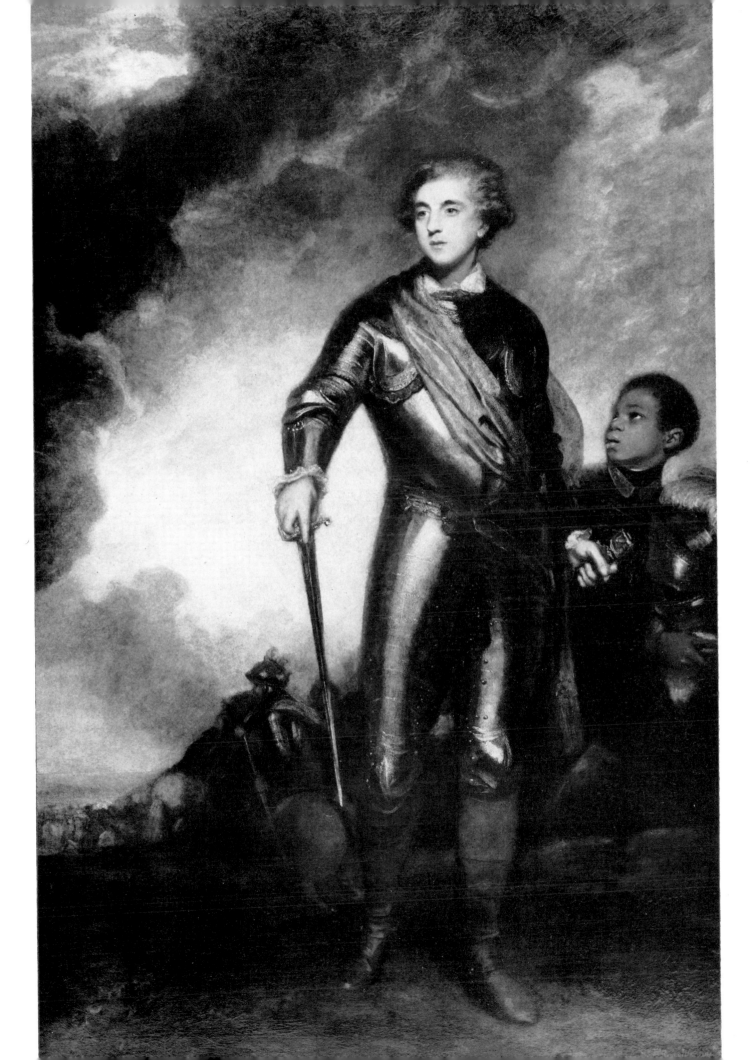

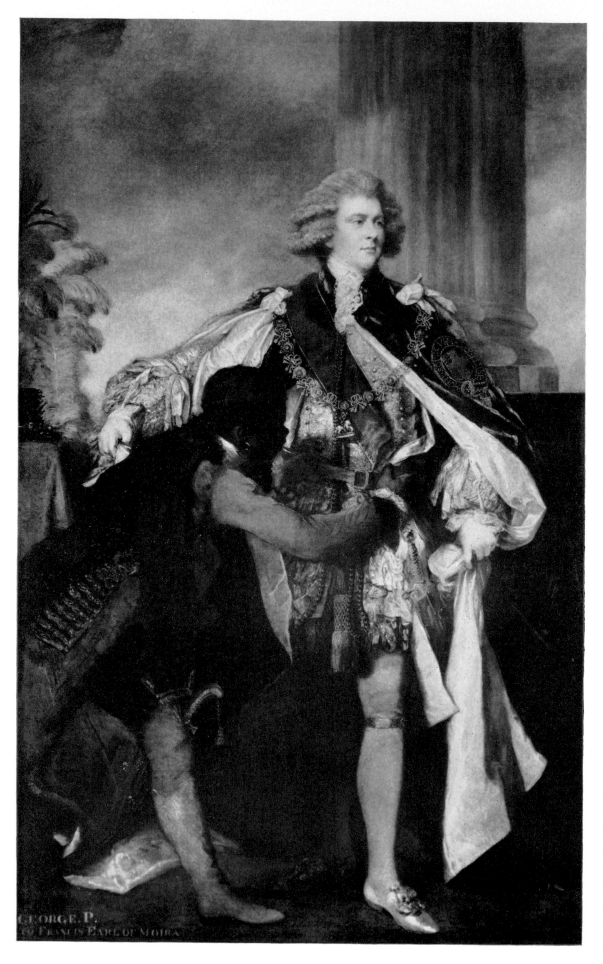

103
GEORGE IV
(1762–1830),
WHEN PRINCE
OF WALES
Exhibited R.A.
1787 (90).
Canvas,
239 × 148 cm.
Arundel Castle,
Duke of Norfolk

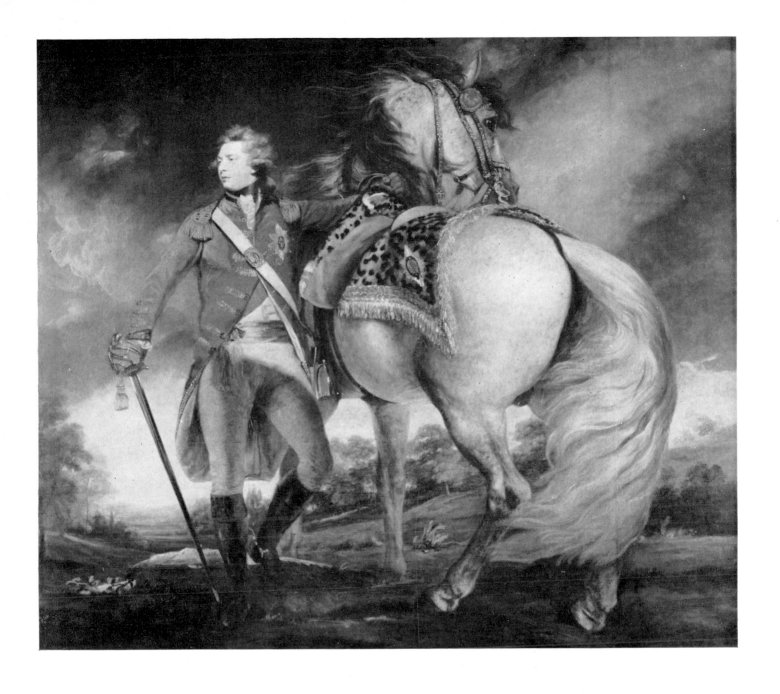

104 GEORGE IV (1762–1830), WHEN PRINCE OF WALES
Exhibited R.A. 1784 (70). Canvas, 239 × 260 cm.
Brocket Hall, Executors of the late Lord Brocket

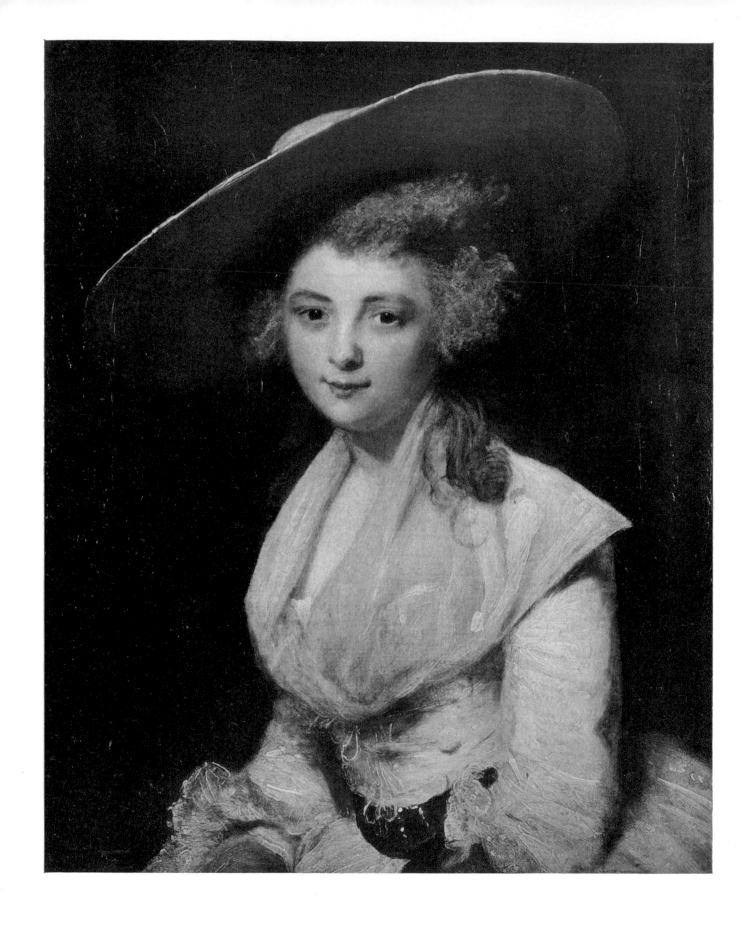

105 LADY ANNE BINGHAM (1767–1840)
 Exhibited R.A. 1786 (224). Canvas, 74 × 63 cm.
 Althorp, Earl Spencer

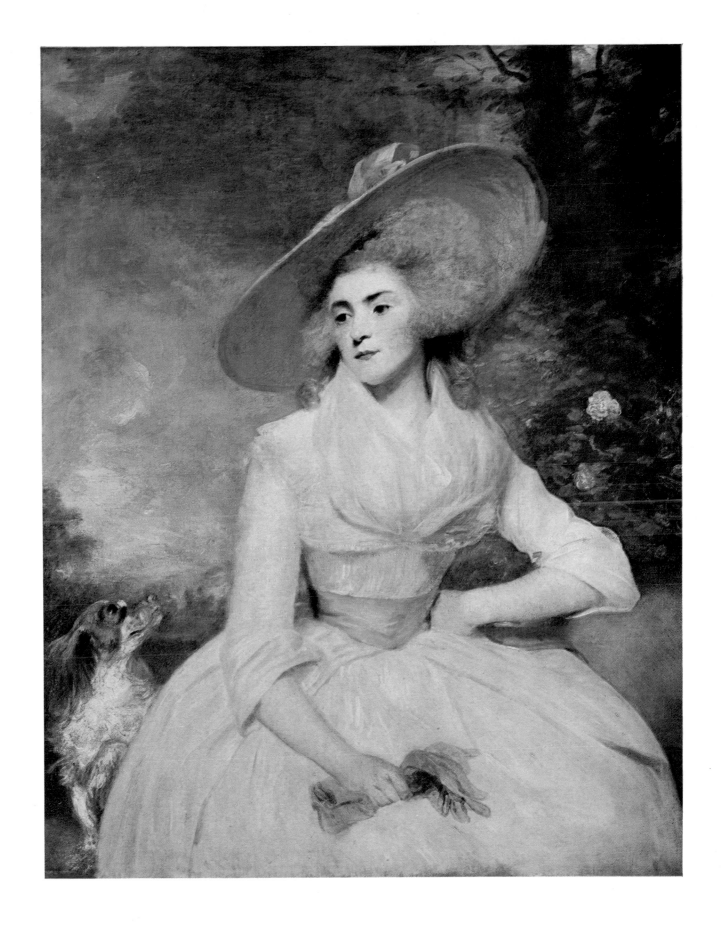

106 MRS SCOTT OF DANESFIELD (d.1834)
1786. Canvas, 126 × 100 cm.
Waddesdon Manor, The National Trust

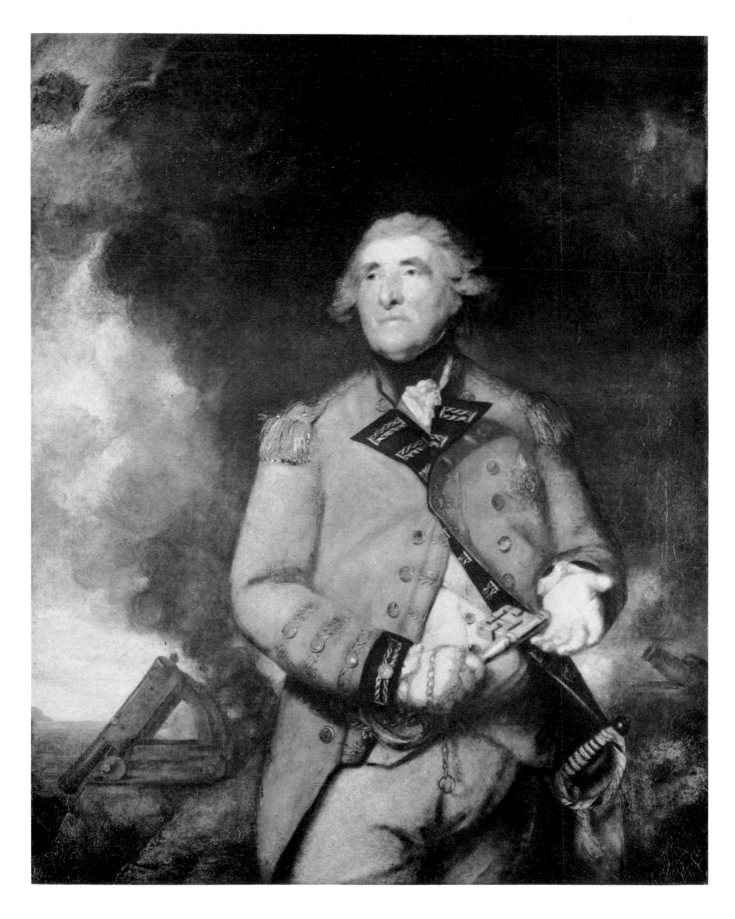

107 GEORGE AUGUSTUS ELIOTT, LORD HEATHFIELD (1717–90)
Exhibited R.A. 1788 (115). Canvas, 142 × 114 cm.
London, National Gallery

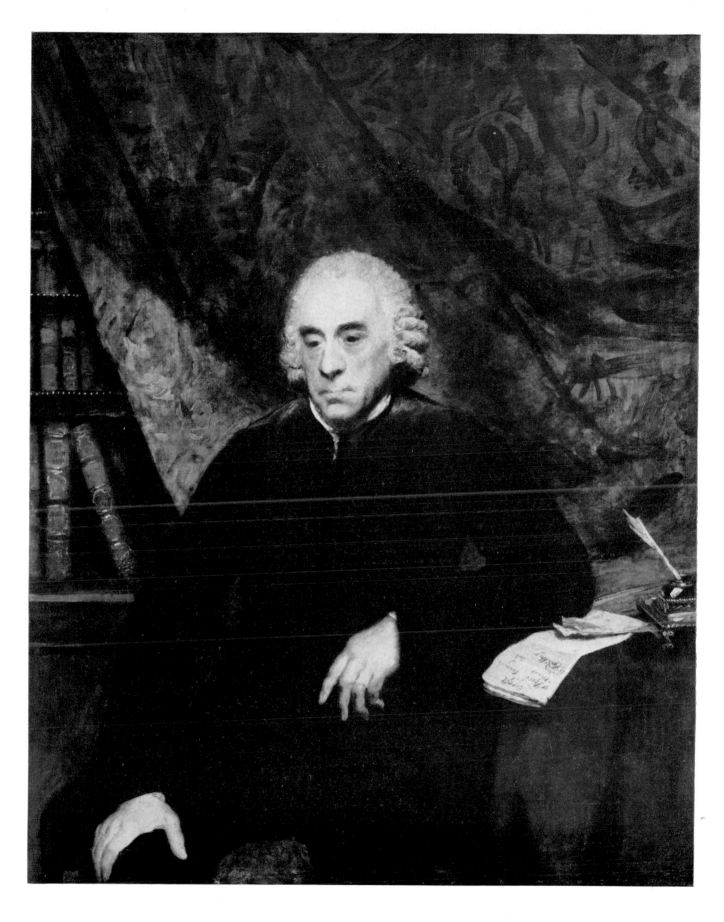

108 JOSHUA SHARPE (d.1786)
Exhibited R.A. 1786 (178). Canvas, 126 × 100 cm.
Cowdray Park, Viscount Cowdray

109 PUCK
 Exhibited R.A. 1789 (82). Wood, 103 × 80 cm.
 Milton Park, Earl Fitzwilliam

110 HEADS OF ANGELS: MISS FRANCES ISABELLA GORDON (1782–1831)
Exhibited R.A. 1787 (24). Canvas, 74 × 62 cm.
London, The Tate Gallery

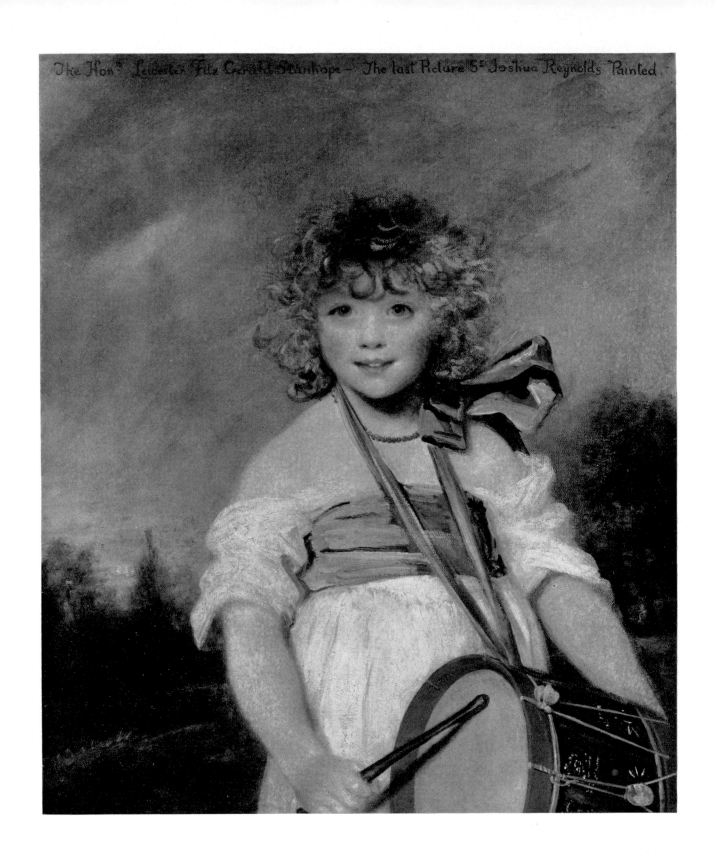

The Hon.ᵇˡᵉ Leicester Fitz Gerald Stanhope – The last Picture Sʳ Joshua Reynold's Painted

III THE HON. LEICESTER STANHOPE (1784–1862)
1788. Canvas, 74 × 62 cm.
Patrickswell, Ireland, Earl of Harrington

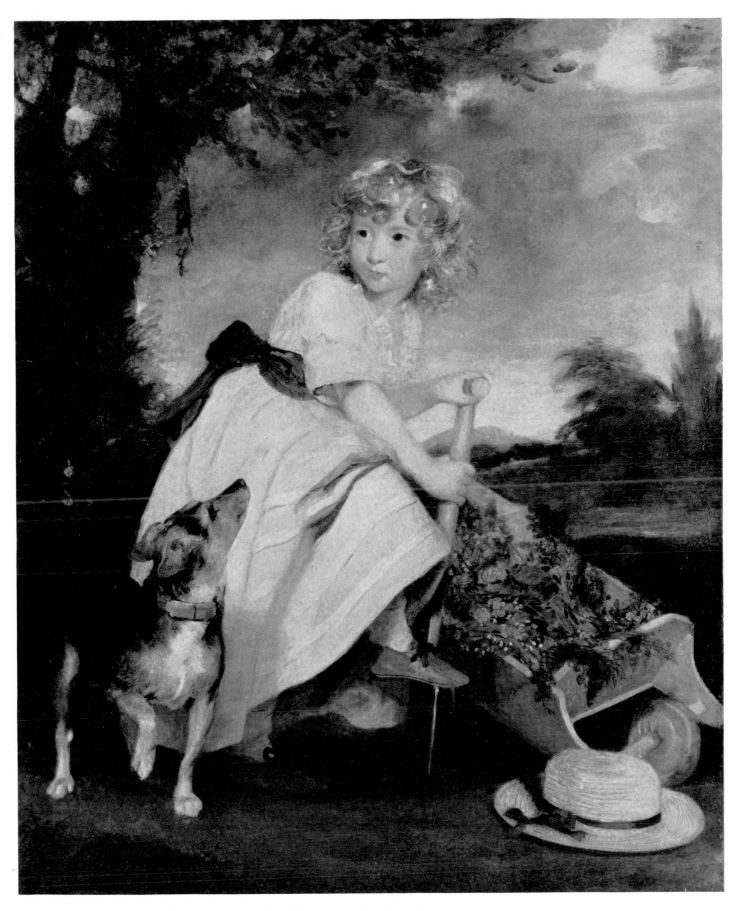

112 MASTER HENRY HOARE (1784–1836). 'The young Gardener.'
1788. Canvas, 127 × 102 cm.
Toledo, Ohio, The Toledo Museum of Art

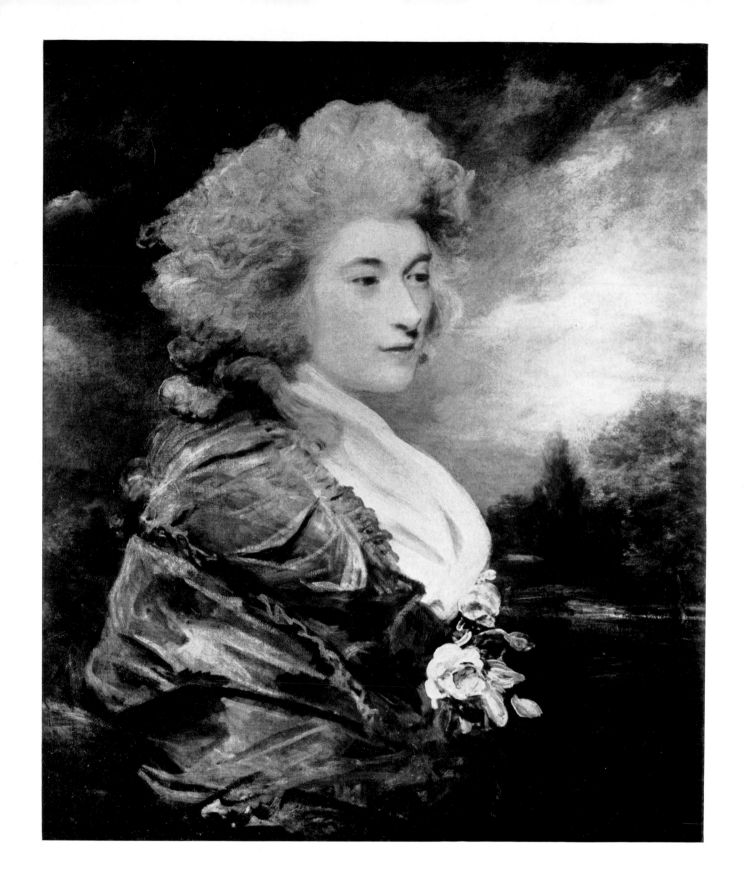

113 HENRIETTA FRANCES, VISCOUNTESS DUNCANNON, LATER
COUNTESS OF BESSBOROUGH (1761–1821)
1786. Canvas, 76 × 63 cm.
Althorp, Earl Spencer

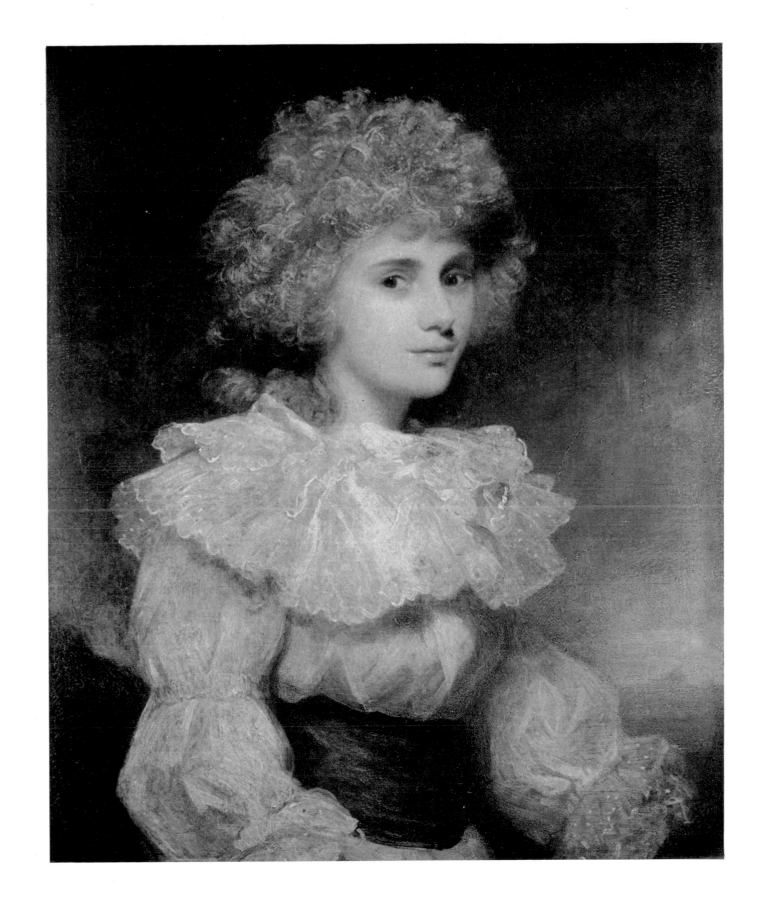

114 LADY BETTY FOSTER, LATER DUCHESS OF DEVONSHIRE (1759–1824)
Exhibited R.A. 1788 (219). Canvas, 74 × 62 cm.
Chatsworth, Devonshire Collection

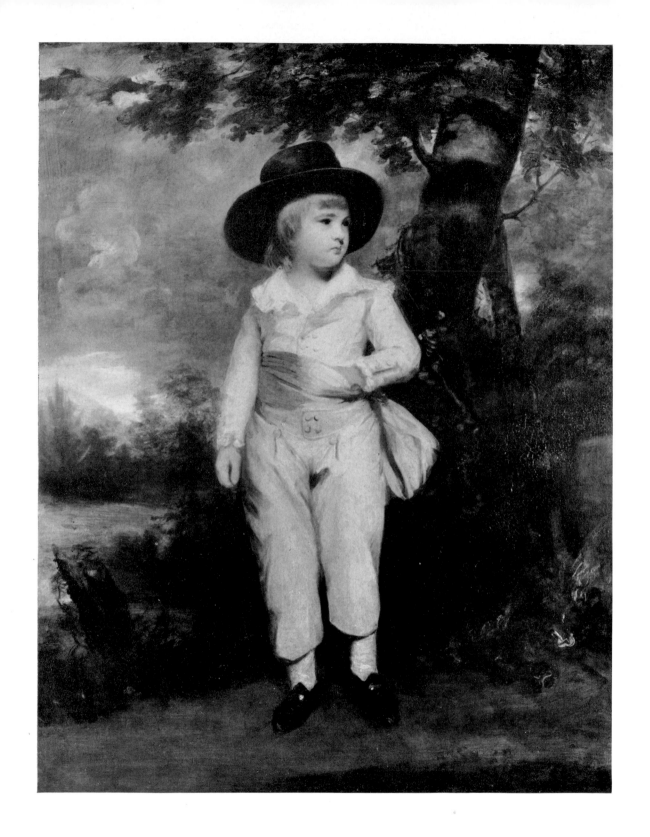

115 JOHN CHARLES, VISCOUNT ALTHORP, LATER 3RD EARL SPENCER (1782–1845)
1786. Canvas, 141 × 110 cm.
Althorp, Earl Spencer

116 COLONEL (LATER GENERAL) GEORGE MORGAN (1740/1–1823)
Exhibited R.A. 1788 (146). Canvas, 196 × 147 cm.
Cardiff, The National Museum of Wales

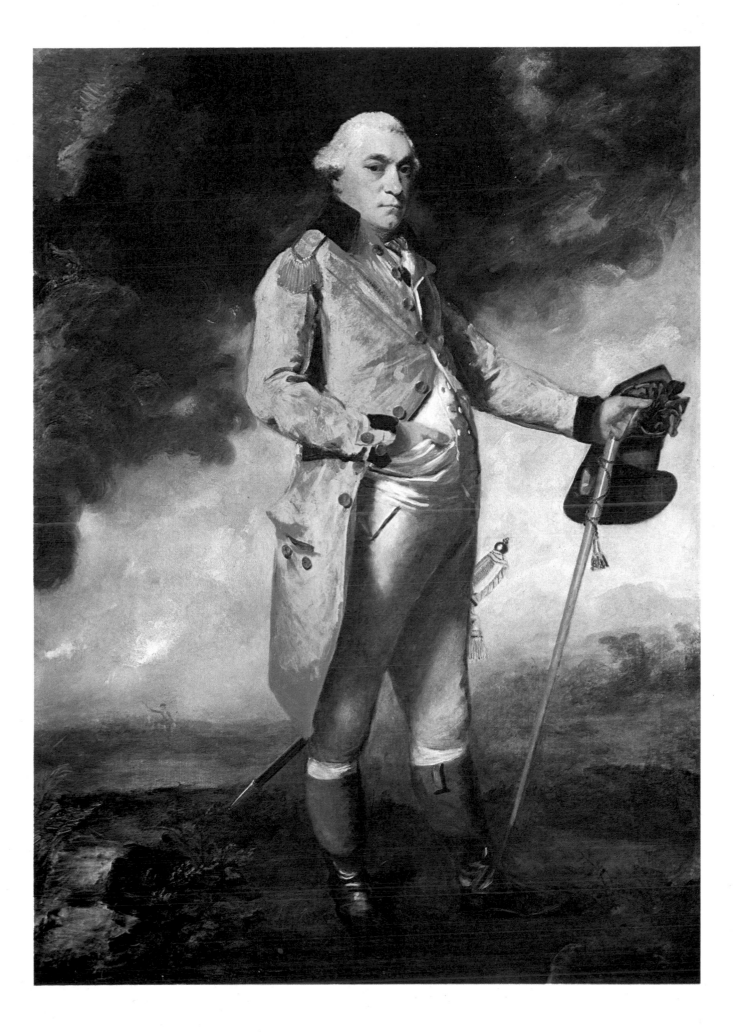

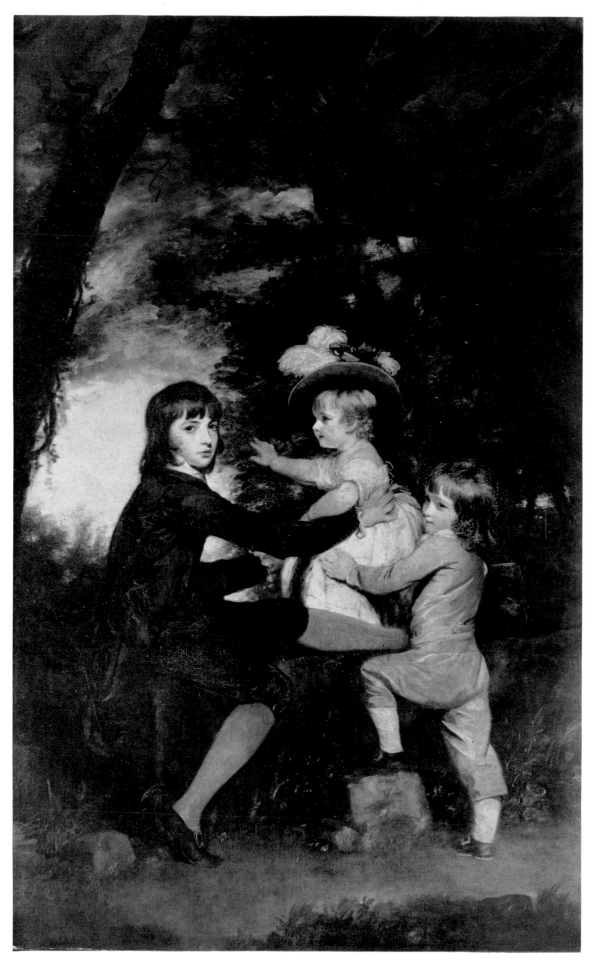

117
THE LAMB
FAMILY
*Children of
1st Lord
Melbourne :
Peniston
(1770–1805) ;
William
(1779–1848),
later 2nd Lord
Melbourne ;
Frederick
(1782–1853),
later 3rd Lord
Melbourne.
About 1785.
Canvas,
239 × 149 cm.
Firle Place,
Viscount Gage*

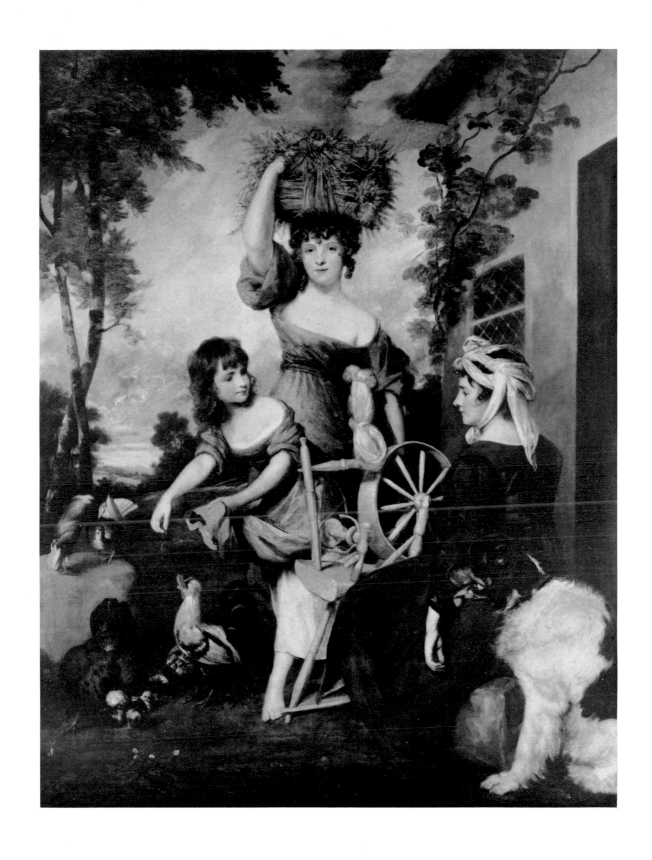

118 THE COTTAGERS. *Mrs and Miss Macklin and Miss Potts.*
1788. Canvas, 241 × 180 cm.
Detroit, The Detroit Institute of Arts

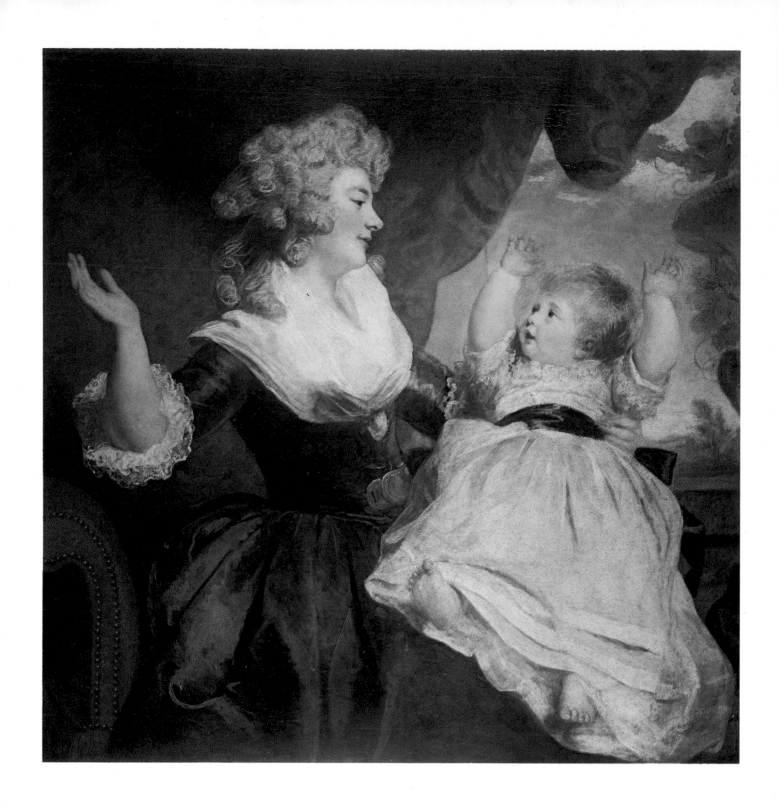

119 GEORGIANA, DUCHESS OF DEVONSHIRE (1757–1806), AND HER DAUGHTER,
LADY GEORGIANA CAVENDISH (1783–1858), LATER COUNTESS OF CARLISLE (*detail*).
Exhibited R.A. 1786 (166). Canvas, 113 × 140 cm.
Chatsworth, Devonshire Collection

120 THE GIPSY FORTUNE-TELLER
Exhibited R.A. 1777 (294). Canvas, 114 × 140 cm.
Waddesdon Manor, The National Trust

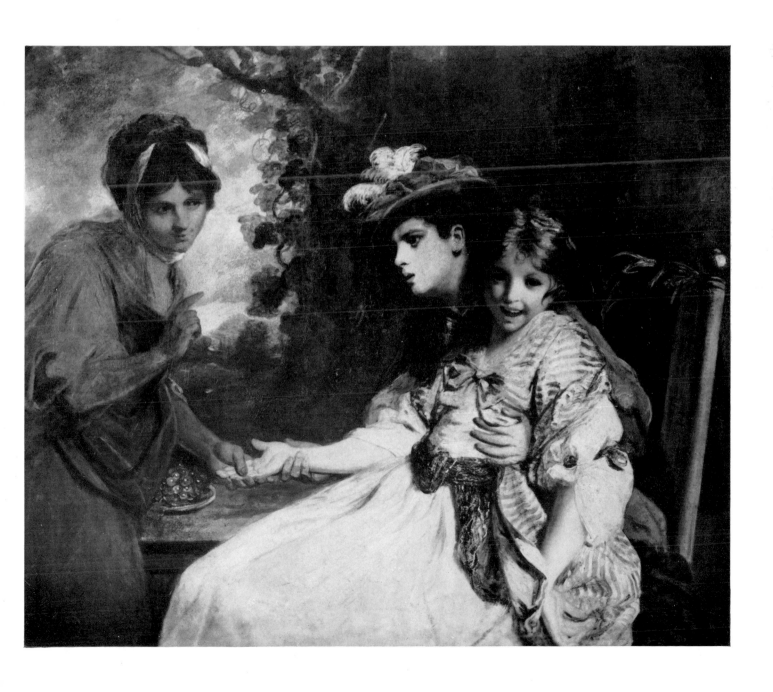

121 JAMES BOSWELL (1740–95)
Exhibited R.A. 1787 (113). Canvas, 72 × 60 cm.
London, National Portrait Gallery

122 GEORGE JAMES CHOLMONDELEY (1752–1830)
Exhibited R.A. 1790 (236). Canvas, 76 × 63 cm
Felbrigg Hall, The National Trust

123 CHARLOTTE (PONSONBY), COUNTESS FITZWILLIAM (1747–1822)
1784–5. Canvas, 127 × 101 cm.
Milton Park, Earl Fitzwilliam

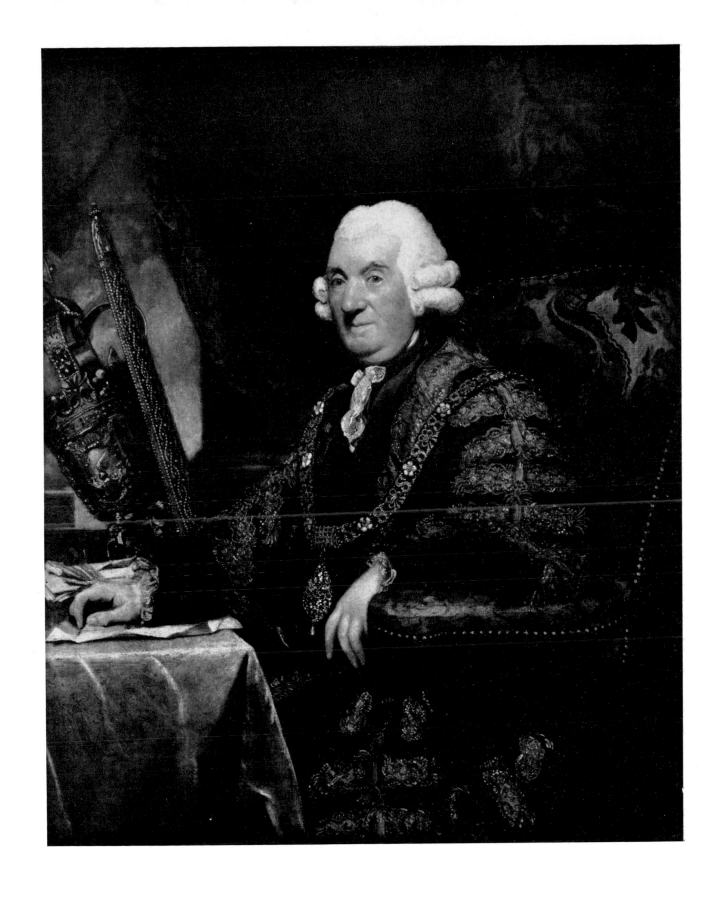

124 SIR JAMES ESDAILE (d.1793). *Lord Mayor of London.*
Exhibited R.A. 1790 (410). Canvas, 127 × 101 cm.
St Louis, Missouri, Washington University Gallery of Art

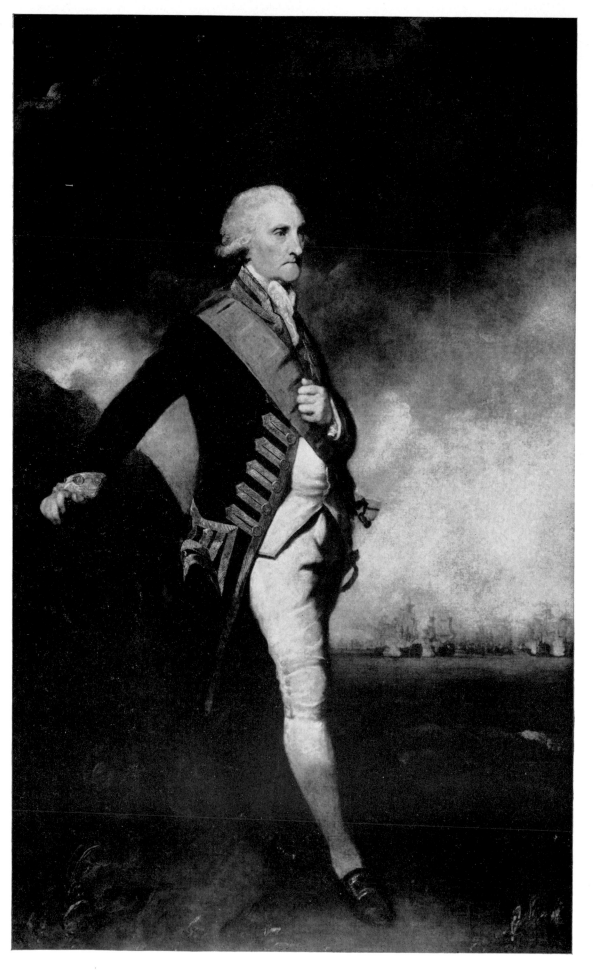

125
ADMIRAL LORD
RODNEY (1719–92)
Exhibited
R.A. 1789 (225).
Canvas,
239 × 147 cm.
Royal Collection

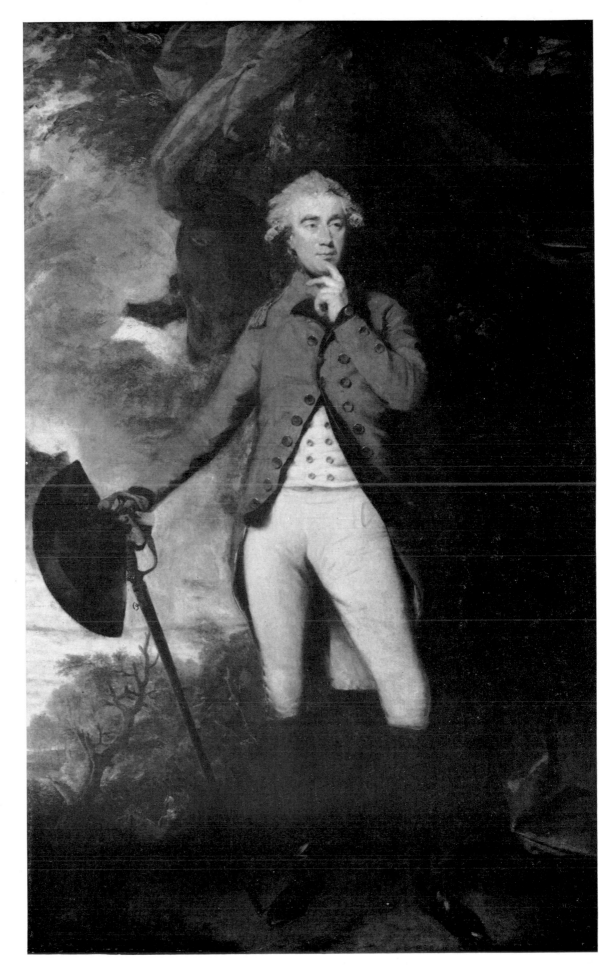

126
FRANCIS, LORD
RAWDON, LATER
MARQUESS OF
HASTINGS
(1754–1825)
Exhibited
R.A. 1790 (94).
Canvas,
239 × 148 cm.
Royal Collection

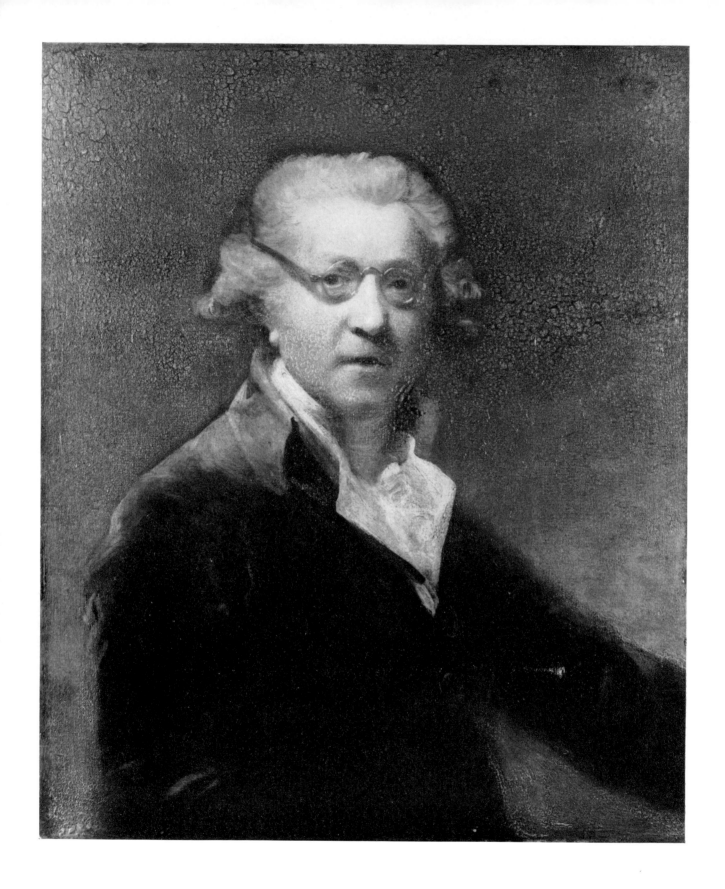

127 SELF-PORTRAIT
1788. Wood, 75 × 63 cm.
Royal Collection

Pictures exhibited during Reynolds's lifetime

Works reproduced in E. K. Waterhouse : Reynolds (1941) but not in this volume are designated by the abbreviation w followed by the plate number.

SOCIETY OF ARTISTS

1760	47	Duchess of Hamilton (Port Sunlight, Lady Lever Art Gallery), w67
	48	Lady Elizabeth Keppel (Ascott, The National Trust), w46
	49	General Kingsley (C. Kingsley)
	50	General Charles Vernon (Ponce, Puerto Rico, Art Museum), Plate 30

1761	81	Countess Waldegrave (Baton Rouge, Louisiana State University, Anglo-American Museum)
	82	Dr Sterne (private collection), Plate 28
	83	Duke of Beaufort (Badminton)
	84	Captain Robert Orme (London, National Gallery), Plate 14
	85	Lord Ligonier on Horseback (London, Tate Gallery), w61

1762	87	Lady Elizabeth Keppel (Woburn), Plate 32
	88	Garrick between Tragedy and Comedy (private collection), Plate 31
	89	Lady Waldegrave and Child (Chantilly, Musée Condé)

1763	96	The Ladies Elizabeth and Henrietta Montagu (Bowhill), Plate 38
	97	Earl of Rothes (Earl of Rothes)
	98	'A gentleman; three-quarters'
	99	Nelly O'Brien (London, Wallace Collection), Plate 29

| 1764 | 92 | Duchess of Ancaster (Houghton), w92 |
| | 93 | Mrs Collier (Maureen, Marchioness of Dufferin) |

| 1765 | 104 | Lady Sarah Bunbury (Chicago, Art Institute), Plate 37 |
| | 105 | Countess Waldegrave as a Widow (?Jacksonville, Cummer Gallery of Art) |

1766	136	Mrs Hale as 'Euphrosyne' (Harewood), w90
	137	Marquess of Granby (Royal Collection)
	138	Sir Jeffrey Amherst (Lord Amherst)
	139	James Paine and Son (Oxford, Ashmolean Museum), w114

| 1768 | 134 | Miss Hester Cholmondeley (John Yerburgh) |

ROYAL ACADEMY

1769	89	Duchess of Manchester and Son (private collection), w125
	90	Lady Blake as 'Juno' (lost), w126
	91	Mrs Bouverie and Mrs Crewe (private collection), Plate 45
	92	'Hope nursing Love' (Bowood), w124

1770 145 Colonel Acland and Viscount Sydney (E. A. M. H. M. Herbert), Plate 50
146 The Hon. Mrs Bouverie and Child (Longford Castle), W133
147 Miss Sarah Price (Hatfield)
148 Lady Cornwallis (Port Eliot)
149 The Babes in the Wood (Burns sale, 6 May, 1926, No. 148)
150 Dr Samuel Johnson (Knole)
151 Oliver Goldsmith (Knole), Plate 53
152 George Colman (copy in National Portrait Gallery)

1771 156 Venus chiding Cupid (London, Kenwood)
157 Ino and infant Bacchus (Abdy sale, 1936)
158 Theophila Palmer reading (Lord Hillingdon), Plate 55
159 'Resignation' (Sedelmeyer sale, Paris 1907)
160 Samuel Dyer (Lord Cranworth)
161 Mrs Abington (Mr and Mrs Paul Mellon), Plate 54

1772 205 Miss Meyer as 'Hebe' (Ascott, The National Trust), W140
206 Mrs Crewe (private collection), W139
207 Dr Robertson (Edinburgh, Scottish National Portrait Gallery), W145
208 Joseph Hickey (lost)
209 Mrs Quarrington (Luton Hoo, Sir Harold Wernher), W138b
210 'A Captain of Banditti' (private collection)

1773 232 Henry Frederick, Duke of Cumberland (destroyed)
233 Duchess of Cumberland (Waddesdon Manor, The National Trust), W146
234 Duchess of Buccleuch and Daughter (Bowhill), W148
235 Lady Melbourne and Her Son (Firle Place, Viscount Gage), W149
236 The Hon. Mrs Damer (Price sale, 1895)
237 Miss Sarah Child (Earl of Jersey), W147
238 David Garrick and his Wife (General Goulburn), W143
239 Sir Joseph Banks (Hon. Mrs Clive Pearson), Plate 73
240 'A gentleman, three-quarters'
241 A Nymph with young Bacchus (London, Tate Gallery), W141b
242 The Strawberry Girl (London, Wallace Collection), Plate 63
243 Count Ugolino and his Children (Knole)
382 The Hon. Mrs Parker (Saltram, The National Trust), Plate 66

1774 214 Duchess of Gloucester (Royal Collection), W154
215 Princess Sophia of Gloucester (Royal Collection), W153
216 Three Ladies adorning a Term of Hymen (London, Tate Gallery), Plate 72
217 Mrs Tollemache as Miranda (London, Kenwood)
218 Mrs Pelham feeding Poultry (Earl of Yarborough), Plate 91
219 Earl of Bellamont (Dublin, National Gallery of Ireland), W156
220 Lady Cockburn and her Sons (London, National Gallery), Plate 70
220* Thomas Newton, Bishop of Bristol (London, Lambeth Palace), Plate 68
221 Dr Beattie (Aberdeen University, Marischal College), Plate 67
222 The Hon. Richard Edgcumbe (destroyed)
223 Giuseppe Baretti (Lady Teresa Agnew), Plate 64
224 possibly Edmund Burke (Dublin, National Gallery of Ireland), W160a
225 Infant Jupiter (destroyed)

1779 245 Nativity (for New College window) (destroyed)

246, 247, 248 Faith, Hope and Charity (for New College window) (Somerley)

249 Lady Louisa Manners (London, Kenwood), w212

250 Lady Jane Halliday (Waddesdon, The National Trust), Plate 87

251 Viscountess Crosbie (San Marino, California, Henry E. Huntington Art Gallery), w208

252 Lady Caroline Howard (Washington, D.C., National Gallery of Art), w211

253 Mrs Payne Gallwey and Son (formerly J. P. Morgan), w206b

254 possibly Edmund Malone (London, National Portrait Gallery)

255 Andrew Stuart (on loan to Glasgow Art Gallery)

1780 12 Lady Beaumont (Miss Helen Frick, Pittsburgh), w216a

18 Edward Gibbon (Lord Primrose, Dalmeny), Plate 98

32 Marquess of Cholmondeley (Houghton), w221

102 Lady Worsley (Harewood House), Plate 83

138 Miss Beauclerc as Spenser's 'Una' (Cambridge, Mass., Fogg Art Museum)

157 Justice (for New College window) (Somerley)

167 Prince William Frederick of Gloucester (Cambridge, Trinity College), w220

1781 10 Thaïs (Waddesdon, The National Trust), Plate 99

16 Dr Charles Burney (London, National Portrait Gallery)

21 Robert Thoroton (untraced)

140 Lord Granby and Sister (Belvoir Castle)

147 Master Bunbury (Philadelphia Museum of Art)

160 The Death of Dido (Buckingham Palace)

182 Lord Richard Cavendish (Welbeck Abbey), w225

187 The Ladies Waldebrave (Edinburgh, National Gallery of Scotland), Plate 96

225 Duchess of Rutland (destroyed by fire)

241 Marchioness of Salisbury (Hatfield)

389 Temperance (for New College window) (Somerley)

395 A Child asleep (Earl of Aylesford, Packington)

402 Fortitude (for New College window) (Somerley)

421 Boy laughing (untraced)

427 possibly Lady Craven and Child (Petworth)

1782 10 William Beckford (Mrs S. P. Rotan, Philadelphia), w233

22 Mrs Robinson (Waddesdon, The National Trust)

54 Countess of Aylesford (Earl of Aylesford)

72 The Infant Academy (London, Kenwood), Plate 90

73 An Angel (Welbeck Abbey)

74 Dr Thomas, Bishop of Rochester (Mrs R. K. Smith, San Francisco, 1933)

149 Lt.-Col. Banastre Tarleton (London, National Gallery), Plate 101

157 Lavinia, Viscountess Althorp (Althorp), Plate 94

158 Lord Chancellor Thurlow (Longleat)

159 Mrs Baldwin (Bowood)

186 possibly The Hon. Mrs Peter Beckford (Port Sunlight, Lady Lever Art Gallery), w235

198 A Girl (untraced)

204 Lady Elizabeth Compton (Washington, D.C., National Gallery of Art), w230

218 Countess Talbot (London, National Gallery), w231

1786 76 Vandergucht Children (San Marino, California, Henry E. Huntington Art
(cont'd) Gallery)
 85 Duke of Orleans (damaged: Royal Collection)
 95 Lady de Clifford (C. Morland Agnew estate), w266b
 103 John Lee (Sir Harold Cassel, Bt.) w262
 166 Duchess of Devonshire and Daughter (Duke of Devonshire), Plate 119
 178 Joshua Sharpe (Viscount Cowdray), Plate 108
 198 Lavinia, Countess Spencer (Althorp), w261
 215 John Barker (New York, Metropolitan Museum of Art)
 223 John Hunter (London, Royal College of Surgeons)
 224 Lady Anne Bingham (Althorp), Plate 105
 396 A Child with Guardian Angels (formerly Duke of Leeds)

1787 7 Lady Smith and Children (New York, Metropolitan Museum of Art), w272
 24 Heads of Angels (London, Tate Gallery), Plate 110
 33 Miss Ward (Fort Worth, Texas, Kimball Art Foundation)
 69 Sir Henry Englefield (Lasy Heathcote), w269b
 76 The Hon. Mrs Stanhope (untraced)
 90 George IV, when Prince of Wales (Duke of Norfolk), Plate 103
 100 Lady St Asaph and Son (Baltimore Museum), w284
 113 James Boswell (London, National Portrait Gallery), Plate 121
 146 Lord Burghersh (Earl of Jersey), w278
 167 Master Philip Yorke (London, Kenwood), w279
 187 Lady Cadogan (untraced)
 200 Mrs Williams Hope (untraced)
 217 Lady Elliot (probably destroyed)

1788 23 Earl of Sheffield (Lord Sheffield sale 1909)
 38 William Windham (London, National Portrait Gallery), w286b
 51 A Girl sleeping (formerly Lord Northbrook)
 84 Lady Harris (Earl of Malmesbury), w292
 88 Frederick, Duke of York (Royal Collection), w288
 97 Sir George Beaumont (Miss Helen Frick, Pittsburgh), w283
 115 Lord Heathfield (London, National Gallery), Plate 107
 116 Mrs Drummond Smith (Castle Ashby), w285
 124 The Hon. Leicester Stanhope (Earl of Harrington), Plate 111
 146 General Morgan (Cardiff, National Museum of Wales), Plate 116
 162 Earl of Darnley (untraced)
 167 Infant Hercules strangling Serpents (Leningrad, Hermitage)
 183 Lord Grantham and Brothers (Baroness Lucas), w287
 189 Wilson Gale Braddyll (untraced)
 219 Lady Betty Foster (Chatsworth, Devonshire Collection), Plate 114
 226 Miss Gideon and her Brother (Viscount Cowdray), w289
 265 Earl of Lindsey (Toronto, Private Collection), w286a
 378 A Girl with a Kitten (Detroit, Institute of Arts)

1789 65 The Hon. Mrs Watson (Lt. Commander L. M. M. Saunders), w293
 82 Robin Goodfellow (Earl Fitzwilliam), Plate 109
 86 'A young gentleman' (untraced)

Bibliographical notes

Writings of Sir Joshua Reynolds

Frederick Whiley Hilles: *The Literary Career of Sir Joshua Reynolds*, Cambridge University Press, 1936, pp. 277–300, gives a full bibliography of everything published during Reynolds's lifetime and also of the first two editions (1797 and 1798) of *The Works of Sir Joshua Reynolds*, edited by Edmond Malone. The various later editions brought out during the nineteenth century all derive, with varying degrees of inaccuracy, from the 1798 edition, which contains Malone's last additions and corrections.

The only posthumously published literary work is *Portraits by Sir Joshua Reynolds*, edited by Frederick Whiley Hilles, London, 1952. These are character sketches (and certain other papers), and the misleading title does not allude at all to paintings.

Reynolds's one major literary work was the *Discourses*. The only reliable text, which provides a collation of the early editions, is that edited by Robert R. Wark, Huntington Library, San Marino, California, 1959.

A few extracts only from his Italian sketchbooks have been published by William Cotton: *Sir Joshua Reynolds' Notes and Observations on Pictures, etc.*, London, 1859.

Finally there is *Letters of Sir Joshua Reynolds*, collected and edited by Frederick Whiley Hilles, Cambridge University Press, 1929. A few additional letters have been published by Professor Hilles in an article printed in *Horace Walpole, Writer, Politician and Connoisseur*, edited by Warren Hunting Smith, New Haven, 1967.

Biographical works

James Northcote: *Memoirs of Sir Joshua Reynolds, Knt., etc.*, 2 vols., London, 1813–15. This is the main source for first-hand information about Reynolds and it should be supplemented by parts of *Conversations of James Northcote, R.A., with William Hazlitt*, edited by Edmund Gosse, London, 1894; *Conversations of James Northcote, R.A., with James Ward*, edited by Ernest Fletcher, London, 1901; and Stephen Gwynne: *Memorials of an Eighteenth Century Painter (James Northcote)*, London, 1898.

William Cotton: *Sir Joshua Reynolds and his Works*, London, 1856.

Charles Robert Leslie and Tom Taylor: *Life and Times of Sir Joshua Reynolds*, 2 vols., London, 1865. This is still the standard biography and contains most of the reliable information amidst an excessive quantity of contemporary historical gossip.

The only one of the many later biographies which deserves mention is Derek Hudson: *Sir Joshua Reynolds*, London, 1958.

Documentary and critical works and catalogues

The source material for a knowledge of Reynolds's works consists of two kinds—sitter books and ledgers. There are also a great many contemporary engravings.

The sitter book for 1755 (with one or two pages missing) is in the Cottonian Library at Plymouth. This is the only sitter book which has so far been published in full, (Waterhouse, *The Walpole Society*, XLI, 1968, pp. 112–64).

All the other surviving sitter books are in the Royal Academy Library and range from 1757 to 1789; the volume for 1756 is missing and so are those for 1763, 1774, 1775, 1776, 1778, 1783 and 1785.

The information in the sitter books and ledgers has been used to a considerable extent (but often in a misleading way) in Algernon Graves and William Vine Cronin: *A History of the Works of Sir Joshua Reynolds*, 4 vols., published by subscription (125 copies only), London, 1899–1901. The last volume contains a reprint of the sale catalogues of Reynolds's collection, and also of the sale in 1821 by the Marchioness of Thomond of the remainder of Reynolds's pictures. There is also a bibliography of all works of Reynolds, however trivial, up to 1894, and, in the body of the text, most of the contemporary press notices of his pictures in the R.A. exhibitions are reprinted. In the main this is a *catalogue raisonné*, arranged alphabetically under sitters, of all pictures known or believed to be by Reynolds, which includes most of the sale and exhibition references to his pictures up to the end of the nineteenth century. There is also a great deal of valuable (though sometimes irrelevant) genealogical information about the sitters; months for sittings are included but not the days and numbers of sittings. It is a monument of pious labour, compiled, in large part by correspondence, in the interests of the art trade. It may be ungenerous (considering how useful the book is) to say that it is almost wholly uncritical and that there is hardly a single entry which does not need some correction, but forty years of annotating a copy have led to this conviction.

The only attempt at a chronological catalogue of Reynolds's entire output, in so far as it was then known to me, is in my *Reynolds*, 1941. This still has the largest collection of illustrations of Reynolds's portraits. I have supplemented the list of pre-Italian portraits in *The Walpole Society*, XLI, 1968, pp. 165 7, and many additions to the 1755 list will be found in the same volume.

The ledgers have been published by Malcolm Cormack in *The Walpole Society*, XLII, 1970, pp. 105–69. Both volumes are now in the Fitzwilliam Museum, Cambridge.

The fullest description of the numerous, very splendid mezzotints produced in Reynolds's lifetime is to be found in John Chaloner Smith: *British Mezzotint Portraits*, 4 vols. in 5, London, 1878–83.

The fullest listing of engravings in all mediums, both fine and trivial (with probably only inconsiderable omissions) is in Freeman O'Donoghue (Volume 6 by Henry M. Hake): *Catalogue of Engraved British Portraits . . . in the British Museum*, 6 vols., London, 1908–25.

There are also two series of engravings after Reynolds, normally bound up in series, and varying in different copies:

Engravings from the Works of Sir Joshua Reynolds, issued by Samuel William Reynolds: first in 1820 ff., and reissued by Hodgson and Graves about 1835–8. There are about 420 subjects engraved in all. The full list, as bound up in 4 volumes in the British Museum set, is listed in Alfred Whitman: *Samuel William Reynolds*, London, 1903, pp. 147–58.

Engravings from the Works of Sir Joshua Reynolds, P.R.A. Engraved by various hands and published by Henry Graves & Co., 1865, as a supplement to the S. W. Reynolds series. A full set should have 270 subjects.

Exhibition catalogues

The first 'Reynolds Exhibition' was held at the British Institution in 1813. The catalogue is of interest only as a list of what were then considered Sir Joshua's most important works.

The catalogues of the following exhibitions make some contribution to scholarship:

Catalogue of the Works of Sir Joshua Reynolds, P.R.A., exhibited at The Grosvenor Gallery, 1883–4. Notes by F. G. Stephens.

Sir Joshua Reynolds Loan Exhibition at 45 Park Lane, 1937. Notes by E. K. Waterhouse. Text and illustrations issued separately.

Sir Joshua Reynolds, Arts Council of Great Britain, 1949.

Paintings by Sir Joshua Reynolds, P.R.A., Plymouth, 1951.

Exhibition of Works of Sir Joshua Reynolds, P.R.A., Birmingham, 1961. Notes by Malcolm Cormack.

Royal Academy of Arts Bicentenary Exhibition, 1968.

Lists of collections

PUBLIC

Index